Helen Ibbitson Jessup is an indeper
in the art and architecture of Sout
Courtauld Institute of Art, Londo
important exhibition that toured i
Ancient Cambodia: Millennium of Glory, whose catalogue (
by Thames & Hudson) won the Alfred H. Barr, Jr. prize.

Thames & Hudson world of art

This famous series provides the widest available
range of illustrated books on art in all its aspects.

If you would like to receive a complete list
of titles in print please write to:

THAMES & HUDSON
181A High Holborn
London WC1V 7QX

In the United States please write to:

THAMES & HUDSON INC.
500 Fifth Avenue
New York, New York 10110

Printed in Singapore

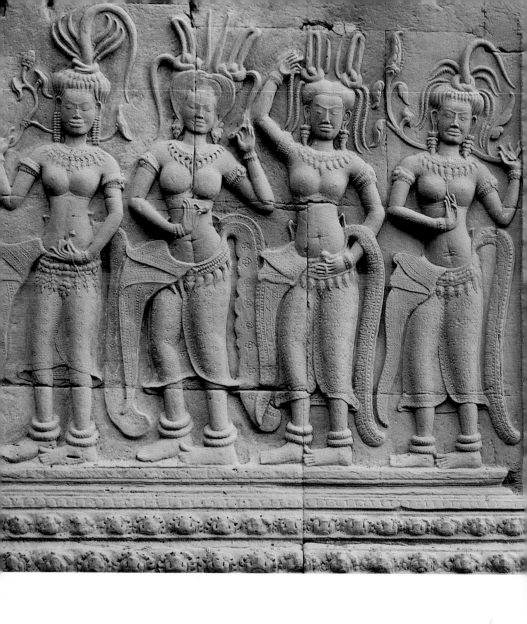

with 195 illustrations, 96 in colour

Helen Ibbitson Jessup

Art & Architecture of Cambodia

Thames & Hudson world of art

For Phil

First published in the United Kingdom in 2004 by Thames & Hudson Ltd,
181A High Holborn, London WC1V 7QX

www.thamesandhudson.com

Note
In the interests of the non-
specialist reader, Sanskrit and
Khmer words have been rendered
phonetically, without the diacritical
marks devised to bridge the gap
between the European alphabet
and the different scripts of Sanskrit
and Khmer.

British Library Cataloguing-in-Publication Data
A catalogue record for this book is available from the British Library

ISBN 0-500-20375-X

(title page)
1 Angkor Wat, apsaras (heavenly
nymphs), early 12th cent.

Designed by John Morgan
Printed and bound in Singapore by C.S. Graphics

Contents

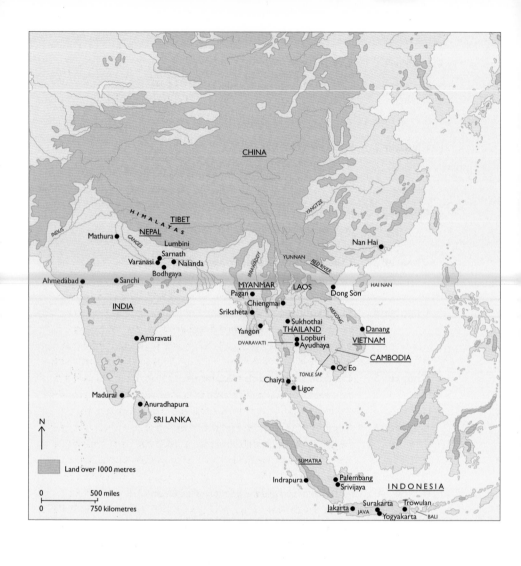

CHINA

HIMALAYAS

TIBET

NEPAL

INDUS

GANGES

Mathura

Lumbini

Sarnath

Varanasi ● Nalanda

Bodhgaya

Ahmedabad ● ● Sanchi

INDIA

Amaravati

Madurai ●

● Anuradhapura

SRI LANKA

N

Land over 1000 metres

0 500 miles

0 750 kilometres

YANGTZE

Nan Hai ●

YUNNAN RED RIVER

IRRAWADDY

HAI NAN

MYANMAR LAOS

Pagan ●

● Chiengmai ● Dong Son

Sriksheta ●

● Sukhothai

Yangon ● THAILAND

DVARAVATI ● Lopburi ● Danang

● Ayudhaya VIETNAM

MEKONG CAMBODIA

TONLE SAP ● Oc Eo

Chaiya ●

● Ligor

SUMATRA

Indrapura ● ● Palembang

● Srivijaya INDONESIA

Jakarta ● Surakarta Trowulan

JAVA ● Yogyakarta BALI

Chapter 1　Myth and Matrix: Prehistory and the origins of the Khmer people and their religions

History begins with geography, at least in the early years of a country's genesis. Cambodia's development was certainly shaped by its location in monsoonal regions where rain falls for half the year, heavily during about four months, and which are dry for the remainder of the year. If agriculture is to be sustained and settlements founded beyond riverine areas, techniques for water storage and distribution are essential. It is no accident that myths connected with water have been central to Cambodia's evolution, as have skills in hydraulic engineering. The river network provided the grid along which settlements were established, and the Mekong in particular, the longest river in Southeast Asia, has been responsible for one of the most important natural phenomena in Cambodia. The huge volume of water fed into the Mekong by melting snows in its Tibetan source during the northern spring swells the floods generated by the monsoonal rains that fall in Cambodia between May and October. At Phnom Penh the Tonle Sap, a river rising in the Great Lake of the same name, flows into the Mekong. By August or September the Mekong has such torrential force that its surge reverses the direction of the Tonle Sap, engorging the lake threefold to cover an area of 10,000 square kilometres (3860 square miles). Not only does this foster a huge yield of fish, it also deposits fertile silt when the water recedes at the beginning of the dry season, factors that have always been crucial in Cambodia's prosperity.

Our knowledge of prehistoric Cambodia is limited. Palaeolithic remains are rare, but Hoabinhian material has been found in scattered areas, from Mliu Prei in the north, Laang Spean to the west, Samrong Sen and Long Prao in the centre to Phnom Loang and Kbal Romeas in the southwest near the coast (see map

2 Southeast Asia, showing early settlements (countries underlined to indicate modern names). Early settlements evolved near rivers and lakes. Developments in ship building techniques, making longer voyages possible and reducing the need for intermediate stops, undermined the importance of entrepot ports like Oc Eo.

on p. 22). These settlements were established on or near rivers and their kitchen midden shell mounds have yielded lithic objects from the seventh millennium BCE and handbuilt pottery beginning from about two thousand years later and becoming common early in the first millennium BCE. It is often decorated with geometric patterns, including spirals. Bronze objects, mostly tools as well as rings and bells, were also found in the settlements.

The techniques and motifs are part of the Neolithic and Bronze Age cultures that were pervasive in Southeast Asia and not necessarily continuous with the culture of the people who inhabited Cambodia in the historical period. But there has been a persistence of habitation in many of the most ancient sites, and a significant number of sacred places evolved from archaic importance through Brahmanistic definition to contemporary Buddhist usage, so there is a basis for inferring considerable social, spiritual and perhaps also cultural continuity. Recent research in the Angkor Borei area, for example, establishes a continuous ceramic tradition and evidence of canal construction early in the first millennium.

Little is known about the history of metalworking in Cambodia, though finds of moulds and crucibles establish that metal was locally cast during the Neolithic period. The most notable bronze objects resemble a few vessels classified as Dongsonian in type, found in greater profusion in Yunnan, Central Asia, and particularly in the eponymous village of Dong Son in northern Vietnam. The culture producing these highly sophisticated vessels seems to have flourished from the second half of the first millennium BCE till about 300 CE. Though some examples of ritual drums, bells and urns were found in Cambodia, there is no evidence that they were made there, and they probably establish that widespread exchange of objects was already common in the prehistoric and early historic period in Southeast Asia.

Who were the Khmers? Their language is related to the Mon language in the Austro-Asiatic group, and they were probably part of the huge slow migrations from the Yunnan area of peoples who pre-dated the Mongolian race there. Another wave, or a differentiation of the same wave, generated the movements of the Austronesian peoples, including the Malay-speaking peoples of Indonesia. A later wave saw the Thai people, whose language belongs to the same group as Khmer, moving south. Our knowledge is limited, as there is no written record, and any understanding of the culture is dependent on archaeological

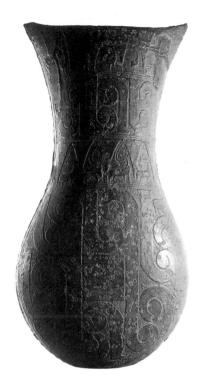
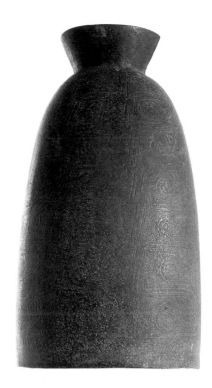

3 Ceremonial urn. Kandal. Dongsonian era, c. 300 BCE–300 CE. Bronze, 0.56 m (22 in).
The spiral and elongated triangle motifs of this bronze vessel are characteristic of the Dongsonian art produced in Vietnam from c. 300 BCE until c. 300 CE. Whether the object was imported or made in Cambodia is unknown. Similar vessels as well as ceremonial drums are found throughout Southeast Asia.

4 Bell. Samrong. Dongsonian era, c. 300 BCE–300 CE. Bronze, 0.56 m (22 in).
Like the urn on the left, this heavy ovoid bell with elliptical rim is decorated with a series of moulded interlocking spiral motifs in horizontal bands. As it lacks a clapper, it was probably struck on the exterior. Such highly refined vessels were undoubtedly used in ceremonies of high status.

investigations of urban sites and material evidence such as bronze and ceramic artifacts. When these are divorced from matrix, which is the case with most of the objects preserved in museums, we cannot tell whether they were imported or locally made, whether they indicate a pervasive culture in the region or efficient trade connections that distributed single-source production over a wide area.

Our understanding of the identity of the Khmers is drawn partly from foreign records and partly from mythology. The latter is more colourful. It concerns the tale of an Indian Brahman who arrived by boat. He married the daughter of the local serpent king (nagaraja) and together they founded a dynasty. Her father drank the waters of the swampy land and made agriculture possible. Overlapping with this description is a later naming of Kambu as the founding ancestor. His land was called Kambujadesa, from which the word 'Cambodia' is derived, but we do not know what the original inhabitants of historical Cambodia called their land at the time it first entered foreign awareness. A Chinese variant, probably a distortion of the Indian legend, names the Brahman as

Kaundinya, who in a dream was instructed to travel on a ship to a far country. The following day, after finding a magic bow beneath a tree, he made preparations to sail on a trading junk. Enchanted winds blew the vessel to the coast of a land that can be identified as Cambodia. The local princess, Nagi Soma, tried to capture his ship, but Kaundinya used his bow to shoot an arrow that pierced her boat. She submitted, he became her husband and the ruler of the country. Extrapolating meaning from myth could lead to describing the tale of the nagini, or naga princess, as a symbol of the merging of Indic culture with autochthonous elements. The story of the naga king's drainage of the land (presumably the delta of the Mekong) can similarly be inferred to show how the importance of hydraulic control is even enshrined in the Khmer myth of origin.

The naga, or serpent, continued to be important in Khmer symbolism and imagery, as will be seen in later chapters. Its importance derives both from Indian ideas, where the naga is connected with the Buddha's story, but also from the older, perhaps Vedic legends of the royal naga cult, and from the indigenous belief that the naga was the ruler of the underworld and, by extension, of water and fertility. The similarity of the philosophies makes it easy to comprehend the apparently easy absorption of Indic elements into Khmer culture. Nor was this restricted to the Cambodian setting: a similar syncretism shaped the evolution of Indonesian culture. The dragon can be seen as an equivalent in Chinese culture.

The role of India in Cambodian cultural history was central, but for the earliest historical awareness of the Khmers we are indebted to the Chinese, whose diligence in keeping written records is responsible for most of our knowledge of early Southeast Asian history. Dynastic annals of the Wu emperor (ruled 222–52 CE) noted that the envoys Kang Tai and Zhu Ying visited a country they called Funan. Kang Tai wrote an account of the land and although his account survives only in quotations of it by others, his description of Funan's location clearly places it in today's southern Cambodia and Vietnam. The port was at Oc Eo, and the capital somewhat inland, probably at Angkor Borei. Ship building was practised, the palaces and villages were walled, the utensils were sometimes made of silver, while taxes were paid in gold, gems and perfumes, and the writing was an Indian-derived script. Other accounts describe buildings on piles (consistent with the swampy conditions of coastal areas in the delta). The annals of the Liang (502–56), written in the seventh century, mention

statues of deities with multiple heads and arms (consistent with the possibility that travellers from India had brought religion as well as trade to the area).

In 243 an envoy from the king of Funan arrived in the Chinese court bringing a gift of dancers. The records give the names of kings who had titles incorporating the word 'Fan'. This is probably the equivalent of 'pon', a Khmer word for a leader found in early inscriptions. Like 'Funan', it is a transcription of uncertain accuracy from Chinese characters; it is thought that 'Funan' derives from the Khmer word 'phnom' (or 'bhnam', an alternative phonetic spelling), meaning 'mountain', and that the title may refer to the conception of the ruler as lord of the mountains. Though this is a tenuous idea, the invocation of the mountain introduces another pervasive symbol in Southeast Asia. Like the naga, it is relevant to autochthonous myths of origin as well as to Indic ideas of divinity and power. Its accuracy in the context of Angkor Borei, situated in the low-lying Mekong delta regions, could be questionable, except for the references in later inscriptions to a city called Ba Phnom, centred on a small hill whose relative size was not as important as its symbolism.

Whatever the accuracy of the nomenclature, the evidence of a thriving polity engaging in extensive international trade can be gleaned not only from Chinese accounts but also from twentieth-century and continuing excavations by Louis Malleret, the Vietnamese and others at Oc Eo. Engraved Indian gold jewelry, Roman coins of the second century, Chinese bronze mirrors and trade goods from many countries have been found, indicating a lively international commerce. The maritime activity was presumably stimulated by the disruption of the overland Silk Route in the third century because of dynastic disturbances in China. The shipping movements of the time were still largely coast-hugging routes, giving entrepot ports like Oc Eo a great importance. When ship building techniques improved, vessels could cover longer distances and cross the open sea, leading to the obsolescence of some formerly essential ports. Such a change may account for the decline of the Funan kingdom in the sixth century and an increase in power in the more northerly areas that were less dependent on maritime connections, a more tenable explanation than the former belief that it had been conquered by the northern kingdom the Chinese called Zhenla.

Discussion of early polities must be tempered by the understanding that regardless of the titles of their rulers, they were not necessarily kingdoms in the modern sense, but more

5 Mukhalinga. Vat Po Metrey, Takeo, 7th–8th cent. Sandstone, 0.83 m (32⅝ in).

The earliest representations of Shiva were abstracted and usually took the form of the linga, symbol of fertility and the life force. The body of the linga is often carved in three sections that represent the trimurti, the three chief Brahmanic deities: square, referring to four-headed Brahma and the four cardinal directions; octagonal, referring to Vishnu and the cardinal and sub-cardinal directions; and circular, referring to Shiva and the infinite cosmos. This linga has a face (mukha), hence its designation as a mukhalinga. Khmer mukhalingas are found only in pre-Angkorian art.

likely to have been trading centres that expanded to exert influence on other nearby centres, gradually achieving hegemony of trade though not necessarily central administrative organization. What is of interest in the study of art and architecture is the extent to which the consolidation and centralization of power resulted in the desire among the leaders to create symbols of material and spiritual power in permanent form.

For internal information about Cambodia we have to wait until the seventh century. Ongoing archaeological and epigraphic research will lead to more certain dating of the earliest Khmer sculpture and architecture, but at the moment the oldest images and structures can be dated with certainty only from early in the seventh or possibly late in the sixth century. The earliest inscriptions in Cambodia begin in the seventh century, the first dated example in Sanskrit inscribed in 613, the first in Khmer in 611. (Note: Inscription dates in Sanskrit and Old Khmer would have been formulated on the basis of the Shaka calendar, said to have been initiated 500 years after the birth of the Buddha. Although its years' beginnings vary slightly from our CE dating, Shaka dates are between 78 and 79 years earlier than CE dates.) Although these inscriptions and the contemporary sculpture and architecture are the first visible proofs of the profound influence of India on Khmer culture and the role of the Cambodian ruler, his nomenclature (notably the addition of the Sanskrit word '-varman' – 'protected by' – as a suffix to his name) and his relationship with religion, it is clear that Brahmanism had been present in the area from early in the millennium, or before. The stele found at Vo Canh in southern Vietnam, for example, has been dated to the second half of the third century and is written in Sanskrit. It is reasonable to infer that this confirms the presence of the Indic religions that Sanskrit served. Trading connections with India were part of a pendulum of commerce that swung from the Mediterranean, prosperous and outreaching during Pax Romana, to China. Aromatics from the former were exchanged for silk and porcelain from the latter, among other goods, the exchange being enriched by the input of products from intermediary stops on the route, such as the spices from the Indonesian archipelago and forest products from Sumatra.

The origins of Brahmanism and Buddhism in Cambodia, which arrived first, and what route they came by, are uncertain. It might have been an inadvertent spread, transmitted by traders who practised one or other religion. Or the religions might have been

6 Stele with Trimurti. Unknown provenance, second half 7th cent. Sandstone, 0.77 m (30⅜ in). The stele represents the three gods of the trimurti in the form of symbolic attributes. On the viewer's left are the rosary (akshamala) and water vessel (kamandalu) of Brahma. In the centre (and thus dominant) is Shiva's trident (trishula). To the right are Vishnu's attributes: the earth (Prthivi), the disk (chakra), the conch (sankha) and the club (gada).

adopted by rulers who sought to enhance their spiritual power through exotic rites and status, and perhaps at first affected only the small upper echelon of the population. Such a limited spread at first would be understandable in the light of the persistence of the indigenous religion with its veneration of earth symbols, in particular sacred rocks that were connected with ancestor spirits, or neak ta; these are still important in Cambodia today. The sanctuary constructed on Phnom Thma Dos ('stone that grows'), which enshrines a 6-metre (20-foot) natural stone linga considered holy, is just one of many examples. There is a clear affinity between this belief and the Brahmanic cult of the linga, a non-material form of Shiva with fertility symbolism. Its earliest forms in India are probably svayambhuvalinga, natural outcrops of rock suggestive of phallic form. The earliest representations of Shiva in Cambodia take the form of the linga [5], often with three sections whose differing plans represent the trimurti, the Brahmanistic trinity, subsumed into the total supremacy of Shiva. Brahma is implied in the lower third (square), Vishnu in the middle (octagonal) and Shiva in the summit (cylindrical). Occasionally the linga's upper section was carved in the likeness of a face ('mukha'), a step towards anthropomorphic form. Other early non-material representations of Shiva and the other two trimurti gods employ their attributes to imply the deity [6].

An awareness of the role of the several streams of spiritual belief in Cambodia's cultural evolution is essential for understanding Khmer art: there is perhaps no country where architecture and sculpture are so profoundly generated and pervaded by religion. Brahmanism is represented by several divinities, though fewer than in the vast variety of India itself, and although apparently polytheistic, in its essence it comprises beings who are all aspects of a single divine spirit. Trimurti images predominate. Brahma the Creator, whose four-headed gaze surveys the universe in all cardinal directions, appears less frequently than Vishnu and Shiva, except in architectural reliefs and in association with representations of Vishnu in Cosmic Sleep. Brahma is the author of the Veda, the ancient Indian texts of knowledge forming the basis of religion. The gods have specific mounts, or vahana, themselves divine; Brahma's is the hamsa, or goose. Recognition of Hindu deities partly relies on their attributes. In Brahma's case these include the rosary (the beads being the letters of the Sanskrit alphabet, appropriate for the author of the sacred texts), the manuscript and the water flask.

Shiva, as the legend depicted in the stele of Vat Eng Khna

7 Lintel. Vat Eng Khna, Kompong Thom, second half 7th cent. Sandstone, 0.55 x 1.85 m (21⅝ x 72⅞ in).

The form of this vegetal band flanked by figurative consoles is typical of the pre-Angkorian style of Prei Kmeng. The three cartouches featuring Shiva's head set in a linga surrounded by flames in the centre, with Brahma's to his right and Vishnu's to his left, invoke the legend of Shiva's manifestation in a flame-ringed linga. Its depth was unplumbable by Brahma, its height was unscalable by Vishnu, thus proving the superiority of Shiva. Below, processions bearing ceremonial vessels attend a figure in a columned pavilion. The scene may represent the abhisheka, or consecration of a king; its conjunction with the scene referring to Shiva's supremacy may invoke divine sanction for kingly power.

suggests [7], is first among equals in the trimurti. His appellation as the Destroyer omits the complex relationship of creation to destruction: one is not possible without the other. This is an encapsulation of the Hindu belief in the necessity for balance between opposite forces. The earliest Khmer images are Shiva's non-material manifestations, chiefly the linga but also the footprints, Shivapada [51]. Most of the anthropomorphic versions depict the god with two arms but occasionally he is shown with ten, in his supreme form, Sadashiva. In the centre of his forehead is his third eye, the eye of knowledge that, if opened, can project annihilating fire. Typically his headdress (jatamukuta) is a crown made of twisted locks in which sits the crescent moon. The gods have multiple identities (avatars) and names; Shiva's, to cite just three, include Girisha, Ishvara and Bhadreshvara. In addition, female divinities presented as spouses (shakti), such as Parvati and Uma, can also be interpreted as the female element within the god. Not to be confused with this is the androgynous manifestation of Shiva, Ardhanarishvara, whose body incorporates female characteristics on one side and male on the other [172]. Attributes include the trident (trishula), the rosary or noose (akshamala) and the sacred water flask (kamandalu). His mount is the bull, Nandin [9], whose presence in front of a temple indicates its dedication to Shiva. Nandin illustrates well the symbiosis of Indic and Khmer legends: the divine Hindu vahana fuses with the story of the protective Preah Ko (sacred bull) who can be viewed

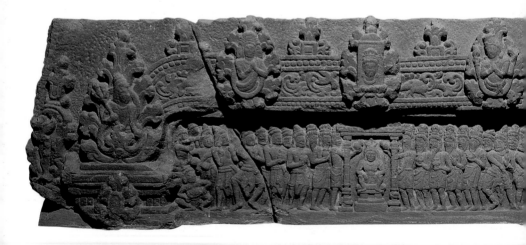

8 Vishnu. Prasat Kroh Bei (Damrei) Krap. N. Sanctuary, Phnom Kulen, first half 9th cent. Sandstone, 1.79 m (70½ in). Images of Vishnu usually have four or eight arms. The hands of this four-armed representation (Vishnu Chaturbhuja) hold the god's most important attributes (clockwise from the proper lower right): the globe (Prthivi), the disk or wheel (chakra), the conch (sankha) and the club or mace (gada). It is rare to find a Vishnu statue with four attributes intact, as here, as they are structurally vulnerable.

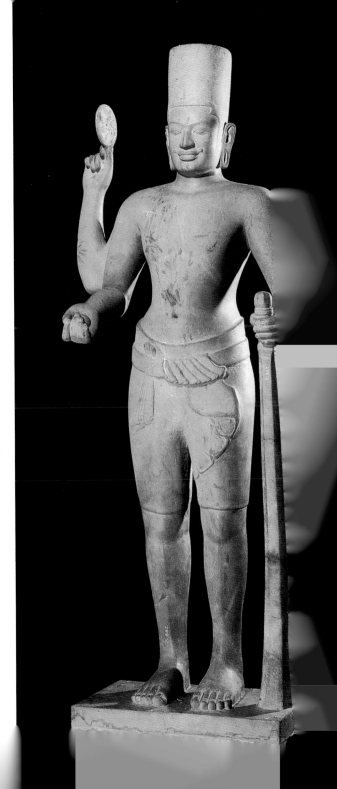

as the palladium of the kingdom. Associated with both Shiva and Parvati is Ganesha, their son, the beloved half-elephant god who combines extreme intelligence and resourcefulness with great physical strength, a fusion of the important forces of life [27, 28].

The third god of the trimurti, Vishnu, is known as the Preserver. Like the description of Brahma as Creator and Shiva as Destroyer, this is an oversimplification. During his cosmic sleep, for example, it is Vishnu who gives rise from his navel to Brahma, who creates the new cycle of existence. In his anthropomorphic form he may have four arms (Vishnu Chaturbhuja) [8] or in his supreme form as universal ruler, or chakravartin, up to eight (Vishnu-Vasudeva-Narayana) [17]. He is often depicted striding on three lotus pads, symbolizing his domination of the universe by three giant steps encompassing the water and lower world, the middle earth, and the upper world of heaven (Vishnu Trivikrama). In Cambodia he is frequently shown riding his vahana, the divine eagle-like Garuda [87]. His many avatars are both anthropomorphic, including Krishna [19] and Rama [16], and zoomorphic: two equine forms (vajimukha), Kalkin and Hayashiras [23] and a lion form, Narasimha. His attributes include the disk (chakra), the conch (sankha), the mace (gada) and the globe (personified by Prithivi). In pre-Angkorian Cambodia his headdress was a tall mitre (kirita) but later he wore a conical crown and diadem. In Khmer art Vishnu's most frequently represented shakti is Lakshmi. Other Brahmanic gods frequently encountered in Khmer statuary are Harihara, Durga, Indra, Skanda and Varuna. They will be discussed later (see Chapters 2 and 4).

From at least the seventh century most Khmer rulers sought identification with either Shiva or Vishnu. Foundations were established honouring the chosen deity (though others were not ignored) and in many cases a stele was erected recording the act in grandiloquent language, usually in Sanskrit verse [9]. A posthumous name was chosen by the king incorporating his own name with that of the deity whose protection he sought in the afterlife. The Shaivites Indravarman I and Rajendravarman, for example, had the posthumous names of Ishvaraloka and Shivaloka respectively, while the Vaishnavites Jayavarman III and Suryavarman II were remembered as Vishnuloka and Paramavishnuloka. Harshavarman II uniquely has a posthumous name invoking Brahma: Brahmaloka. Adherence to Vishnu or Shiva as principal deity fluctuated from reign to reign but at no point does there seem to have been serious conflict or iconoclasm.

Stele with Nandin. Tuol Neak Bak Ka, Kandal. Sandstone, 96 m (37¾ in; without tenon). Nandin, the sacred mount (vahana) Shiva, is shown seated on a lotus ossom. The Khmer inscription elow is in a script indicating a 7th-8th-century date and deals, as scriptions in the Khmer language ten do, with practical matters. this case an unnamed official rders the consignment of salt several sanctuaries dedicated Shiva.

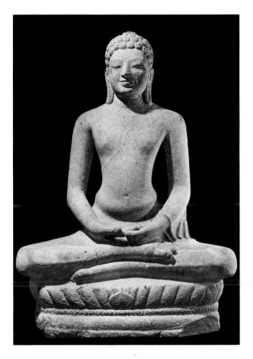

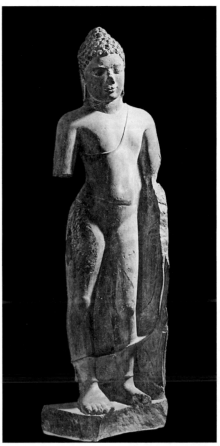

10 Seated Buddha. Phum Thmei, Kompong Speu, 7th cent. Sandstone, 0.9 m (35⅜ in). The attitude of the Buddha sitting on a lotus cushion with legs crossed in half-lotus position and hands palm upward in the lap represents the meditation pose.
11 Standing Buddha. Vat Romlok, Ta Keo, 7th cent. Sandstone, 1.25 m (49 in). The hip-swayed posture (tribhanga, or triple flexion) of this Buddha from Angkor Borei reveals the strong post-Gupta Indian influence on early Khmer sculpture. The spiral curls and cranial protuberance (ushnisha), and the outer robe leaving the right shoulder bare and flowing loosely over a supple undergarment, conform to the visual canon of early Buddha images.

Early Chinese reports of Funanese images with many arms suggest that perhaps Brahmanism arrived earlier than Buddhism, but the evidence is flimsy and the likelihood of their simultaneous arrival is equally possible. Certainly the earliest Khmer sculpture offers both Buddhist and Brahmanic examples, and furthermore reveals that Buddhism came not as a single school of thought, but in both Theravada and Mahayana forms. Some of the most serene representations of the Buddha are those from the seventh century, many found in the region of Angkor Borei, the heartland of Funan, strongly marked by the Gupta-period morphology that infuses early Khmer art. This comprises a hip-swayed posture (tribhanga) in the standing figures [11], and the meditation posture, cross-legged on a lotus, in the seated figures [10] as well as an oval face, continuous brow line and almond-shaped eyes. The iconography includes some of the lakshana, or distinguishing

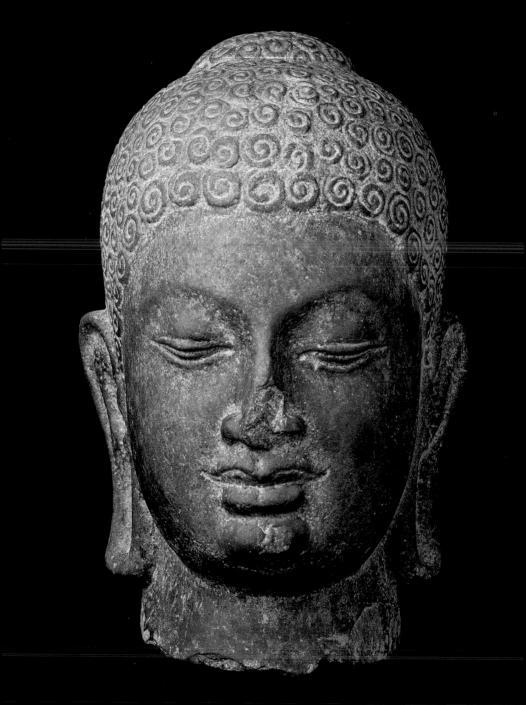

characteristics of the Buddha, among which are spiral curls (indicating the cutting of his hair from its princely length), elongated ear lobes (stretched from the wearing of heavy gold pendants that are now rejected) and the cranial protuberance (ushnisha) signifying wisdom [12].

The philosophy and spiritual beliefs of Buddhism were initiated in about 500 BCE by Siddharta Gautama (c. 560–c. 480 BCE), the prince who became known as the sage Shakyamuni after renouncing worldly possessions to meditate and seek enlightenment to gain liberation from the cycle of existence. The faith evolved in several schools, of which the earliest to be identified in Cambodia are known as the Way of the Masters (Theravada, sometimes called Hinayana, or Lesser Vehicle) and the Greater Vehicle (Mahayana). Theravada emphasizes a pure concentration on the Three Jewels: the Buddha himself, his teachings, and holy relics. Mahayana embraces a large pantheon of bodhisattva, entities who have gained enlightenment and the right to nirvana, the ultimate goal of nothingness, but who have postponed the end of their existence in order to help others achieve the state. Theravada employs Pali, a Sanskrit-related language, for its sacred texts and ritual, whereas Mahayana uses Sanskrit. Their contemporary existence in Cambodia is attested by two sculptures from the seventh century. On the back of the Buddha from Tuol Preah Theat [14], in characters paleologically contemporary with the sculpture, the Buddhist creed is inscribed in Pali, proving incontestably the presence of the Theravada school. The figure of the meditating Buddha Amitabha in the headdress of the small standing bronze from Angkor Borei [13] unmistakably identifies him as Avalokiteshvara, a bodhisattva confirming the presence of the Mahayana school.

A sub-school of Buddhism within Mahayana, Vajrayana, is also known as Tantrism and the Diamond Way; 'vajra' means thunderbolt and lightning. By extrapolation, the brilliance also led to the meaning of 'diamond'. This sect emphasizes the possibility of finding a more rapid path to enlightenment by ritual and prayer, but only under the close guidance of a guru, for which reason it is classified as Esoteric Buddhism. The most important deity in this pursuit was Hevajra. Tantrism was practised in Cambodia between the tenth and thirteenth centuries and inspired some of the most animated of Khmer statuary (see Chapters 3 and 4).

The sources of Cambodian Buddhism were complex. By the beginning of the first millennium the teachings had been interpreted variously in different areas. The Theravada school was

12 Head of Buddha. Vat Romlok, Angkor Borei, Ta Keo, ?6th–7th cent. Sandstone, 0.28 m (11 in). Distinct spiral curls, almond-shaped eyes, strongly arched eyebrows and oval face in this serene Buddha typify post-Gupta influences on the sculpture of Angkor Borei. The empty elongated ear lobes, stretched by heavy ornaments in his former princely life, are a reminder of the Buddha's rejection of material wealth.

fostered in Sri Lanka, to whose centre at Anuradhapura the faith had been carried in mid-third century BCE by the missionary Thera Mahinda at the instigation of the Buddhist emperor Ashoka. It spread chiefly to the Mon people of Dvaravati, in present-day Burma and Thailand, which to this day remain Theravadin. It was possibly brought overland to Cambodia. An important centre in southern India was at Amaravati near the East coast, a location that facilitated its connections with the maritime traders and a sea route. The scholarly foundation at Nalanda in northern India was a third source of Buddhist doctrine and practice. By the first millennium, the philosophy had acquired the infrastructure of organized religion and an international character. It is known from Chinese records that monks from Funan were sent to China to translate Buddhist texts from Sanskrit to Chinese in the late fifth and early sixth centuries, so it is clear that Cambodia was part of a cosmopolitan scholarly network.

The variety of Buddhist images within the Khmer corpus establishes the multiple sources of both iconography and morphology. The coexistence of Brahmanic material amplifies the scene. What is implicit in the accounts of the travels of both Buddhist monks and Hindu sages and ascetics, and what was important for the development of Khmer art, is the international nature of the exchange of ideas and styles as well as of goods. But what evolved in the form of architecture and sculpture in Cambodia has a dimension that cannot be explained solely in that context. It can only be explained in the light of a unique Khmer vision.

13 Avalokiteshvara. Vat Kompong Luong, Angkor Borei, Ta Keo, 7th cent. Lead-tin alloy, 0.178 m (7 in). This standing figure is the bodhisattva Avalokiteshvara (sometimes called Lokeshvara), recognizable from the seated figure of the Amitabha Buddha in his headdress. Bodhisattvas are beings who have gained enlightenment but postpone their accession to Nirvana in order to help others achieve it. It demonstrates that Mahayana Buddhism, with a pantheon comprising bodhisattvas as well as the Buddha himself, was already present in 7th-century Cambodia.

14 Buddha. Tuol Preah Theat. Kompong Speu, 7th cent. Sandstone, 0.925 m (36½ in). The Buddha establishes the early presence in Khmer religion of Theravada Buddhism, the Way of the Masters where Buddha himself is almost the only figure of consequence. The Buddhist creed inscribed in 7th-century script on the Buddha's back is not in Sanskrit, the language of Mahayana Buddhism, but in Pali, the sacred language of the Theravada sect. The right hand, with forefinger meeting thumb, indicates the hand gesture (mudra) of discussion (vitarkamudra).

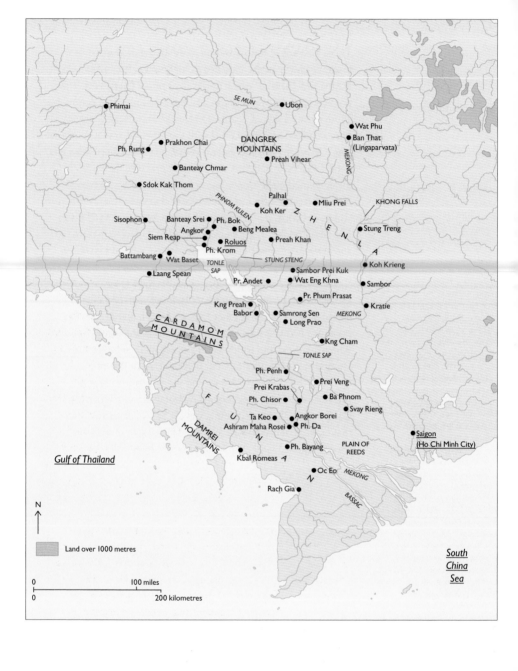

Phimai

SE MUN

Ubon

DANGREK
MOUNTAINS

Wat Phu
Ban That
(Lingaparvata)

Ph. Rung
Prakhon Chai

Preah Vihear

Banteay Chmar

Sdok Kak Thom

MEKONG

PHNOM KULEN

Palhal
Koh Ker

Mliu Prei

KHONG FALLS

Z H E N L A

Sisophon
Banteay Srei
Ph. Bok
Angkor
Beng Mealea

Siem Reap
Roluos
Preah Khan
Ph. Krom

Stung Treng

Battambang
Wat Baset

STUNG STENG

Koh Krieng

Laang Spean

TONLE
SAP

Pr. Andet
Sambor Prei Kuk
Wat Eng Khna

Sambor

C A R D A M O M
M O U N T A I N S

Kng Preah
Babor
Pr. Phum Prasat

Samrong Sen
Long Prao

MEKONG

Kratie

Kng Cham

TONLE SAP

Ph. Penh

Prei Krabas

Prei Veng

Ph. Chisor
Ta Keo
Ashram Maha Rosei
Angkor Borei
Ph. Da

Ba Phnom

Svay Rieng

Saigon
(Ho Chi Minh City)

F
U
N
A
N

DAMREI
MOUNTAINS

Ph. Bayang

PLAIN OF
REEDS

Kbal Romeas

Gulf of Thailand

Oc Eo

MEKONG

Rach Gia

BASSAC

N

South
China
Sea

Land over 1000 metres

0 100 miles

0 200 kilometres

Chapter 2 Pre-Angkor States:
from the second to the eighth century

Southern Centres

The history of early Cambodia is known to us from several sources. Palaeontology and archaeology have laid the foundation for our knowledge of the prehistoric period, though they are sketchy within Cambodia itself and depend on a corpus of investigation of more copious material in contiguous eastern Thailand and southern Vietnam. Our understanding of the Khmer identity is also shaped by its mythology, with the embrace of the allusive and speculative that this mandates. The continuity of chthonic beliefs, such as the sacred nature of stones and the importance of ancestor spirits, is relevant but unquantifiable. Until the seventh century, however, when architecture and sculpture that are incontestably Khmer appear, we are dependent on Chinese records for a grid of historical fact. Even these are not completely reliable: the challenge of transliterating a non-phonetic script poses one problem, and the inaccuracy of events relayed several times, as when lost original records were replaced from secondary sources, invokes another.

Despite these qualifications, it seems certain that a polity involved with international maritime trade, having a port at what has been established as Oc Eo (now in southern Vietnam) and a capital somewhat inland, probably at Angkor Borei, was an important entity in the Southeast Asian area from about the second or third century. It should be emphasized that the administrative and social organization was likely to have been based on an association of smaller units, perhaps successful trading or agricultural villages, rather than a centralized state as we conceive of it today. The name of Funan is purely a Chinese ascription, since there is no trace of what the Khmers themselves called their country at that time.

15 Pre-Angkorian and Angkorian sites (countries underlined to indicate modern names).
The distribution of Khmer settlements indicates former Cambodian influence over regions in present-day Laos, Thailand and Vietnam.

16, 17, 18 Rama, Vishnu, Balarama.
Phnom Da, Ta Keo, ?6th–7th cent.
Sandstone, Rama: 1.85 m (73 in),
Vishnu: 2.87 m (113 in), Balarama:
1.76 m (70 in).

This towering image of the eight-armed cosmic version of Vishnu (centre) is one of the most magnificent and probably one of the earliest of the sculptures from Phnom Da. The Gupta-like oval face and aquiline nose can also be seen in the flanking figures of Rama (left, with bow) and Balarama (right), both avatars, or manifestations, of Vishnu. The arch surrounding Vishnu demonstrates the oldest of Khmer carving techniques, where the matrix of the stone block was retained to support the radiating arms and their attributes.

Funan rulers with the title 'Fan' vied for power in the third century, according to the *Liang-shu* account, most inheritance being predicated on the assassination of the incumbent by his successor. The first was Fan Shih Man, who was reported to have conquered ten neighbours and extended his kingdom more than a thousand miles. The Chinese claimed that a delegate was sent to India by the third Fan, Fan Chan. The fifth, Fan Hsun, was probably the ruler at the time of the 240 CE visit to Funan by the Chinese emissaries Kang Tai and Zhu Ying, and of the first embassy from Funan to China, under the Wu emperor, in 243 CE, and a second in 268. There were three more delegations – in 285, 286, and 287 – which presumably sought to establish good relations with the new Chin emperor whose dynasty began in 280. During Fan Hsun's reign the annals first mention Funan's relations with Lin-i (formerly Lin-yi), later known as Champa. This neighbour, centred on what is

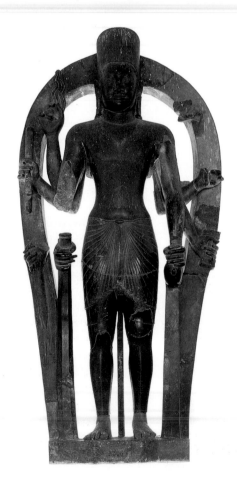

now the city of Danang in central Vietnam, was to play an important role for many centuries as one of Cambodia's chief adversaries.

The title 'Fan' persisted through the fourth century, a Chinese version of 'pon', the title of a chief of a village of up to a thousand inhabitants or more, according to Michael Vickery, who has recently done invaluable work on Khmer inscriptions. He suggests that rulers' adoption by the fifth century of the Sanskrit suffix '-varman' was possibly a way to by-pass the matrilineal inheritance practice in Funan where a sister's sons inherited the pon title and land.

Southern Chi records mention a Funan ruler called Jayavarman in the last quarter of the fifth and early in the sixth century. He sent embassies to the Liang court in 511 and 514. His successor, a son by a concubine, was Rudravarman, who sent six missions to the Chinese court, the last in 539. He is the last king of Funan to be mentioned by the Chinese. Rudravarman also happens to be the first king mentioned in local inscriptions, which proliferated in the seventh century. Epigraphy in Khmer makes it clear that there was a complex system of social organization and rank that pre-dated Indian influences and used Khmer titles.

By the seventh century Funan was in decline (see Chapter 1) as maritime routes by-passed entrepot ports like Oc Eo, and the focus of power shifted north to the polity the Chinese called Zhenl a (like Funan, this was not a word used by its inhabitants; we do not know the local name for the kingdom, which will be discussed later in this chapter). In one of the strange anomalies of history, the period of the waning of Funan's power coincides with the appearance of its oldest surviving art and architecture. It is puzzling that art of such astonishing quality could be produced by an allegedly declining society.

A distinctive group of sculpture dating from the seventh century is the determinant of the style of Phnom Da, named for the hill near Angkor Borei where many of the examples were found. They are all Vaishnavite and very homogeneous in morphology, with features still revealing the Indian sources of the Gupta style with classical oval face, rather aquiline nose, elegantly arched and almost continuous brow line, almond-shaped eyes and naturalistic anatomy. Despite these parallels, the Khmer sculpture is clearly distinct from the Indian models: the naturalism is more pronounced, the flexion of the postures much less exaggerated, the expressions more serene. The most spectacular work in the corpus is undoubtedly the great masterpiece of Vishnu as chakravartin, or universal monarch [17], standing almost 3 metres (10 feet) tall. It is almost certainly the image referred to as 'Hari Kambujendra' (Vishnu, lord

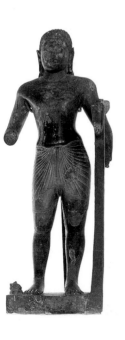

19 Krishna Govardhana. Vat Koh, Prei Krabas, Ta Keo, ?6th–7th cent. Sandstone, 1.60 m (63 in).
This high-relief representation of Krishna, one of the twenty-four avatars of Vishnu, embodies the Hindu legend in which the god lifts up Mount Govardhana to protect shepherds from the torrential rain inflicted on them as a punishment by the angry Indra, king of the gods and lord of storms.

20 Vishnu. Tuol Dai Buon, Prei Veng, 7th cent. Sandstone, 1.83 m (72 in).
The cylindrical mitre worn by this figure is characteristic of pre-Angkor Vishnu images. The attachment of the conch to the head as well as to the upper right hand indicates the remains of a supporting arch. The naturalistic treatment of the torso and the benign facial expression are typical of the humanistic style of pre-Angkor sculpture, while his four arms identify the god as Vishnu Chaturbhuja ('chatur' is Sanskrit for four), the most frequently represented version of Vishnu in Cambodia.

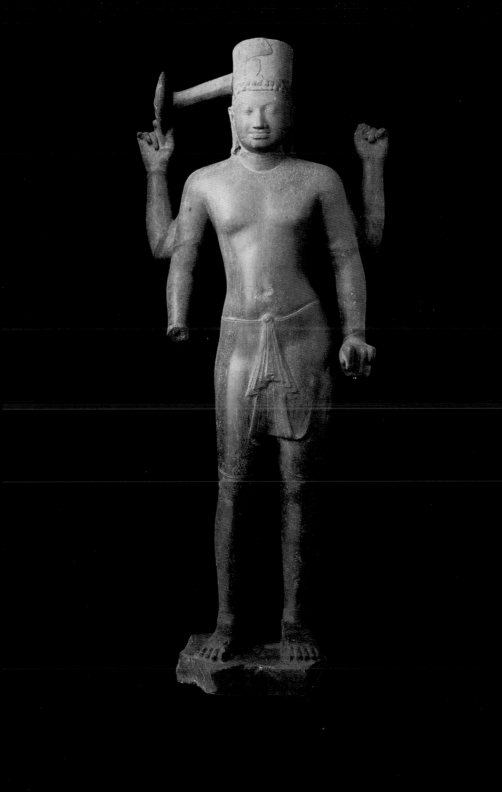

of the Kambu, that is, the Khmers) in inscription K549, which was found at Phnom Da in a temple from a much later date, the twelfth century.

Not all of its eight arms have survived, though in some cases the hands are still present. The attributes, which include (clockwise from proper lower right) a deer pelt, a baton, a flame, a vajra and a flask, differ from the usual Vaishnavite items, but the god is identifiable through his imposing mitre. The majesty of the image is not negated by the slenderness of the torso and the accurate rendering of physical details, including the sturdy braced legs, the delicate indication of ribs below the skin, a slight swelling of flesh where a short pleated sarong is knotted below the navel, and the musculature and impression of tension in the broad shoulders. The compelling power that radiates from the image is tempered by the serenity of the downcast gaze.

This Vishnu is instructive about sculptural techniques in Khmer art. The huge statue is carved from a single block of stone where the artist retained part of the monolith as a framing arch to support the arms and their attributes. The method was ubiquitous in pre-Angkorian creations of multi-armed gods, and is only a short step from totally free-standing sculpture in the round. Despite the carvers' precautions, the hands and attributes have usually suffered considerable fracture and very few images offer a complete set.

Found in the same twelfth-century temple as the monumental Vishnu were two sculptures of Vishnu avatars, Rama and Balarama [16, 18], contemporary with the Vishnu. The group is sometimes referred to as a triad, but there is no basis for this assumption. Certainly the treatment of faces, hands and torsos strongly suggests, however, that the same artist sculpted all three. Their status as avatars gives the two smaller statues a thematic connection with the Vishnu: Rama, identified by his bow, is the hero of the *Ramayana*; Balarama, older brother of Krishna, carries a plough, which he used to dig a channel to alter the course of the Yamuna river so that he could bathe in it. He appears in the *Mahabharata*, where he instructs Bhima, the warrior Pandava's brother, in the use of the club (this is alluded to in the pediment from Banteay Srei [98]). Less of the supporting arch remains in these two pieces, but the benevolent and refined face, graceful tribhanga stance and naturalistic treatment of the legs and body ties them firmly to the Phnom Da school.

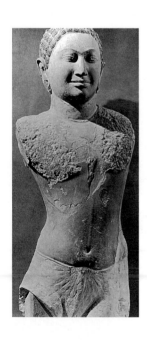

Further examples of the Phnom Da style can be seen in representations of Krishna, another avatar of Vishnu. Krishna

21 (opposite, top) Krishna Govardhana. Phnom Da, Ta Keo, 7th cent. Sandstone. The facial features, hip-swayed posture, naturalistic treatment of torso and finely incised sampot (loincloth) are characteristic of the sculpture of Phnom Da.

22 (opposite, bottom) Krishna. Phnom Da, Angkor Borei, Ta Keo, 7th cent. Sandstone, 1.02 m (40 in). The aquiline nose, elegantly arched brows and oval face typify the style of Phnom Da.

23 Vajimukha. Kuk Trap, Kandal, 7th cent. Sandstone, 1.35 m (53 in). This figure (possibly Kalkin or Hayashiras, two equine avatars of Vishnu) blends human and equine features, its hip-swayed posture and naturalistic torso embodying pre-Angkorian humanism.

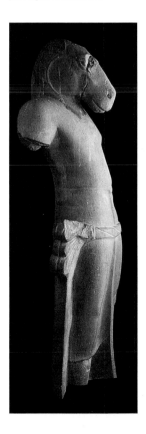

Govardhana [21] reveals a command of the expression of implicit movement that is possibly the most successful in the group, the stretch of the god's left arm as he supports the uplifted Mount Govardhana convincingly balanced by the consolidation of the opposed side of his body. The same naturalistic treatment of anatomy, the subtle indication of the suppleness of the cloth girding his hips, and the same incorporation of Gupta-like physiognomy ties the piece to the Phnom Da oeuvre, with an added touch of realism in the youthful aspect of the face, its slightly smiling, even mischievous expression consistent with the character of Krishna, a young god. Another head and torso [22] can be identified as Krishna from the tricira, the triple locks twisted on the top of his head. Despite the extensive losses in this figure, the face is in an unusually intact condition and illustrates well the refinement and serenity of the Phnom Da school. The slight tilt of the torso may indicate the Govardhana version of the god.

The third image of Krishna [19] found at Prei Krabas to the north of Angkor Borei does not belong to the Phnom Da group, despite sharing many of its characteristics of facial and torso modelling, including the youthfulness of expression. The impression of movement is even more compelling, the treatment of the folds of the cloth flowing from behind the hips and the braced position of the right knee adding to the tension of the stretched posture. The preservation of detail can be assumed to result from the reduced isolation of the limbs in the high-relief form of the sculpture. From this technique a slightly earlier date could perhaps be inferred for this image than for those from Phnom Da.

The Phnom Da group includes a few more sculptures, one of which is another avatar of Vishnu, Parashurama, adding to the certainty that the patron commissioning them was a devotee of that god; patrons of such ambitious works were almost certainly rulers. Sometimes inscriptions mention donations by kings, but we have no certain connection between these images and a specific personage. The entire body of Khmer art is anonymously created: not a single artist's name has survived. What is certain, however, is that a strongly unifying vision shaped this extraordinary corpus.

From nearby but different locations come two sculptures that demonstrate that the stylistic heritage of the Gupta period pervaded Khmer art in the southern regions of Cambodia that comprised Funan. Both are Vaishnavite, and probably contemporary with the Phnom Da works. Stylistically, the closer is an equine avatar of Vishnu [23], one of two possible entities mentioned in Indian sacred writings. Hayashiras (also Hayagriva) is

24 Standing Buddha. Binh Dinh, Plain of Reeds, Vietnam, ?6th–7th cent. Wood, 1.35 m (53⅛ in). This rare wooden figure was found well preserved in marshy soil.

25 Durga Mahishasuramaradini. Tuol Kamnap, Svay Rieng, 7th cent. Sandstone, 1.06 m (41¾ in). The goddess, 'slayer of the buffalo demon', is one of Shiva's shakti (spouses) but is also associated with Vishnu. The dual association endows her with supreme power.

26 Devi. Prasat Thleay, Ta Keo, 7th cent. Sandstone, 0.48 m (18⅞ in). This female divinity (maybe Uma or Parvati, shakti of Shiva) has coiled locks that resemble the jatamukuta coiffure associated with Shiva.

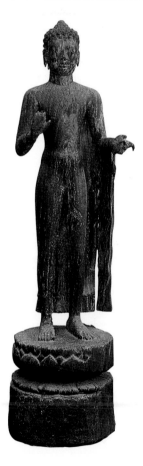

the rescuer of the *Veda* from the thieves who stole those sacred texts, identified in the Vaishnavite tract *Bhagavatapurana* as the 'all-powerful Himself…the colour of gold'. Kalkin is the avatar yet to come, Vishnu's incarnation at the end of time, who is extolled in the *Kalkipurana*. For lack of identifying attributes, this deity is described simply as 'Horse-faced' (Vajimukha). The remarkable dignity and nobility of the figure, with its strongly braced legs and gentle expression, has qualities in common with the Phnom Da sculptures and also the Vat Koh Krishna, whose flowing sash is treated in a similar way to that of Vajimukha's. Like the Krishna, the Vajimukha retains a strong connection with the stone matrix. What is most memorable about the piece is the mastery of the sculptor's merging of the human and equine elements. The accommodation of the horse's broad neck and slender head to the proportions of the human shoulders and torso is executed with such skill, the differing scales so harmoniously adjusted, that disbelief is totally suspended.

The other Vaishnavite figure of extraordinary beauty among the male gods of the seventh century in the southern regions is a Vishnu Chaturbhuja [20]. While the legs and hips are somewhat heavier than those of the Phnom Da statues, the hands, and particularly the face, are executed with finesse. The slightly hip-swayed stance and the double fishtail pleats of his hip-wrapping garment, the closest representation at the time of the Cambodian draped sampot that persists until today, lend grace to the regal figure. But it is the expression that most distinguishes this sculpture: the powerful, self-confident mien is tempered by a half-smiling serenity and downcast gaze that suggest spirituality.

A question arises about the level of artistry of these works. If they are the earliest examples of Khmer art, and if, as is certain, they are locally made, how is it possible that Cambodian artists could produce such perfection of form seemingly out of nowhere? In the early years of Indian contacts there may well have been imported sculptures that served as stylistic models, but given the challenge of transport, these would necessarily have been small objects, probably bronzes. Indeed, there are several examples, usually Buddhistic, especially in Vietnamese collections, of bronzes with all the characteristics of Indian facture that were in all likelihood imported. It is inconceivable, however, that stone sculptures on the scale of the Phnom Da work could have been carried any significant distance.

The answer surely lies in an evolution of technique honed in the use of perishable, less challenging media such as wood. For the

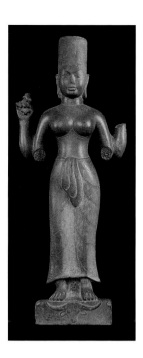

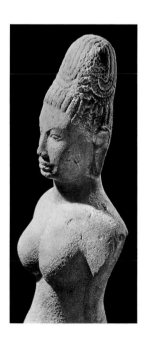

most part such works would not have survived, being subject to rot and pests, but some evidence exceptionally exists in a group of wood images of the Buddha discovered in a location in Vietnam that would have been Khmer in the Funan era [24]. The marshy soil they were found in has chemical properties that help the preservation of wood (alum and sea salt). Furthermore, they were carved from one of two species of wood (Hopea odorata or Calophyllum inophyllum) known for its resistance to decay and termites. While the carbon-14 tests they underwent are not conclusive, they could be from the sixth century, perhaps even earlier, and could demonstrate the gradual evolution of carving skills to the level of the astonishing works of the seventh century.

While the male deities mentioned above illustrate forcibly the uniquely Khmer quality of representation, it is the female deities that perhaps most fully embody the essence of Cambodia's art. The memorable goddesses of the northern area will be discussed later in this chapter, but two examples will illustrate that the distinctive morphology was also present in the south. Images of Durga were widespread in early Cambodia, her fame as the slayer of the powerful buffalo demon, Mahishasura, giving her the name Durga Mahishasuramardini. As one of the shakti of Shiva, the female aspect of his destructive powers, she invokes the power of one part of the Brahmanic pantheon. As the sibling of Vishnu, attested by her tall mitre, she also draws on another source of power. It takes the combined energies to overcome the buffalo demon, which in some instances she is depicted in the act of striking, sword upraised [37]. Frequently in Khmer art, however, her role is indicated only by a summarily incised or moulded figure on the base [25] and by the sword in her hand, the broken-off hilt of which remains here, while her importance as an image of voluptuous femininity seems to lend her overtones of fertility cults. These figures, which are numerous, clearly conform to a Khmer ideal of youthful female beauty: full- and high-breasted, with slender short waist, generous hips and round cheeks. The impression is even stronger in a head and torso image of about the same date [26]. The headdress of twisted locks suggests that the goddess might be one of Shiva's spouses, perhaps Uma, but the lack of attributes makes identification speculative.

Even more than the male deities, these female images illustrate the marked difference, despite their many shared traits, between Indian sculpture and Khmer. While the full breasts and slender waists are common to both, the voluptuousness in Khmer figures,

unlike in Indian, does not translate into sensuality. This is partly because the less exaggerated hip-swayed posture of the Cambodian works is more hieratic, less suggestive.

The Brahmanic works of the region are predominantly Vaishnavite, but Harihara and some Shaivite gods are also found. The cult of Harihara was important in pre-Angkorian Cambodia, though for some reason it disappeared in Angkorian times. Perhaps, like Durga, the god who fused the powers of Vishnu and Shiva was perceived as more powerful, or perhaps adherence to him averted any offence to either of his formidable component deities. The sculpture that most clearly illustrates the duality of the god is the magnificent image from Ashram Maha Rosei, which stylistically conforms to the canon of Phnom Da [29]. Its proper right shows Shiva's (Hara's) elaborately braided and piled locks forming a jatamukuta with crescent moon attached, his trident, half his third eye and, visible on both front and back of the thigh, a tiger skin signifying Shiva's role as Lord of the Beasts. The coiffure has been shaped to conform with the profile of the mitre, or kirita, on the Vishnu (Hari) side, where the chakra, or disk, is the only remaining attribute.

Ganesha has always been one of the most popular gods in the Hindu pantheon, the patina on his ample stomach testifying to the countless touches of suppliants. As with figures that blend human

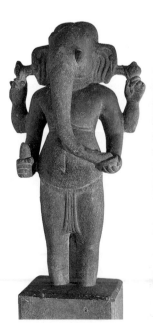

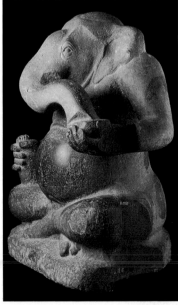

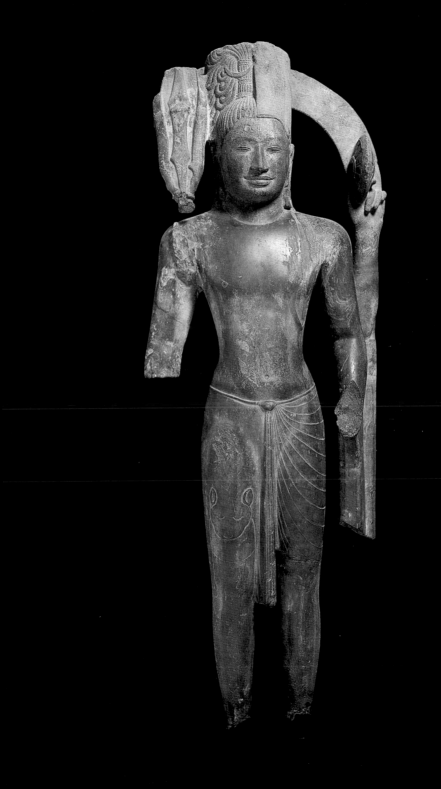

with horse or boar features, the merging of the elephant head with male body is a triumph of inventiveness that challenges logic. Both seated and standing versions [27, 28] embody power; both show, in the lower left hand, the bowl of sweets that the god enjoys, his trunk dipping into the treat, and his broken-off left tusk in his lower right hand. The stylization of the ears, particularly in the standing Ganesha, add an almost whimsical touch of fantasy. The apparent benign accessibility of the figure suggested by these attributes is underlaid with complex iconography. The vehicle of this enormous creature is the rat, implying the fusion of the great and the small, a duality of macro- and microcosm that is also inherent in the combination of the elephant's great strength with the intelligence of man. Ganesha, according to the legend, was the scribe of the *Mahabharata*, hence protector of letters and god of knowledge. He is also lord of categories, in which guise he is called Ganapati. His popularity is doubtless due to his role as the conqueror of obstacles, but his ability to create them is the obverse side of this talent, and the insightful depiction of the cunning eye in the seated figure hints at his paradoxical character.

Although the Hindu pantheon is enormous, not all its gods were depicted in Cambodian art, at least, not that have survived. Some, like Indra, are ubiquitous in relief sculpture, particularly on lintels, but not represented in the round. As king of the gods, Indra could be expected to symbolize great power, but in fact he plays a subsidiary role to the trimurti gods. His frequent depiction on lintels may have more to do with his role as guardian of the East, the direction most Khmer temples face, than as chief of the inhabitants of the Hindu heaven on Mount Meru. He is god of storms, like Zeus in Greek mythology, and holds a vajra, the symbol of thunder and lightning that is also important in Tantric Buddhism; the appearance of similar symbols in Brahmanism and Buddhism is not surprising given their mutual source in Hindu belief. We can only speculate about which gods were perceived as important by the Khmer. One who seems to have been depicted in pre-Angkorian days but not later is Skanda. Like most Brahmanic deities, he has multiple names and persona. He is the brother of Ganesha, hence a Shaivite god, and rides a peacock. As commander of the army of the gods he is a powerful entity despite his perpetually youthful appearance.

While the Vaishnavite pantheon dominated the sculpture of Phnom Da and other southern areas, Buddhist images were created at the same time in close geographical proximity. One of the most important sources is Vat Romlok, in Angkor Borei,

30 Skanda. Kdei Ang, Prey Veng, 7th century, or earlier. Sandstone, 1.03 m (40½ in; without tenon). Born of Shiva's semen falling on the earth in the Himalayas, Skanda was created to overcome the demon Taraka and became lord of the army of the gods. Legend states that his foster mothers were the Pleiades, or Krittika, so he is sometimes known as Kartikkeya. His three locks of hair (tricira) indicate his eternal youth, giving rise to another name for this god, Kumara, or youthful; the *Mahabharata* mentions thirty-one names for him. He is brother to Ganesha, and chaste, his bride being the army, and was considered by the Khmers to be the guardian of the south. His mount is the peacock, Paravani, killer of snakes.

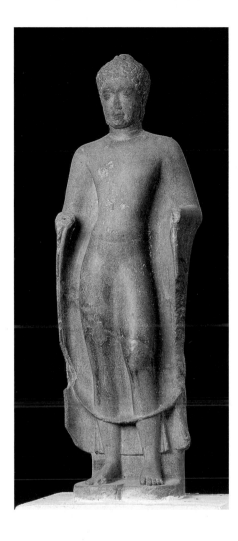

32 (below) Buddha. Vat Banon, Battambang, 7th–8th cent. Bronze, 0.275 m (10⅞ in). The Buddha's left hand holds his outer garment in a gesture characteristic of the 7th and 8th centuries. Bronze figures like this, being small and easily portable, offered an important medium for the transfer of iconography and style from Buddhist centres in India and Sri Lanka to Southeast Asia.

31 (above) Buddha. Vat Romlok, Angkor Borei, Ta Keo, 7th cent. Sandstone, 0.93 m (36⅝ in). The slender torso and slightly hip-swayed posture of this Buddha are typical of the style of Angkor Borei, one of the most important centres of Buddhism in Southeast Asia in the seventh century. The elongated ear lobes, spiral curls and cranial protuberance (ushnisha) are among the thirty-two distinguishing characteristics (lakshana) of the Buddha.

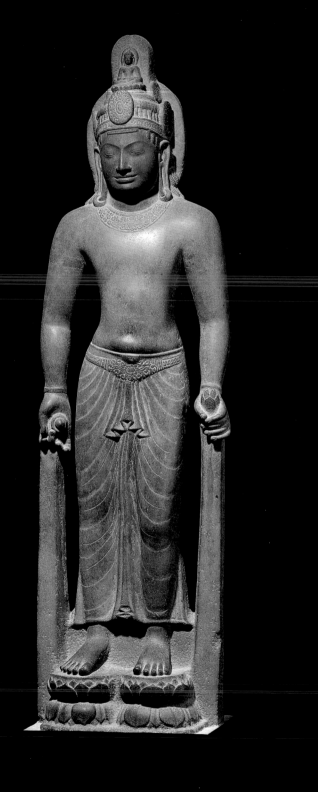

which is very close to Phnom Da in the supposed heartland of Funan. Several moving images of the Buddha were found there [11, 12, 31], all manifesting the features (lakshana) that define the depiction of the Buddha, the draping of the outer garment and the suggestion of typical mudra, or hand positions, despite the loss of the hands in most cases. The simplicity and spirituality of the faces, enhanced by the slight tribhanga of the pose, conform perfectly to the canon of the sage's demeanour, but morphologically they do not differ significantly from the contemporary Brahmanic works. The images could be either Theravada or Mahayana, there is no hint of distinction except in the case of the figure with the Pali script on his back [14]. Several images of Avalokiteshvara, in both stone and bronze, attest the presence of the Mahayana school. Again, it is striking how little stylistic difference can be discerned between a piece like the supremely spiritual image of the bodhisattva from Tan Long [33] and Phnom Da Vishnu figures.

The sculptural heritage of the southern civilization of Cambodia in the seventh century is rich. Its setting has virtually disappeared, with one important exception, the sanctuary of Ashram Maha Rosei [35]. Its survival is presumably attributable to its stone construction, unique in the region. It is not an area with readily available sandstone resources, and the blocks must have been brought over a considerable distance up the steep hill where the temple sits, an extraordinary feat. The temple comprises a double construction, where an interior cell with a steep corbelled vault is enclosed within another structure forming a narrow corridor on all four sides with windows opening to the exterior. The two spaces have a common heavy roof. The inner sanctuary once housed the important Harihara image referred to above [29]. It is possible that the isolated inner cell derived from the symbolism of the cave, considered a holy place in many cultures and long associated with meditation. There are similar structures in Sambor Prei Kuk, as will be seen in the following section.

There are many remains of small brick structures in the general area, but they are in a state of great ruin and there are no traces of monumental buildings that would accord with the idea of Funan as a powerful state. Extant temples date from a later period. It is not unreasonable to assume that many constructions might have been made of impermanent materials like wood, as palaces continued to be until Angkorian times and later, and which have remained important in Cambodian architecture. Current archaeological projects are revealing buried vestiges that may lead to a greater understanding of seventh-century architecture, but

33 (left) Avalokiteshvara. Tan Long, Rach Gia, Vietnam, mid-7th–8th cent. Sandstone, 1.88 m (74 in; with tenon). This remarkably well-preserved sculpture represents the bodhisattva of compassion, the Lord who looks down from above (sometimes called Lokeshvara). He is recognizable from the seated figure in his headdress of the meditating Amitabha Buddha, one of the supreme Dhyani Buddhas, the Buddha of the afterlife and of intellectual power and wisdom, whose representative he is.

34 (below) Avalokiteshvara. Prasat Ak Yum, Siem Reap, c. 7th cent. Bronze, 18 cm (7 in). The flask containing holy water and the lotus bud held by the smiling image are characteristic attributes for this bodhisattva. The figure is typical of the bronze votive images of the pre-Angkorian period.

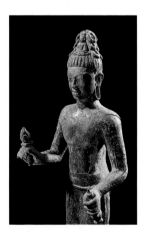

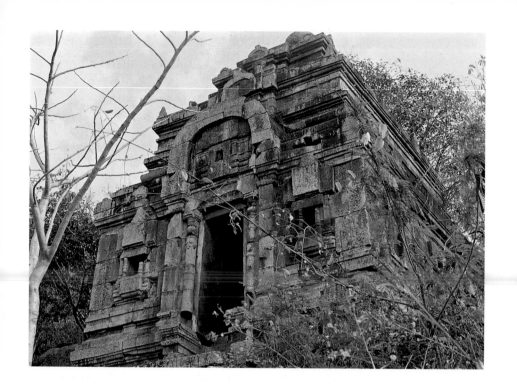

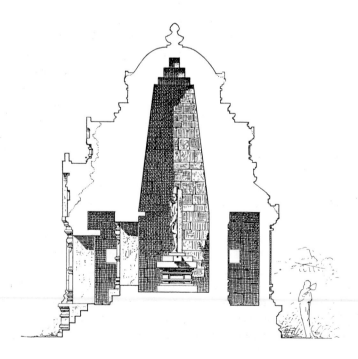

for any significant examples of early structures it is necessary to move north, to the region where power shifted after the decline of Funan and its maritime connections.

Despite the lack of architectural evidence of the power of the Funan polity in its supposed capital, Angkor Borei, support for its sophistication can be found in a study of its hydraulic engineering skills. Aerial surveys in the 1930s led to the discovery of a complex network of canals connecting Angkor Borei to its port at Rach Gia and to many other settlements. Whether these were used for transport, or for irrigation, or, as seems likely, both, has not been fully substantiated, but the scale of the enterprise is impressive. Similar skills laid the foundation for the prosperity of the later Angkorian state and offer practical fulfilment of the Khmer veneration for the naga, serpent ruler of the water.

Exciting recent satellite and radar imaging, as well as infrared analysis, promise greatly expanded understanding of early Khmer settlements.

Northern Centres

Assessment of Chinese records and a few Khmer inscriptions led modern historians to assert for almost a century that Funan came under the suzerainty of a later northern state the Chinese called Zhenla (formerly Chenla) through conquest. An elaborate set of suppositions was built on rather flimsy foundations, with confirming evidence often being drawn from much later inscriptions and occasionally faulty translations, as recent analyses by Vickery have convincingly shown. In fact the Chinese references are sparse. The nineteenth-century Chinese historian Ma Touan-Lin interpreted earlier sources as stating: 'His ancestors [he is referring to a northern ruler called Chitrasena] gradually got the power of the country'. The only Chinese indication of Zhenla's location was the statement that it was 'Southwest of Lin-i and Northeast of Funan'. The *History of the Sui* of the end of the sixth century or early seventh, alluding to Zhenla, states: 'Near the capital there is a mountain named Ling-kia-po-p'o, on the summit of which is a temple…dedicated to a spirit named P'o-to-li'. It was believed for a long time that this must refer to Mount Lingaparvata in present-day southern Laos, and that the capital of Zhenla was there.

Inscriptions written at the time Funan was declining were instigated by several generations of sixth-century rulers from the region near the Dangrek range (Viravarman, Bhavarman I, Mahendravarman/Chitrasena). When cross-referenced with

35 Ashram Maha Rosei, Angkor Borei, Ta Keo, 7th cent. Stone. The name of this temple means 'the sanctuary of the great ascetic'. In its inner chamber, which is surrounded by an ambulatory corridor, was found the remarkable sculpture of Harihara (ill. 29, p. 33). The temple is unusual in being made entirely of stone at a time when the usual material for sanctuaries was brick.

36 Section, Ashram Maha Rosei. The continuous single vault over corridor and inner chamber is notable. The remains of a sutasoma, a channel for draining lustration water, is visible on the west wall. The temple faces north instead of the usual east because of the exigencies of the mountain site.

inscriptions of their descendants and with genealogical lines recounted in inscriptions from the time of Indravarman I (ruled 877–89), they reveal a closely related group of families with connections in Funan as well as the north, probably near Sambor on the Mekong in Kratie province. While there is ample evidence of several polities – Bhavavarman I, for example, ruling in Bhavapura (Sambor) while his brother and successor, Mahendravarman/Chitrasena established a separate base in what was to be the capital of his son, Ishanavarman I, at Ishanapura (now Sambor Prei Kuk) – there is little evidence of a rupture with the south. The likelier explanation is that the inhabitants of Funan sought inland resources as their maritime prosperity waned, and since the rulers of the separate states mostly belonged to related families, the shift of power was gradual and not hostile. There is also no convincing basis for the claim by the Chinese that Zhenla was divided into two parts, Water Zhenla in the south and Land Zhenla in the north. It is believable, however, that as the northern regions became more important, the Chinese, while acknowledging a single sovereignty, might have defined two areas within the new state to distinguish between the old and new power.

The case for a gradual and peaceable absorption of one Khmer region by another helps to explain the mystery of how a state in decline could have produced the assured works of art that were so abundantly created in Angkor Borei and Phnom Da in the seventh century. Such an explanation is reinforced by the continuity of style and iconography embodied simultaneously in the art of the polities to the north and northeast of Funan. Epigraphic evidence establishes a succession of rulers in those regions that seems to have followed a peaceful pattern of inheritance.

As with the Funan region, no sculpture or architecture can be securely dated before the seventh century, but for the first time in Khmer history a body of art can be firmly associated with a specific period in an identifiable place. Ishanavarman I (ruled c. 616–35), the son of Mahendravarman/Chitrasena and the nephew of Bhavavarman I, reigned in the eponymous city of Ishanapura, at present-day Sambor Prei Kuk in Kompong Thom province. It is an extraordinary place, with more than one hundred temples in three main groups, designated South (S), Central (C) and North (N), with a few outlying subsidiary groups and isolated structures. The buildings are in varying states of ruin, but several dozen exist in a reasonably intact and clearly legible condition.

37 Durga Mahishasuramardini. Sambor Prei Kuk, sanctuary N 9, Kompong Thom, first half 7th cent. Sandstone, 1.65 m (65 in).
This is one of the most remarkable sculptures from the pre-Angkor period. The sensuous torso in triple-flexed posture expresses the grace and vigour of the goddess who embodies the powers of both Shiva and Vishnu and is alone capable of killing the evil buffalo demon, formerly represented under the goddess's feet. She was found in the northern group of the temple complex of Sambor Prei Kuk, the capital of Ishanavarman I.

Near two of the temples of the northern group (N9 and N1) were found, over a period of more than forty years, three components of a sculpture that is perhaps the most astonishing work of art created by the Khmers in more than a millennium of civilization. Though the head is missing, this image of Durga Mahishasurmardini [37] is the epitome of the Khmer ability simultaneously to invoke vigour and serenity, voluptuousness and spirituality. The graceful tribhanga posture with its slightly raised shoulder and braced knee, and the flare of the goddess's sarong, convey the motion at the completion of the blow slaying the buffalo demon. The slender short-waisted, high-breasted torso with generous hips defines the Khmer feminine ideal, while the naturalism of the flesh and the suggestion of the limbs beneath the garment are masterly. More than one observer has drawn a parallel between this dynamic and sensuous image and the ancient Greek statue known as the Winged Victory of Samothrace.

Found nearby (N10) was a Harihara figure of almost the same height [38]. It embodies many of the Gupta-style elements that characterize the works of Phnom Da, the oval face, slender hip-swayed body and slim limbs. The youthfulness of the calmly smiling face is reinforced by the tautness of the torso with its strong musculature and clearly defined ribs. The fingers and toes with clearly indicated nails are exceptionally delicate. As with the sculpture of Angkor Borei, the accomplished fusion of technical and expressive skills shown in this Harihara and Durga argues for a substantial foundation of preceding works that have not survived.

The temple groups were probably not in the capital city, which has not yet been identified but which was possibly situated to the west, where a double enclosure of more than 2 kilometres (1¼ miles) per side can be discerned. As was the case throughout Cambodian history, secular buildings here were constructed of perishable materials and no trace of them remains. Following the typical pattern of settlement near a river, the city might also have been built to the east, closer to the Stung Sen, which rises near the present Thai border and flows south into the Tonle Sap.

All three main groups of temples are surrounded by two sets of square enclosure walls. The inner wall of the South group is substantial, though ruined in many places. Made of brick filled with earth, it stood more than 3 metres (10 feet) high and was more than 1 metre (3 feet) thick. On both inner and outer faces it is decorated on the interpilaster walls with medallions carved into the brick surface. The remaining legible scenes within the circular rims depict lively scenes with people and animals, the most striking

of which shows a man brandishing two swords in combat with a bounding lion. The laterite outer wall of the South group has yielded two very important inscriptions (K440 and K442) that establish the date of the complex. King Ishanavarman is mentioned by name in effulgent Sanskrit verse that extols Shiva and describes the king in terms where word-play implies a blurring of the distinction between god and king. We learn that he installed many images: a gold smiling Shiva (probably in mukhalinga form) called Prahasiteshvara in the central sanctuary, and a silver Nandin, Shiva's mount, in another (S2). In addition are listed Brahma, Harihara, Sarasvati (goddess of knowledge and one of Brahma's shakti), and other manifestations of Shiva. A small temple between outer and inner walls has an inscription (K604) erected by a Brahman in the king's service (his son-in-law Durgasvamin) and dated 627.

The chief sanctuary (S1) and S9 were possibly built slightly later than others in the group, but all three groups have a remarkable stylistic homogeneity. With C1, S1 [40] is one of the largest temples at Sambor Prei Kuk and measures almost 32 by 13 metres (105 by 42 feet) on the exterior, its 2.5-metre (8 foot) thick walls enclosing an inner space of 9.13 by 5.16 metres (30 by 17 feet). The interior walls are decorated by pilasters; these are found in only the larger temples. S1 opens to the east and redented projections frame both the entrance doorway and the false doors on the other facades. The tower, a form deriving from the Indian shikhara, comprises five corbelled storeys in gradual diminution [39]. A slight recession at cornice height and some projecting pegs of wood embedded in the walls (in other temples these are sometimes of stone) indicate the support structure for the former wood ceiling ubiquitous in Khmer temples. Much of the highly refined carving of lintels and typically round colonettes is damaged, as are many of the so-called flying palaces, representations in reliefs of reductions of edifice that decorate the interpilaster spaces [41]. The construction, with profiled sub-basement and basement, projecting cornice, and wall sections sub-divided externally by pilasters, is typical of the sanctuaries in all three groups. It is, indeed, a pervasive model for single-tower sanctuaries that persisted till Angkorian times. The material for almost all the temples is brick with sandstone lintels and door frames, and there are remains of thick stucco that in all likelihood once covered all the brickwork.

Among the most interesting structures in the S group are five small temples in octagonal form. Four, opening to the east, form a

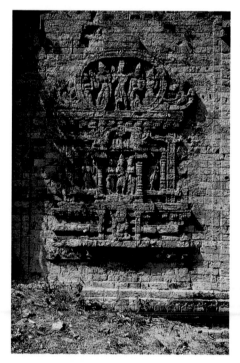

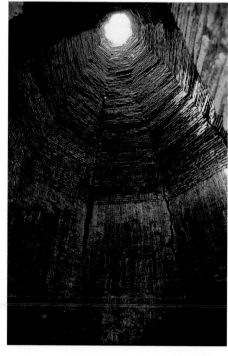

39 (opposite, top left) Sambor Prei Kuk, sanctuary S1, section. S1, the largest of the group, was perhaps Ishanavarman's state temple. An inscription states that its chief idol was a gold linga (now missing).

40 (opposite, top right) Sambor Prei Kuk, sanctuary S1, Kompong Thom, first half 7th cent. Built of brick with sandstone portals and false doors, the temples of Sambor Prei Kuk, constructed by Ishanavarman I (c. 616–635 CE), offer the oldest evidence of Khmer sacred edifices and are notable for their relief carvings depicting miniature monuments, or flying palaces, in the inter-pilaster spaces.

41 (opposite, bottom left) Sambor Prei Kuk, relief, temple XXXIX. The refined depictions of flying palaces and their inhabitants on the external walls of many of the Sambor Prei Kuk temples form the basis for understanding how the temples looked originally.

42 (opposite, bottom right) Sambor Prei Kuk, octagonal prasat, corbelled vault. The vaults of Cambodian temples were constructed by corbelling, where projecting stones are stacked in an overlapping technique to span spaces. These could be up to 3.5 m (11½ ft) across, as in the widest known example, the Hall of the Dancers at Preah Khan (1191), which later collapsed. Lateral movement severely threatens the stability of a corbelled structure; the Khmers did not employ the true keystone arch.

43 (right) Sambor Prei Kuk, octagonal prasat, S group. Rare elsewhere in Cambodia, octagonal temples are numerous at this site. This is one of four, facing east, arranged around S1 temple in quincunx form (a central temple surrounded by subsidiary temples at the four sub-cardinal corners). A fifth octagonal structure in this group, further away, faces west.

quincunx around S1; the fifth, S9, opening to the west and lying slightly to the north, seems to have no symmetrically placed counterpart. Its western orientation can be seen in Angkorian period 'libraries', subsidiary structures whose openings face the front facade of the main temple, but there is no evidence to construe the Ishanapura example as a prototype. The walls with entrance portals are slightly wider that the others. The corbelling in the remaining roof structures shows a steep rise with almost continuous tapering [42]. Apart from their rare octagonal form (one example also exists in the North group and in an isolated temple, XXXIX [41]) they are distinctive for the quality of the elaborate flying palaces reliefs that decorate seven of their eight walls; thirty-five remain, in varying states of preservation. They are intricately carved into the brick surface and depict several types of multi-storeyed construction with fore-porches, colonettes and elaborate frontons, a fascinating catalogue of ideal building types illustrating many of the forms that are exploited in full-scale structures. Inside the palaces groups of personages, seemingly of noble condition, are depicted, and the architectural detailing offers a microcosm of the interwoven images of the makara heads, with riders, spitting lions or garlands, and the loops

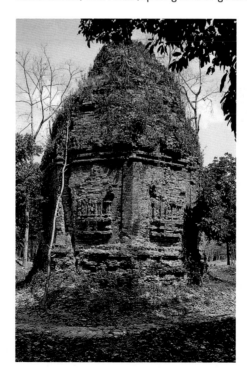

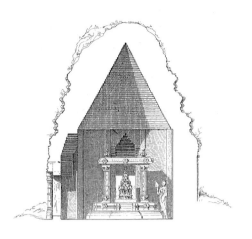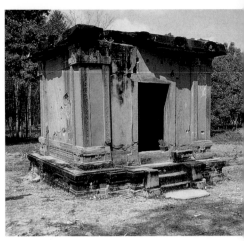

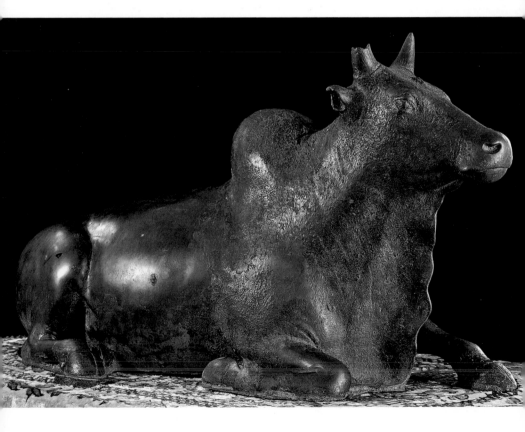

of garlands with pendants characteristic of lintels of this era [7].

A building of major importance in the South group is the sanctuary S2 [44] which encloses a free-standing cell or mandapa within its walls. The cell is roofed by a huge stone monolith supported on square columns at the corners and there is enough space around it to permit ritual circumambulation. An inscription on the slab repeats some of the information inscribed on the piers of the outer enclosure gates (K440 and 442) which tell us that a silver Nandin was installed in the cell. This deity, the mount of Shiva, is not only found as guardian of temples throughout Cambodian history but is a cult figure in his own right, not just as a Brahmanic god but also as a central entity in a Khmer legend. The legend of Preah Ko and Preah Keo, the magical bull and his human twin brother, has become associated with the identity of the Khmer people. The divine bull, with the syncretic dualism of Hindu Nandin and indigenous Preah Ko, has become a palladium of the country in the case of a remarkable seventh-century sculpture of Nandin found in 1983 near the Vietnamese border at Tuol Kuhea [46]. It may resemble the image mentioned in the inscription. Installed in a pagoda in the compound of the Royal Palace in Phnom Penh, he is seen today, in defiance of the seeming paradox, as the guardian of the sacred Buddhist palm-leaf text of the Tripitaka, which is housed in the same pagoda.

A similar cell can be seen in the North group (N17) [45]. Its enclosing temple has disappeared, but its foundations can be discerned surrounding the mandapa. Like S2, it offered space around the cell for circumambulation. Another seventh-century example is to be found at Han Cei, south and east on the Mekong. These structures share with the inner sanctuary at Ashram Maha Rosei the concept of the closed isolated cella (an inner chamber housing a cult figure) where worship of a sacred image possibly derives from the meditation practised by ascetics in caves. Indeed, the N17 mandapa is locally called Ashram Maha Rosei (Sanctuary of the Great Ascetic).

The biggest temple of the Central group (C1) has an exceptionally steeply corbelled roof and is distinguished by the presence on the casings of its steps of highly fantasized lions with luxuriant manes [47]. Its interior walls are decorated with pilasters as in S1. Its rare octagonal colonettes are unusually intricate and its lintels typical of the pre-Angkorian form with broad horizontal band and pendants.

Almost all the temples are partially hidden by mounds of earth around their bases, so it is hard to gauge their true proportions.

44 Sambor Prei Kuk, central mandapa, S2, section.
This temple features a free-standing interior mandapa, or pavilion, with a ceiling formed by a monolithic slab of stone.

45 Sambor Prei Kuk, interior mandapa, N17.
The base of this mandapa, comparable to the interior structure of S2 [44], is a solid slab of sandstone. There are traces of the foundations of an enclosing structure of light materials beyond the base of the mandapa.

46 Nandin. Tuol Kuhea, Koh Kong, 7th cent. Bronze with high silver content, 0.8 x 1.3 m (31½ x 51 in). Ho Preah Tri pagoda, Royal Palace. This magnificent image of Nandin, the mount of Shiva, was found in 1983 not far from the Vietnamese border at Tuol Kuhea. Now kept in a dedicated pagoda in the Royal Palace compound, he is also associated with the Khmer legend of Preah Ko, a mythological bull seen as the protector of the land. The image has come to be viewed as the palladium of the kingdom in a syncretic absorption of a Brahmanistic deity into the Buddhistic matrix of contemporary Cambodia.

47 Sambor Prei Kuk, lintel and guardian lion, temple C1.
The lintel has a typical early form, with a simple thick arch from which hang pendentives of garlands. The guardian lions are noted for their unusually luxuriant manes.

Their slender towers, intricate doors, false doors, colonettes and lintels are of exceptional grace and their rich diversity of edifice reductions attests to the remarkable skills of seventh-century Khmer artists.

The domain of Ishanavarman I seems to have been extensive. There are references acknowledging him, though not in terms implying sovereignty, in inscriptions in Ta Keo, Prey Veng, Kompong Cham and Kandal. The reign dates of the seventh century are uncertain, the last date for Ishanavarman I being establish by a Chinese reference in 635. His son and successor, Bhavavarman II, was mentioned around 635 and seems to have been ruling still until the 650s. Khmer inscriptions reveal that while the Khmer title of 'pon' continued to be used in the former Funan areas in the south throughout the seventh century, in the region near Isanapura it was superseded by 'mratan' by the middle of the century. Unlike pon-ship, which was a position of moral

authority inherited matrilineally and did not provide for inheritance of power or possessions by the incumbent's direct descendants, 'mratan' was a title that could be conferred and that implied patrilineal descent.

Bhavavarman's successor's dates are based on skimpy evidence, but Jayavarman I probably ruled from about 655/657 until 680 or 681, from a capital whose identity is unknown, though it was not Ishanapura. He appears to have become heir to the throne on the basis of his mother's family, his father being a chieftain from the north called Chandravarman. During his reign there is evidence for the growing centralisation of the state, with royal edicts affecting regional chiefs, and imprecations inserted into inscriptions that threaten punishment for non-compliance with royal injunctions.

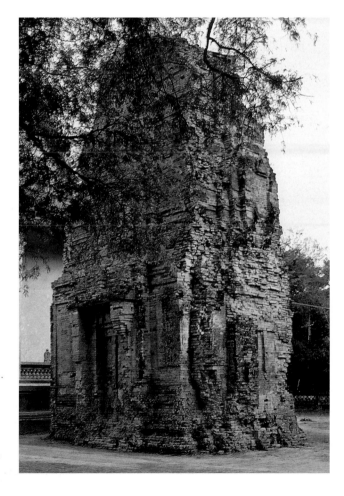

48 Prasat Phoum Prasat, late 7th–early 8th cent. Brick with sandstone.
One of a group of temples in the style of Prasat Andet, the nearby temple where the Harihara in ill. 49 (p. 51) was found.

There is no irrefutable evidence of the date of the small temple of Prasat Andet at Kompong Thom [48] or the remarkable Harihara image found in its inner sanctuary [49], but they probably date from the last quarter of the seventh century, thus in the reign of Jayavarman I or his daughter Jayadevi. It is built on a slight hillock, perhaps composed of the earth from the ponds that surrounded the temple to the south, west and north, and is oriented slightly north of due east. Henri Parmentier, architect and honorary head of the archaeological service of the Ecole française d'Extrême-Orient (EFEO), noted that the most pre-Angkor temples were so aligned, which leads to the speculation that this practice may imply a veneration of the northeast as the most sacred of cardinal or sub-cardinal points, an estimation that prevails in Indonesia, particularly in Bali. In structure Prasat Andet conforms to the type prevalent at Sambor Prei Kuk, with a single chamber preceded by a shallow porch, with false doors on south, west and north sides and a tower in corbelled sections with shallow drums between. Unfortunately very little remains of the sandstone door, lintel and colonette elements, and the monument is awkwardly abutted by the vihara of a modern monastery at its east end, a conjunction of new Buddhist and ancient Hindu that is frequently seen in Cambodia.

The Harihara image found there, almost 2 metres (more than 6 feet) tall, is perhaps the most spiritual and certainly the most elegant of all Khmer deities. The Shiva half of the statue is distinguished from the Vishnu side only by the treatment of the coiffure and headdress, comprising the twisted and looped locks characteristic of the Shaivite jatamukuta, here subsumed in profile to the form of Vishnu's mitre. A band of incised overlapping foliate forms at the base of the mitre may presage the diadems that characterized later Vishnu images, while the looped end of the cloth that forms the sampot, here in faint relief, is loosely draped to form a pocket-like flap that was to become increasingly stylized in later sculpture. Despite the slenderness of the torso, musculature is evident in the shoulders and thorax, and the upper abdomen is slightly inflated in the manner indicating prana, or inner breath, a condition of superior moral strength. Such modelling was to be accentuated in the Angkor period, with its emphasis on hieratical images that embodied ashana, the invulnerability to material and worldly challenges. The frontal stance of the Prasat Andet Harihara, with only a hint of flexion in the right hip and left knee, is predictive of such detachment, but the benign composure of the face with its calm gaze combines

49 Harihara. Praset Andet, Kompong Thom, last quarter 7th cent. Sandstone, 1.97 m (77½ in; without tenon). This slender image determines the canon of the style of Prasat Andet. The distinction is minimal between the Hara, or Shiva half on the proper right, and the Hari, or Vishnu half on the left (compared with the many points of difference in the Harihara shown in ill. 29, p. 32). The division is manifested only in the head, where Shiva's headdress of twisted locks, or jatamukuta, and half his third eye contrast with the smooth mitre characteristic of pre-Angkorian Vishnu figures.

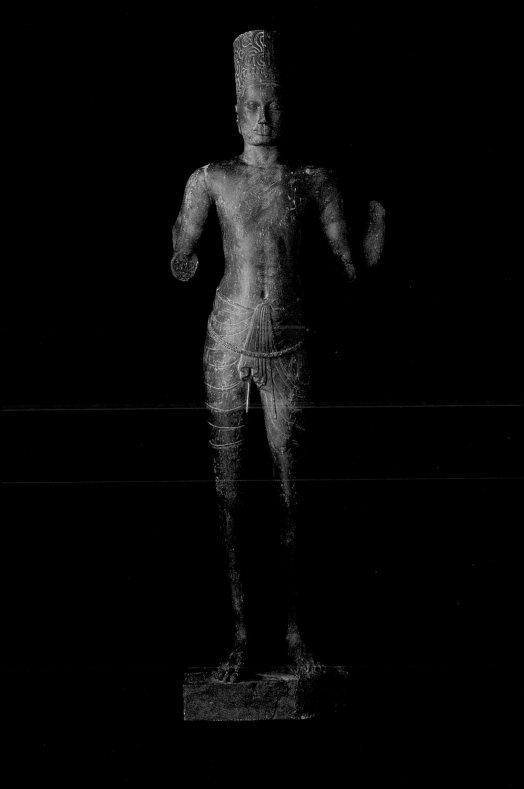

with the grace of the form to link the figure stylistically with earlier pre-Angkorian examples.

Jayadevi succeeded her father in 680 or 681, and possibly ruled from a city in the region of the future Angkor. She adopted the title 'vrah kamratan añ', up till then only applied to male rulers or gods, which perhaps signifies the transcendence of bloodlines over male entailment. Inscriptions reveal complex social hierarchies and thriving commerce and agriculture, with mention of wet rice cultivation, weaving, jewelry crafting and the exchange of goods that suggests prosperity. During her reign there was only one recorded date: the equivalent of 713 CE. After that, the comparatively rich resource of inscriptions dries up, and there are no more dated references to rulers until the name of Jayavarman II is mentioned in 770 (and that is extrapolated from later references).

During the second half of the seventh century a centre of culture and authority emerged further east, on the Mekong, with its centre at present-day Sambor, then called Sambhupura. An inscription dated 803 mentions four generations of rulers who, in the absence of references to allegiances elsewhere, seem to have been independent of other polities. Three of them were queens. We can infer a flourishing state going back in the eighth century at least to the time of Jayadevi. Its origins presumably lay in the importance of the Mekong as a major artery, the last impediment to navigation occurring at the falls of Khong. There was therefore unimpeded river access from Stung Treng in the north through Koh Krieng, Sambor itself to Kratie, and then all the way to the Mekong delta. The importance of the mighty river is attested by a sixth-century inscription of Bhavavarman I, who was possibly trying to consolidate his control beyond the area near the Dangrek range, found on the opposite side of the river from Stung Treng . A deity designated as 'lord of mangoes' is mentioned in inscriptions dating from 629 to 803 found from Kratie all the way to the delta.

The possibility of a polity with hegemony extending as far north as Stung Treng is supported by the sculpture found in that area and also at Kratie. The importance of Shiva is indicated by one of the rare pre-Angkorian anthropomorphic images of the deity as well as a Shivapada slab that represents him in one of his non-material forms [50, 51]. The tall and slender figure with its abstractly modelled limbs represents Shiva as the great ascetic, recognizable from the flask of holy water he holds in his left hand and the simplicity of his brief garment. His jatamukuta in extreme stylization can be compared with the headdress on the meditating

50 Shiva. Kompong Cham Kau, Stung Treng, 7th cent. Sandstone, 1.65 m (65 in).
This sculpture probably represents Shiva as ascetic, holding a flask or gourd. The schematic, almost reductive treatment of torso and limbs and the flaring headdress are unusual for the period.

51 Shivapada. Theat Ba Chung, Stung Treng, ?7th cent. Sandstone, 0.32 m (12⅝ in).
The footprints of Shiva are among the non-manifest images of the deity, which also include the linga. Such abstracted symbols usually predate the anthropomorphic versions of the god.

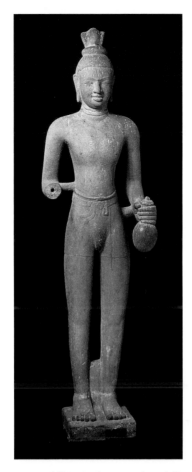

image of Shiva in the central medallion on the lintel of Vat Eng Khna [7] and the head of Shiva on the mukhalinga from Vat Po Metrey [5]. Two prongs of the stone block have been retained to connect the arms to the torso, and there is an undefined mass behind the feet, making it unclear whether the sculpture is unfinished. The lack of sophistication in representing musculature suggests that it might be an early essay in free-standing carving. The Shivapada, with its rather charming naiveté, is fairly rare; the giant steps of Vishnu claiming the universe from underworld to middle world to heaven (Trivikrama) are far more frequently represented in Khmer art. The massive Vishnu [56] found in the same village as the Shiva mentioned above has something of the same denuded representation and simplified anatomy, but its solidity and reliance on the retained matrix technique suggest that it may date from an earlier period.

52 Devi. Koh Krieng, Sambor on
the Mekong, Kratie, ?early 8th cent.
Sandstone, 1.35 m (53 in).
The headdress of twisted locks
(jatamukuta) of this goddess
suggests a Shaivite identity,
although the headdress has been
subsumed into the overall form
of the mitre, a Vishnu sign.
In the absence of attributes it is
impossible to identify her precisely.
Her dress details, incised rather
than carved in three dimensions,
and the somewhat voluptuous
body are typical of pre-Angkorian
female images.

53 Devi. Koh Krieng, Sambor
on the Mekong, Kratie, first half
7th cent.
The distinct features of this
goddess from the Kratie area near
the Mekong have been interpreted
as portraiture, perhaps of a 7th-
century queen, as there were
several female rulers in that region
at the time. The maturity of the
figure, with its maternal breasts
and full chin, is rare, and reinforces
the impression of a specific identity.

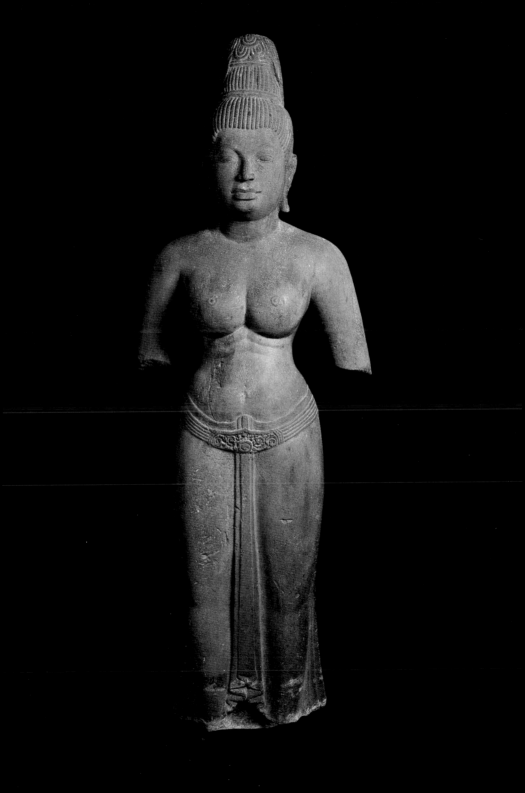

There is no doubt that the glory of the art of the Mekong polity or polities lies in its female images, appropriate for a region where queens were preponderant. The earliest example is one of the two devi figures from Koh Krieng [53]. It is unique in many respects. Though the anatomy still represents a voluptuous body in the Khmer canon, it is clearly that of a more mature woman. The slight plumpness of the abdomen, hips and thighs, the impression that the breasts could have suckled a child, the less than sharp profile of the chin, all suggest an older woman of experience and authority. The particularity of the face leads to the supposition that this is a portrait, perhaps of one of Sambhupura's queens in a form that associates her with a goddess. In the absence of attributes it cannot be determined which goddess is invoked, but the style of her headdress, with its braided locks piled high, suggests the jatamukuta of a Shaivite shakti such as Uma.

Several other images of female deities from this region have been found. The eighth-century devi from Koh Krieng [52] represents a younger female. Her headdress embodies the same twisted and piled coiffure as the earlier deity's, but it is shaped into the mitre form associated with Vishnu. Such a coiffure is often found on Durga images, but in the absence of attributes, as well as any gestural representation of a buffalo at the feet that is often found in Khmer art, it is impossible to make that identification. Certainly her bold gaze and somewhat pouting expression suggest the self-confidence characteristic of the buffalo-slayer. The summary treatment of the folds of the garment may suggest a decline in craftsmanship, but the management of the volumes of the body and the flare of the sarong still exhibit sculptural mastery. The image of a goddess of unknown provenance [54] shares enough traits with the previous sculpture to suggest a similar origin. In this case the mitre is unequivocally Vaishnavite, and she holds what could be the base of a sword in her left hand, so there is a stronger basis for identifying her as Durga. The beauty lines below the breasts are unusually prominent.

It is frequently argued that the eighth century in Cambodia was a period of transition and turmoil that was only resolved during the reign of Jayavarman II and the establishment of the early Angkor. It is true that there is a hiatus in inscriptions, so that we cannot follow the fortunes of the descendants of Jayadevi after 703. It is also true that the supreme accomplishment of the sculptors of Phnom Da, Angkor Borei and Sambor Prei Kuk have scarcely been equalled in Khmer history. But the evidence of sculpture from Kratie and the growing mastery of architecture

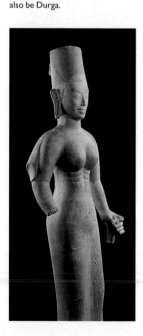

54 Devi. Unknown provenance, c. 7th–8th cent. Sandstone, 1.40 m (55 in).
The naturalistic treatment of the body of this goddess, with its slight hip flexion, is typical of the 7th and early 8th centuries. The incised lines below the breasts are a sign of beauty. Her mitred headdress may indicate the identity of Lakshmi, shakti of Vishnu, who in pre-Angkorian sculpture typically wears a mitred headdress, but she could also be Durga.

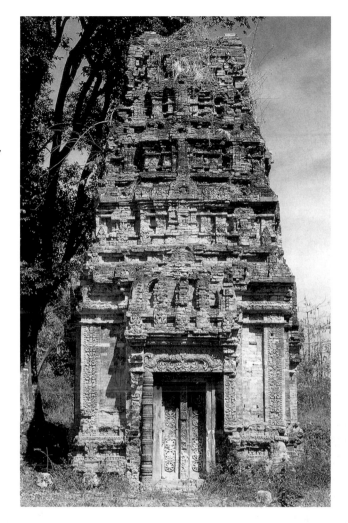

55 Prasat Vat Kompong Preah, Kompong Speu, 8th cent. Brick with sandstone. This 8th-century brick temple with four false storeys has a total height of about 8 metres (26 feet) and a redented plan. Miniature monuments in diminishing proportions decorate its successive facades. The treatment of pilasters, colonettes, and lintels is typical of the growing complexity of decoration in Khmer temples.

evinced in eighth-century temples like Prasat Vat Kompong Preah [55] make it clear that the cultural process was continuous. While historians have tended to concentrate on the development of Angkor evidence from regions in the north reinforces the validity of the multiple origins of Khmer civilization. Following the growing fortunes of the leaders of the polities near the Dangrek ranges who gave rise to the dynasty of Bhavavarman and his descendants, there seems to have been a push to the north of Khmer influence over the escarpment into what is now northeast Thailand.

Strongly Khmer in character and spirituality, yet also partaking of the purity of the Buddhist ethos, are the supremely sculpted bronzes whose type is named for Prakhon Chai, the site where

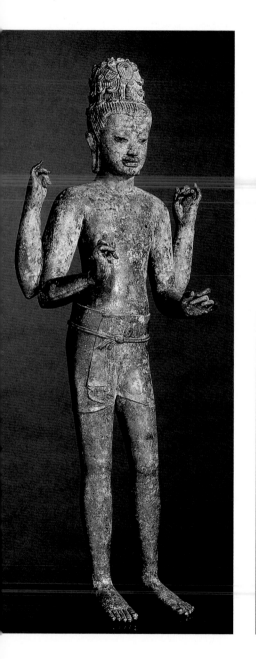
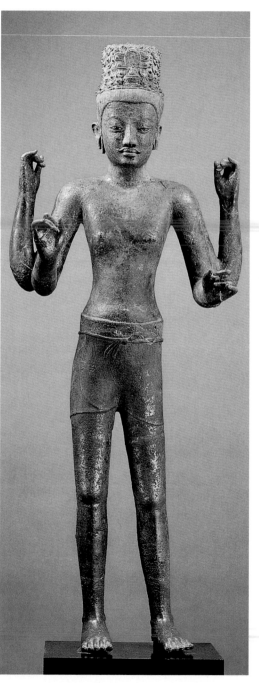

they were found in 1964 in the ruins of a Khmer temple in Buriram province in present-day Thailand. While the presence of a Maitreya [57] would be consistent with a Theravadin identity for the hoard, that of Avalokiteshvara [56] confirms that the collection is Mahayana. These are among the largest Khmer bronzes known and fulfil the highest standards of bronze casting. The naturalism of the limbs and torsos and the delicacy of the fingers and toes is extraordinarily represented, as is the expressiveness of the faces. The high status of these images is reinforced by the use of semi-precious stones for the eyes.

Not only did the eighth century see the emergence of sophisticated stone and bronze sculpture and architectural structure and decoration, it also spawned the emergence of what was to become the high point of Khmer architecture, the temple mountain, which will be described in the next chapter. It should therefore not be sweepingly categorized, as has for so long been customary, as a period of decline.

56 (far left) Maitreya. Prakhon Chai, Buriram, Thailand, 8th cent. Bronze with silver and black stone inlays, 0.96 m (37¾ in).
One of the finest bronzes in Khmer art, this Maitreya, Buddha of the Future, was one of a hoard found in 1964 in a ruined temple of the Khmer type in the village of Prakhon Chai in Buriram Province of present-day Thailand. Maitreya, who is both bodhisattva and the Buddha of the Future, is identified by the stupa in his headdress. He is one of the few beings apart from the Buddha to be recognized in both Theravada and Mahayana pantheons.

57 (left) Avalokiteshvara. Prakhon Chai, Buriram, Thailand, 8th cent. Bronze with silver and glass inlays, 1.422 m (56 in).
The bodhisattva is one of the largest of the bronze images found in the Prakhon Chai hoard. Like the Maitreya's [57], its slender refinement and naturalism and its strong spirituality are characteristic of the group.

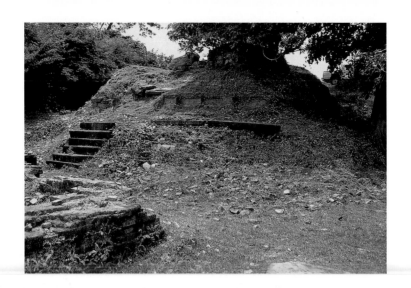

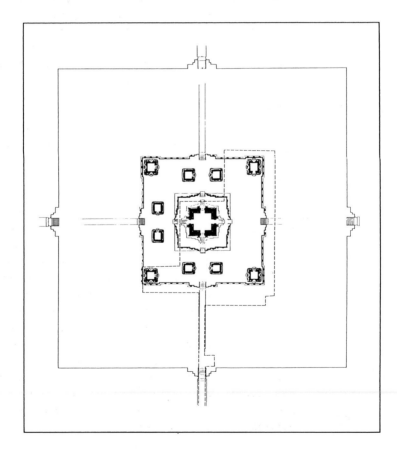

Chapter 3

The Growth of Royal Power: the ninth century and the beginnings of Angkor

58 Prasat Ak Yum, Siem Reap, 8th cent. Brick with sandstone. The 8th-century temple, now back-filled with earth after a 1935 excavation, is the oldest known example of the temple mountain, albeit on a small scale. The lowest of its three levels occupied 100 square metres. Inscriptions on doorway jambs dated 704 and 717 are probably contemporary with its construction.

59 Prasat Ak Yum, plan. The upper platform was 17 square metres, paved in brick and surmounted by a tower. The overall height of the temple above ground level was probably equal to the 12.25 metre shaft below the central point of the sanctuary, probably a reference to the symbol of the axis mundi penetrating earth and sky that is found in other Khmer temples. Below the shaft is a 2.3 cubic metre underground chamber of unknown purpose that is unique in Khmer architecture.

Doubt is an unpopular commodity. Defining eras and styles comforts the researcher trying to manage the inchoate mass of events and records and the concurrent black holes of missing facts that constitute the raw material of history. In reality change is usually a gradual and ragged process, and there are simultaneous developments occurring in many areas that may not reveal their connections. These difficulties help to explain why a reasonable explanation for a sequence of events, coaxed from the evidence by a diligent historian, is hard to give up. The age of Angkor has always been seen as the embodiment of Khmer civilization, and its beginning, pegged at 802 with the consecration of Jayavarman II as chakravartin, or universal monarch, as the end of a century of turbulence when the cultural achievements of the Funan and Zhenla era declined.

Certainly the flow of inscriptions, strong in the seventh and early eighth centuries, slowed in the mid-eighth century, with very few references to kings. But recent research and reassessment of inscriptions in the light of new transcripts makes it more likely that the perceived decline was instead a period of consolidation of authority, particularly under Jayavarman I, the first king who seems to have exerted power beyond a family horizon. Chiefdoms with inherited control over smaller areas continued in several places. The construction of a temple like Prasat Vat Kompong Preah [55] exemplifies an increasing sophistication and scale that belie social unrest. The emergence of Jayavarman II as a paramount ruler was prefaced by decades of gradual accumulation of territory further north than the southern origins posited for that king. He is mentioned in inscriptions as early as 770 but no certain date has been established for the beginning of his reign. Later dynastic

claims mention three lines of ancestry: from the polities of Vyadhapura, Sambhupura and Aninditapura. While Sambhupura is known to have been on the Mekong (see Chapter 2), the precise location of the other two is uncertain. What seems clear is that the ruler claimed relationship to several centres of authority or chiefdoms as a basis for his legitimacy and consolidation of control.

Reinterpretation of epigraphy and increased attention to the Khmer portions of inscriptions also throws doubt on another claim about the eighth century. On the evidence of an inscription of 1052 on a stele found in Sdok Kak Thom it has been claimed that Jayavarman II was consecrated as chakravartin in 802 after his return from 'Java' and his attempt to free Cambodia from its suzerainty. An entire theory about his exile in Java, a state that was said to have conquered Cambodia, was constructed on the basis of this reference. While there were coastal raids on mainland Southeast Asia from Indonesia, they came from Srivijaya (in Sumatra, not Java) and there is no evidence that anything like permanent invasion took place. Vickery makes the convincing case that 'Java' should be interpreted in the context of the Khmer word for Champa, 'chvea'. Champa was already competing with the Khmer regions early in the ninth century, and continued to do so until the twelfth, and is a far more credible interpretation of Cambodia's vulnerability and Jayavarman II's whereabouts than the unsubstantiated suggestion of Indonesia.

Another portion of the Sdok Kak Thom text has led to one of the most disputed elements in Khmer royal history. The stele was installed in a temple (now just across the Thai border in Prachinburi province) by the sacerdotal family of Shivakaivalya, the Brahman who first held the office of keeper of the devaraja cult at the time of Jayavarman II's accession. The family had exclusive guardianship of the devaraja for the subsequent two hundred and fifty years, perhaps longer, but at least until the date of the Sdok Kak Thom inscription of 1052. The stele has texts on all four faces, in both Sanskrit and Khmer, and relates the history of the continuous association of the Shivakaivalya family with the Khmer court, providing many details of ritual and royal genealogy. Jayavarman's consecration as chakravartin and the installation of the devaraja was carried out by a Brahman called Hiranyadama, who recited the holy text *Vinashika* and taught the rites to Shivakaivalya.

What was the devaraja? Although the Sdok Kak Thom inscription makes clear its association with divine sanction for the

legitimacy and authority of the sovereign, it does not specify what it was. For some scholars it is a linga identified with the king's reign, a symbol that had to be recreated for each monarch and could be moved from place to place. For others it is a ceremony associating the monarch with the power of the linga, itself the symbol of Shiva. For one historian the ceremony deified the ruler by making him a portion of Shiva and forging a threefold relationship among officiating Brahman, ruler and linga. Amplifying the links with Shiva led to the assumption by many researchers that the king himself was the devaraja, which translates as god king, and that therefore Khmer kings were perceived as living gods. In fact there is no inscription supporting this inference, and recent convincing explanations suggest that devaraja is a Sanskrit translation of a Khmer phrase that referred to a local deity, an older and indigenous symbol of power.

The Sdok Kak Thom text relates that Jayavarman was proclaimed chakravartin on Mount Mahendraparvata, an appellation from Hindu mythology to designate the home of Indra, king of the gods, which is equated in Cambodian geography with Mount Kulen, a plateau about forty kilometres (25 miles) northeast of Siem Reap to which Jayavarman moved his capital in the early ninth century. Scholars have concluded that the ceremony probably took place in an early ninth-century temple called Krus Preah Aram Rong Chen. Though little remains of it today beyond the vestiges of an enclosure wall and signs of its footings and central foundation shaft, the temple was once constructed in a pyramidal three-tiered form that was an early version of the temple mountain. The evolution of this architectural type, later to be so dramatically a symbol of Khmer civilization, is often cited as evidence for the restitution of prosperity brought about by Jayavarman and other Angkorian period monarchs with divine sanction.

The distinction of being the first temple mountain belongs in fact to another temple, Prasat Ak Yum [58], which dates from the eighth century and offers further evidence of the artificiality of the caesura between the seventh and ninth centuries. The time of its construction is established by inscriptions dated 704 and 717 found on door jambs in characters that are palaeographically consistent with those dates. The area of the lowest of its three stepped levels is 100 square metres (38 square miles), its height 2.6 metres (8½ feet). The second level has four towers at the corners, as well as four small towers flanking the north–south axis and two on the west side of the east–west axis. The structure

climbs in pyramidal form to an upper platform 17 metres (55 feet) square, on which stood a central sanctuary tower, now missing. The relationship of the central tower to the towers at the sub-cardinal points of the second level presages the five-tower quincunx form, with towers at the corners enclosing a central tower, that was to be developed more dramatically during the next four centuries in Bakheng, Pre Rup, Ta Keo and Angkor Wat.

Ak Yum is a far more ambitious construction than the single-tower sanctuaries of the seventh century, though its present appearance does not reveal this. Its architectural details were observed when the temple was uncovered by French archaeologists in 1933. Subsequent back-filling has covered all but the general profile and a few details of steps and walls. It was once part of an extensive settlement called Banteay Choeu that was inundated when the western baray (reservoir) was constructed in the eleventh century. The temple, now on the southern edge of the baray, was buried by the earth rampart supporting its dike, though a laterite construction between the baray and the temple, revealed during the dig, suggests that the builders of the baray tried to protect the temple from the engulfing earth. Scholars have speculated about the nature of the settlement that Ak Yum was connected with and suggested that either Jayavarman I or Jayavarman II might have instigated it. The temple's inscription dates coincide with the reign of Jayadevi, who is known to have made her capital somewhere in this region, but there is no evidence to link it with her. Later modifications are apparent in the construction of the second and upper levels, making interpretation even more difficult.

The symbolism of the temple mountain derives from the mythology of Mount Meru, in Indic belief the home of the Brahmanic deities. If the temple was a microcosm of the realm of the gods, the Khmer ruler, like monarchs in India and Indonesia, could imply a parallel between their kingdom and his. It has been assumed that the appearance of the temple mountain in Khmer architecture was inspired by the ceremonies installing the king as chakravartin on 802. The dating of Prasat Ak Yum demonstrates, however, that the conception of the temple mountain predated the Angkorian era by more than eighty years, supporting further the idea that Khmer civilization evolved continuously.

The reign of Jayavarman II ended after 830, but as with his accession, the exact date is unknown, and no dated inscription instigated by him has been found. During his reign, according to the stele of Sdok Kak Thom, he established his capital in five

different locations, though no reason for the moves is given. The precise sites of several are unknown, but before moving to Mount Kulen he ruled from Hariharalaya, the present region of Roluos, 15 kilometres (9 miles) southeast of Siem Reap. After some years on Mount Kulen, he returned to Hariharalaya, possibly because of difficulties with water supplies. The Siem Reap river and other streams rising in the Kulen region were later put to excellent use by the Cambodians in Angkor by divergences and canals, but the reticulation of the water on the rocky plateau itself and the infertile nature of the soil probably offered too great a challenge for sustaining a growing population.

Although dating the temples on Mount Kulen is tentative, and although inscriptions make it clear that some of the constructions are from the eleventh century (notably the river carving in the Kbal Spean area), there are more than sixty that may coincide with Jayavarman II's residence there in the early ninth century. Krus Preah Aram Rong Chen is the only pyramidal structure, the rest resembling, though sometimes on a larger scale, the single tower sanctuaries of the seventh century. The names are not derived from evidence in early inscriptions, but from local usage. Aram Rong Chen, 'pleasant garden of the Chinese', for example, relates to a local legend that the rectangular depressions carved out of the sandstone slab of the hill indicate the form of gardens developed by Chinese who arrived in a ship. At the time of an immense flood, their junk ran aground on the summit of the plateau, which is referred to as Sampon Thlay, or broken junk. They remained in the area, and local lore connects them with the ceramic kilns that were established not far from the site at Thnal Mrec. Recent research suggests that the wares from Cambodian kilns, which produced jars and lidded vessels with brown and green glazes as well as roof tiles, may date from as early as the tenth century, making them the earliest kilns in Southeast Asia. The carved out rectangular areas, known locally as gardens, in fact probably indicate the sections where blocks were quarried.

The dimensions of Krus Preah Aram Rong Chen are very similar to those of Ak Yum, the base being about 100 metres (328 feet) on each side and the third level 15 metres (49 feet) square with a mound indicating a central tower. The foundation shaft has been pillaged but yielded several cruciform blocks. Some supporting walls of laterite still exist on the second and third levels, but the base terrace was retained in situ on three sides by natural stone ledges. The central tower was possibly made of light perishable materials. The temple is situated on one of the highest

60 Prasat O' Paong, Phnom Kulen, 9th cent. Brick with sandstone. This brick structure of three false storeys with redented plan is one of the largest of the Kulen temples. It is named for the river that rises nearby, called after the Khmer word for the calophyllum tree, a tropical hardwood extremely resistant to rot and termites, that grew in the area.

parts of the plateau, indicating its importance, and nearby are two of the most important of the sanctuaries of the region, Prasat Kroh Bei Krap (formerly known as Prasat Damrei Krap), and Prasat O' Paong [60]. Kroh Bei Krap means 'kneeling buffalo'; O' Paong means 'the river Paong' (Khmer for the calophyllum tree); both are clearly derived from local features. Prasat O' Paong, of brick with a sandstone terrace, has octagonal colonettes and exceptionally steep corbelling. It has no false doors and its lintel and pediment have disappeared. The treatment of the interpilaster spaces on the exterior walls is reminiscent of Cham architecture, with unbroken vertical niches flanked by plain pilasters and overhung by a projecting cornice.

This feature is also found in Prasat Kroh Bei Krap where three brick towers once stood in very close proximity, about 2 metres (6½ feet) apart; only one is still standing, considerably buried at its base. Important sculptures of Vishnu were found in the sanctuaries [8] and the tympanum, in a state of ruin, featured a seated Brahma holding a lotus. The triple arrangement of towers

is one of the earliest examples of what would later become a frequent disposition, particularly in the evolution of temples honouring ancestors.

Prasat Thma Dap ('chiselled stone') is named for the Thma Dap river that flows south to the Tonle Sap past a nearby rocky escarpment. The temple, square with pronounced redentations in plan, has a steeply tapering tower with five false storey sections of exceptionally precise corbelling. The remains of elaborate reductions of edifice can be seen in the retreating storeys over the east portal. The lintels over the false doors are of great refinement with graceful interlocking foliate pendants from a garland held (over the south door) in the jaws of a horned lion [61]. Above the lintel, in a niche flanked by elaborate colonettes, sits a meditating figure. Deep foliate and floral relief carvings horizontally banding the interpilaster walls below the cornices and vertically at the corners of the redents are well preserved and presage the exuberance of the style of Roluos in the last quarter of the century.

61 Prasat Thma Dap, Phnom Kulen, Siem Reap, 9th century, false door and lintel. Brick with sandstone.
Named for the river bounded by a rocky ledge near the edge of the Kulen plateau, this is one of many single-towered sanctuaries in the area dating from the earliest years of the Angkorian period. The richly carved lintel of the false door and wall decorations incorporate foliate forms and motifs of monster heads swallowing garlands.

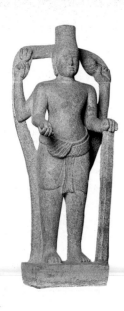

As the temples increased in size and complexity through the late eighth and early ninth centuries, sculpture also underwent changes. A growing rigidity is apparent, for example, in an eight-century Harihara [62]. Still depending on the arch from the stone matrix to support its attributes, its stocky limbs and thick fingers express solidity and power rather than grace and spirituality. The carving of the face and the details of the headdress, Shiva's twisted locks subsumed into the dominant profile of Vishnu's mitre, are skilled and precise, but the gaze is detached and the impression hieratic. By the early ninth century the hieratic tendencies were pronounced, chiefly embodied in a series of Vishnu images with remarkably similar features. One, found under a rock near Rup Arak [63], is probably one of the earliest of the group because remnants of the stone mass are visible supporting the conch in Vishnu's upper left hand, whereas the image from Prasat Kroh Bei Krap [8] is completely free-standing except for the mace extending to the floor from the proper lower left hand. Seven Vishnu sculptures were found in the area, three in Prasat Kroh Bei Krap precincts alone (presumably one for each of its three sanctuaries) and two in Prasat Thma Dap, all manifesting a growing stylization of the folds and flaps of the draped sampot and increasingly hieratical, even arrogant, expressions. Naturalism of the torso is well expressed, and the treatment of fingers and facial features is refined. All trace of tribhanga has been eliminated from the stance, which projects confidence and power.

While relief sculptures on Kulen temples sometimes represent Shiva, Ganesha, Indra and other Brahmanic deities (seldom female deities except Uma in association with Shiva), Vishnu is the only god carved in monumental free-standing form. This is somewhat puzzling, since the posthumous name of Jayavarman II was Parameshvara, an invocation of Shiva. While lingas may have balanced the preponderance of Vishnu figures, they do not seem to have dominated the sanctuaries. Between around 830 or later, and 860 or perhaps as late as 877, Jayavarman III ruled the Khmer kingdom as successor to his father. Inscriptions are scant and we know little about the period. His posthumous name was Vishnuloka, leading to the speculation that some of the temples and statuary of the Kulen area may date from his reign, not from his father's. However, as it is known that Jayavarman II abandoned Mahendraparvata on Kulen as his capital and returned to Hariharalaya, this theory presents another set of problems for establishing dates for the sculpture and architecture.

62 Harihara. Prasat Trapeang Phong, Roluos, 8th cent. Sandstone, 0.99 m (39 in). The characteristics of the dualistic god are dominated here by Vishnu references. Of the four attributes, only the trishula, or trident, relates to the Shiva half, while the form of Vishnu's mitre determines the shape of the head. The frontal stance and increased rigidity reveal a growing hieratic quality that appeared with increasingly centralized state power toward the end of the 8th century.

63 Vishnu. Rup Arak, Phnom Kulen, first half 9th cent. Sandstone, 1.90 m (74¾ in; with tenon). The residual supporting arc, ubiquitous in Pre-Angkorian sculpture but omitted in later Angkorian works, suggests a date early in the Angkorian period for this image. The refinement of the carving, and the stylization of the treatment of the double pleated anchor-shaped panel and the pocket-like folded flap of the garment, predict the style of Angkor.

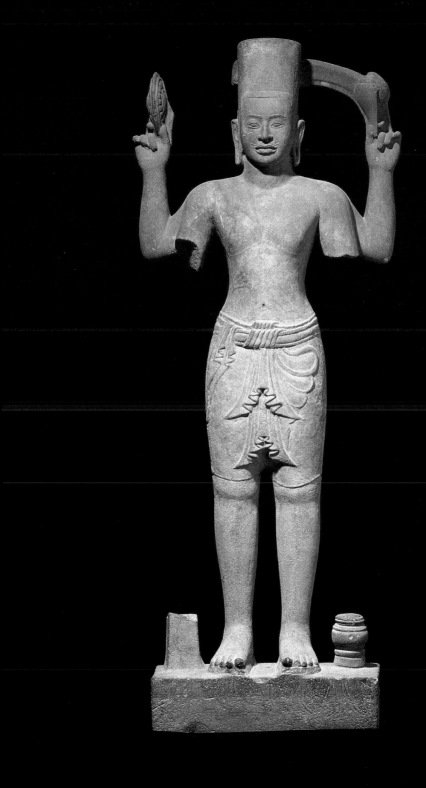

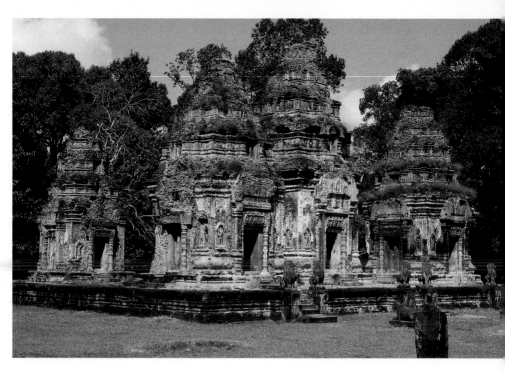

64 Preah Ko, Roluos, 879. Brick with sandstone. This temple, comprising two rows of three single-tower brick sanctuaries on a common base, was built by Indravarman I (877–89) in his capital, Hariharalaya, in honour of his ancestors. The area, about 15 km (9½ miles) southeast of Siem Reap, is now called Roluos.

With the accession of Indravarman I (877–89), the nephew of Jayavarman II, we are better supplied with dated inscriptions and monuments and the Khmer realm moves slowly into the realm of documented history. Just two years into his reign, Indravarman, whose posthumous name was Ishvaraloka, a Shaivite designation, built the six-tower complex of Preah Ko [64] in Hariharalaya (now Roluos), the city where Jayavarman had ended his reign. The name of the temple, meaning sacred bull, indicates its Shaivite affiliation, and there are three sculptures of Nandin, the mount of Shiva, facing the temple in the second enclosure. The foundation stele of the temple, after offering homage to Shiva, gives us the king's genealogy. It refers to the devaraja and mentions the date 879 for the dedication of three statues of Shiva and three of Devi (the generic goddess). Since the complex comprises two rows of three temples, clearly each temple housed a deity image, male in the front row, female in the rear, all facing east. More is learned from a Khmer inscription of 893 on another face (already in the reign of Yashovarman, Indravarman's successor) that names the deities, all versions of Shiva, to which donations are being made: Parameshvara, identified with Jayavarman II, whose posthumous name that was, in the central tower of the front row; Rudreshvara,

70

representing Rudravarman, Indravarman's maternal grandfather, in the northeast tower; and Prithivindreshvara, identified with Indravarman's father, Prithivindravarman, in the southeast tower. These were all chieftains, the first of Dviradapura, the last of a polity of uncertain location. The rear temples housed images of the shakti of the god, representing the spouses of the kings (and consequently Indravarman's female ancestors): Narendradevi, Dharanindradevi and Prithivindradevi.

In Preah Ko Indravarman was thus honouring his royal predecessors, thereby reinforcing his legitimacy, and also his forebears, an action deeply rooted in the Khmer awe of neak ta, or ancestor spirits. Such temples eventually constituted part of

65 Preah Ko. Lintel, door and dvarapala.
The remarkable quality of the carving of the sandstone lintel, with Garuda holding a garland terminating in five-headed nagas, of the false doors and octagonal colonettes with intricate foliate motifs, and of the dvarapala, or guardian figures in elaborate niches flanking the portal, is typical of the art of the late 9th century.

what developed into a three-fold architectural obligation for monarchs. In addition to embodying respect for and acknowledging the validating role of genealogy in an ancestor temple, the king usually constructed a state temple symbolizing the power of his realm. From the ninth century onwards, following the precedents of Ak Yum and Krus Preah Aram Rong Chen, this typically took the form of a temple mountain. The monarch was also required to demonstrate his power and commitment by creating public structures of varying kinds, including hydraulic works, rest houses and hospitals for his subjects. In the case of Indravarman, one such enterprise was the construction of the first of the huge barays that characterize Khmer urban sites, already supplied with canals and reservoirs from the earliest days. The baray was named Indratataka and measured 3.8 by 0.8 kilometres (2.4 by 0.5 miles). Such projects were partly bound into the code of acquiring merit (punya) but clearly also demonstrated power, strengthened authority and were politically expedient.

The six prasats of Preah Ko are grouped on a common sandstone platform. Like the sanctuary towers of the previous centuries, they are constructed of brick with sandstone elements, an exceptionally tall main body being surmounted by four receding false storeys of unprecedented height. The front temples are larger than the rear group, and are redented in plan, with cellas of 3.7 square metres (36 square feet) for the central east tower and 3.4 square metres (40 square feet) for the northeast and southeast towers – compared with 2.5 square metres (27 square feet) for the west row, which have no redentations. For no known reason the northwest tower was built slightly to the south of the east–west axis so, unlike the other rear sanctuaries, is not hidden by the front tower. The west temples have remnants of wood beams, evidence of the timber origins of Khmer architecture, as are the mitred joints of the door frames of sandstone.

Sandstone also comprises the lintels, door frames, false doors and remarkably beautiful octagonal colonettes as well as the niches and the male guardian (dvarapala) statues on the interpilaster spaces of the east temples [65]. In the west group it is employed only for the door frames and female guardians (devata), the other elements being of brick thickly coated with stucco. That substance, which once coated the whole complex, has endured remarkably well in many places, particularly on the northeast tower, and offers testament to new levels of carving genius reached by Khmer craftsmen. In most cases the carving is totally of stucco, though on the lintels the brick has been pre-carved. Recent restoration work

on brick and stucco has revealed traces of interior paint, confirmation of the theory that paint was more widely used than the present state of the monuments would lead us to believe.

Preah Ko has three enclosures, each walled. The inner one, with brick wall and square gopura, or gate, where the foundation stele was found, measures 58 by 56 metres (190 by 184 feet). The second has a laterite wall of 97 by 94 metres (318 by 308 feet), a gopura in cruciform plan and nine subsidiary brick buildings, of unknown purpose, in varying states of ruin. These include a square structure pierced by small holes in the walls, its only fenestration, with pyramidal superstructure and a porch sheltering its opening to the west. Small figures of ascetics are carved into the upper level of its walls, and rows of niches below contain figures also. This unusual building type is found also at Bakong, Indravarman's temple mountain. The combination of ascetics and the dark, cave-like nature of the interior could indicate a meditation space, but its opening to the west and the ventilation holes have led some to think it might be a cremation place. The outer enclosure, also entered by a cruciform gopura, attests to the new scale of temple building, the space to the east of the complex measuring 500 by 400 metres (1640 by 1312 feet). Moats surrounded the outer and second enclosures.

The scale is amplified even further in Bakong, dedicated just two years after Preah Ko in 881, which signalled an entirely new concept of power and architectural complexity [66]. Its centre is an enormous five-level pyramid that is the first Khmer temple built entirely of sandstone; it has a laterite central core extended by an earth mound. Between 1935 and 1943 it underwent extensive anastylosis, the process developed by the Dutch in Java of dismantling the remains of a severely damaged or unstable monument, numbering the stones, and re-erecting it by replacing missing stones with new substitutes. Professional standards mandate marking all new elements to distinguish them from ancient material. Although many of its subsidiary structures are ruined, notably its gopuras and the galleries of its eastern approach, the pyramid is sound and still guarded by Nandin figures at the cardinal points. The management of proportion in the steps that rise to each platform (unusually wide, more than five metres, thus adequate for circumambulation) is manipulated to amplify the effect of height and perspective, with risers diminishing, along with the sizes of the lions that decorate the staircases, and the staircases themselves narrowing, as the steps mount. The huge monolithic elephants guarding the corners of the lower three

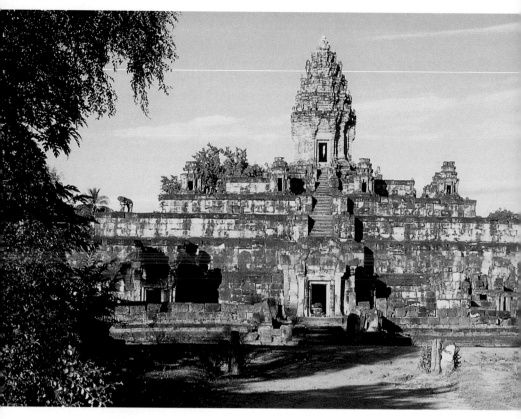

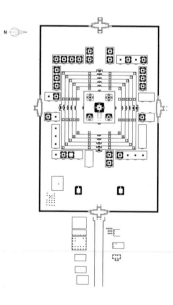

levels are unfortunately severely damaged but still exude a great feeling of power. The fourth platform once had twelve small sandstone prasats, or towers, of which ten still exist, that housed lingas. The base of the upper platform offers the first example in Khmer art of a running narrative relief, although the carving is rather shallow and in most places has become illegible. The upper platform supports a corbelled sanctuary tower in the style of Angkor Wat, 2.7 metres (8.9 feet) square and 15 metres (50 feet) high, that was erected in the twelfth century.

The five levels of the pyramid correspond with the five levels of Mount Meru, home to five categories of living beings, and the surrounding walled and moated precincts invoke the surrounding continents and oceans that Indian myth describes around the cosmic mountain [68]. The foundation stele, incised in exceptionally fine calligraphy, praises the king, records the installation of the linga Sri Indreshvara and the erection of eight prasats to house the eight murti, or images, of Shiva. These are presumably the eight sanctuary towers, two on each flank, that surround the pyramid within the inner enclosure. Five remain standing and demonstrate that the form is close to that of the towers at Preah Ko, square and redented in plan, with four receding false storeys in the towers [67]. They differ in being approached on all cardinal directions by steep flights of steps leading to the east portal and the false doors on the other facades. The prasats are built of brick, with door frames, lintels, colonettes and false doors carved from a monolithic slab of sandstone. The sculpture is remarkably refined, with the undulating horizontal garland characteristic of the lintels of this period, described as the Preah Ko style, enriched with an ordered profusion of floral motifs and creatures such as makaras, lion heads, nagas and seated figures [72]. The towers were covered with thick stucco, which also formed the exceptionally high pediments, now ruined for the most part. The only other sandstone elements were the dvarapala and devata guardian figures in niches on the outer walls, similar to those at Preah Ko. These are naturalistically carved, with details of dress and jewelry of remarkable grace and refinement, an artistry that perhaps reached its peak in the sanctuary towers of Lolei, built by Indravarman's successor twelve years later.

The style of Preah Ko has two aspects, the architectural sculpture gracing the three principal monuments of the Hariharalaya/Roluos group, and the free standing statuary that pushed the hieratism of the Kulen style even further. Three massive sculptures found in or near the eight Shiva temples

66 Bakong, Roluos, 881.
Bakong was Indravarman I's state temple, the first of the monumental temple mountains built as microcosms of Mount Meru, home of the Hindu gods. Built of sandstone with a laterite core, its present form is the result of extensive restoration. The tower on the highest of its five levels reaches a height of almost 30 m (98 ft) above ground level.

67 Bakong. Tower.
The eight brick prasats of Bakong with square redented plan and retreating false storeys are guarded by devas and devatas.

68 Bakong. Plan.
According to the foundation stele, the temple mountain was surrounded by eight prasats, three walled enclosures and two moats.

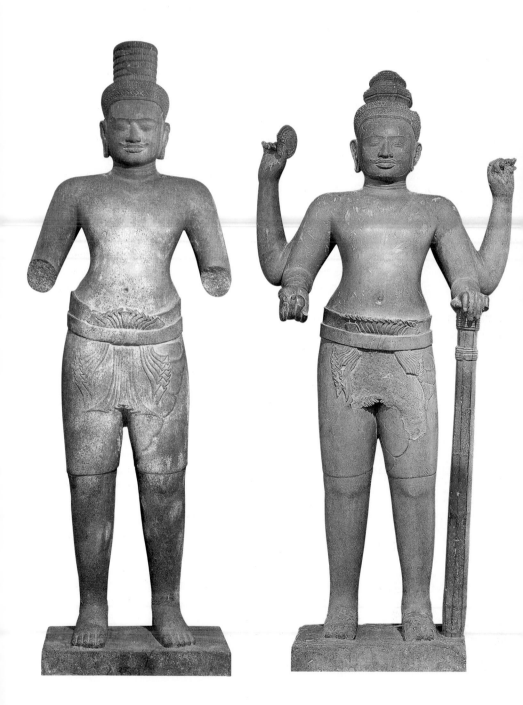

69 Shiva. Bakong, Roluos, tower 9, last quarter 9th cent. Sandstone, 1.86 m (73 in).
The majesty of this monumental figure of Shiva reveals the growing hieratism of Angkorian sculpture.

70 Vishnu. Bakong, Roluos, tower 7, last quarter 9th cent. Sandstone, 1.559 m (61 in).
Though Bakong was dedicated to Shiva, like most Khmer monuments it honoured several other gods in addition to the principal deity. This Vishnu was installed in tower 7 of the complex.

71 Female divinity. Bakong, Roluos, near w. gopura I, last quarter 9th cent. Sandstone, 1.13 m (44½ in).
The treatment of the pleated flap and folded-over panel of the draped garment first appears in the art of Bakong, generally classified as the style of Preah Ko, and is predictive of the following art of Bakheng.

surrounding the Bakong temple mountain epitomize the power projected by the monument. The Shiva [69], the tallest at almost 2 metres (over 6 feet) high, is particularly imbued with the ashana that signifies imperviousness to material concerns. His jatamukuta is cylindrical, the braided locks now schematized into a formal pattern and edged by a diadem, though naturalism is retained in the slightly right-leaning stance and the modelling of the torso and neck. The Vishnu's torso [70] is even closer to naturalistic proportions and his fingers are treated with delicacy, but it has the same rigidity that enhances dignity. Both faces show a differently refined morphology, the eyebrow arch of earlier figures now stylized into an almost horizontal continuous line, the full lips sensitively carved and surmounted by a delicate moustache, and the gaze resolutely downcast and detached from worldly focus. The mitre of Vishnu signals a complete change: the cylindrical mitre has disappeared and is replaced by a triple-tiered crown bordered by an elaborate diadem. The breasts of the Devi [71], underlined by incised beauty lines, are somewhat less opulent than in seventh-century goddesses, consistent with a more exalted aura, and the treatment of the pleated front panel and the flaps of the fabric ends of the sarong show the same refinement and stylization as the devatas of Preah Ko, Bakong towers and Lolei [73].

Yashovarman I (889–early tenth century) began his reign in his father's capital of Hariharalaya. The accession probably involved a struggle with his brother, in the course of which much of Hariharalaya may have been destroyed. Probably his first act, cementing his place in the royal genealogy, was the erection of the four temples of Lolei (an evolved version of the word Hariharalaya) in 893. They were dedicated to Indravarmeshvara, an appellation of Shiva representing his late father, to his mother, and to his maternal grandparents. Similar in construction to the towers of Preah Ko and Bakong, they were built on an island in the middle of the baray Indratataka, an evocation of the microcosm of Mount Meru surrounded by the cosmic ocean that was later to be expressed in East Mebon and Neak Pean temples. It has been speculated that originally there would have been six towers, as at Preah Ko, since the north towers are in alignment with the east–west axis. However, the foundation stele mentions only four towers and the people they are dedicated to. Today the towers are in a state of near collapse, one in fact has fallen, but offer the same rich sculpture of lintels and guardian figures characteristic of the Preah Ko style. Their door piers have yielded some of the most beautiful inscriptions in Khmer epigraphy. They are written in

Kamvujakshara script, said to have been perfected by the Khmer kings themselves on the basis of the Chalukya-Pallava script of southern India, and offer evenly spaced, elegantly rounded characters of exceptional clarity.

At some time between Yashovarman's fulfilment of the obligation to honour his forebears in the ancestor temple of Lolei and the beginning of the tenth century, perhaps spurred by destruction in Hariharalaya, the king founded a new capital about 15 kilometres (more than 9 miles) to the northwest in the area that eventually came to be known as Angkor, meaning 'city state' (from the Sanskrit 'nagara'). It was the beginning of a new era in Khmer civilization.

72 Lolei. Roluos, 893. Lintel.
This ancestor temple was built by Yashovarman I (889–early 10th century) as an artificial island in the middle of a ceremonial lake, or baray, the Indratataka, which was begun in the reign of Yashovarman's father, Indravarman.

73 Lolei. Devata.
The carving at Lolei is among the most remarkable in Khmer art, as can be seen in the flowing pleated garment of this devata, or female guardian deity, and in the details of the stuccoed niche, in the form of a miniature prasat, in which she stands.

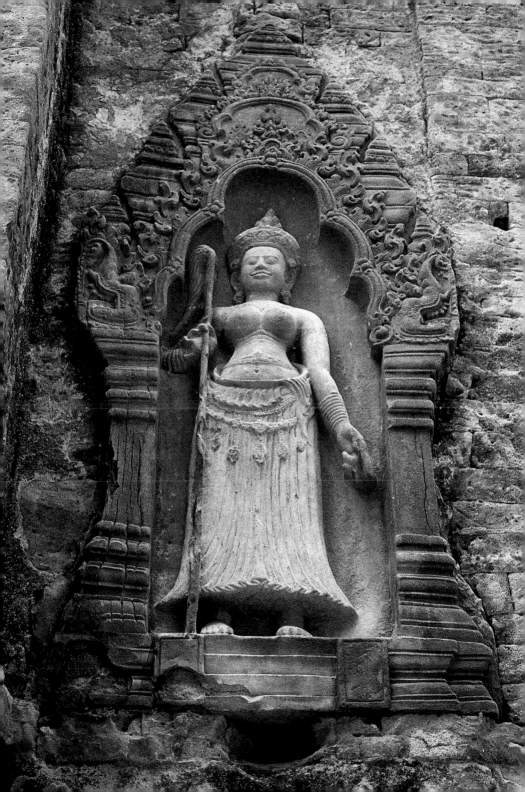

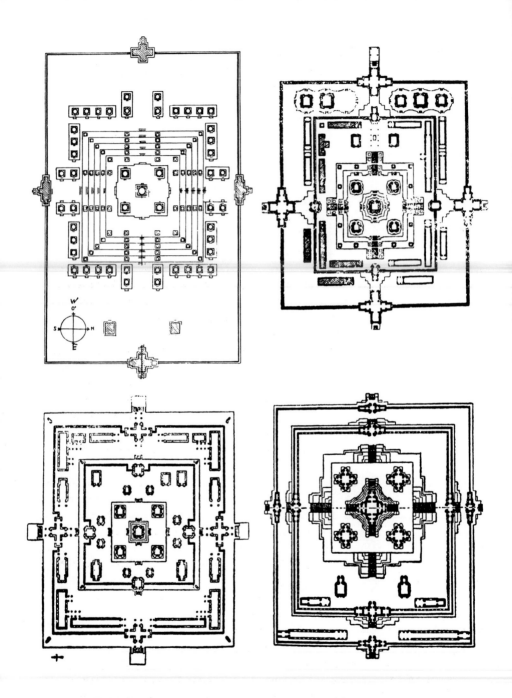

Chapter 4 The Evolution of Angkor:
the architectural and sculptural glories
of the tenth century

For a king intent on invoking the power of Indic mythology the
site chosen by Yashovarman I as his capital was highly appropriate.
Phnom Bakheng, although only 60 metres (200 feet) high, is one
of only a few hills, along with Phnom Bok and Phnom Krom,
in the region near the Tonle Sap lake, and is therefore dominant
in the landscape. In royal Khmer fashion the city was called
Yashodharapura after the monarch, whose posthumous name was
Paramashivaloka, identifying him as a Shaivite like his father. Having
fulfilled the obligation to honour his forebears in the temple
complex of Lolei, he carried out his first major public works
project by creating a baray even bigger than Indratataka. Known
as Yashodharatataka, and today as the eastern baray, it measured
7 by almost 2 kilometres (4½ by 1¼ miles), and lay to the east of
the site chosen for the king's state temple, Phnom Bakheng (a
modern name, like most of the designations used today). Although
dry for centuries, the outline of the baray can be seen as water
accumulates in lower areas during the rainy season. Along the
south edge of the baray the king built a series of four sanctuaries
for meditation. Vestiges of three of them remain and are identified
with the worship of Vishnu, Brahma and Buddha. The fourth was
presumably for Shiva, but was subsumed into the twelfth-century
development of Angkor Thom. We can infer that Yashovarman
was a monarch with an ecumenical outlook.

The summit of Phnom Bakheng offered a natural hill as a basis
for Yashovarman's temple mountain, which was constructed
around the turn of the tenth century. An inscription notes the
installation of a linga called Sri Yashodhareshvara. Like Bakong,
it was a five-tiered pyramid with multiple subsidiary structures.
When a low platform for the five towers of the quincunx and the

74 (clockwise from top left)
Bakheng, East Mebon, Pre Rup,
Takeo. Plan.
Five levels of the Bakheng pyramid
(top left) lead to an upper platform
of 31 square metres, where five
towers in quincunx arrangement
symbolize Mount Meru and the
four surrounding holy mountains
of the Brahmanistic heaven. The
towers on the pyramid and its base
number 109 in all. The monument
is exceptionally steep, probably
because its core is the rock of the
hill itself, gouged out and faced with
sandstone elements.

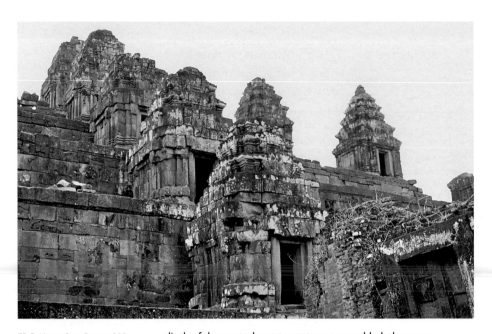

75 Bakheng. Siem Reap, c. 900. This monumental temple mountain was built by Yashovarman I on the summit of the mountain of the same name. It marked the shift of the capital, then called Yashodharapura, from Hariharalaya to the present site of Angkor in Siem Reap. Its base measures 76 square metres.

plinth of the central sanctuary tower are added, there are seven levels, which equal the total in the Indic heaven centred on Mount Meru. The four towers at the corners symbolize the four subsidiary peaks that surround Mount Meru. Using the hill itself as the core of the monument led to an unusually steep ascent, the four levels preceding the upper platform offering only a narrow ledge of less than 4 metres (13 feet), not wide enough to permit circumambulation, which in any case would have been impossible because of the presence on every level of myriad small towers [75]. These are so squeezed into the space that their east and west doors open either to the void or the wall of the next level. Forty-four brick sanctuary towers, now almost entirely ruined, were at ground level, and 12 sandstone towers, at the corners and flanking the central steps in each cardinal direction, were on each of the five levels. To this total of 104 are added 4 corner towers of the quincunx on the upper platform and the central tower making a total of 109, a figure imbued with the symbolism of Indic numerology, the study of numbers and determinism in most mythologies [74]. The lowest level measures 76 metres (250 feet) square, the upper 47 metres (150 feet), with a height of 13 metres (42½ feet), so it is not surprising that the steps on the four sides rise at an angle of 70 degrees.

Nothing remains of the quincunx towers but their bases, with the exception of the central sanctuary, of which only the main

body remains, and which was open on all cardinal faces. The dvarapala figures that flank the doors are set in niches in the manner of Preah Ko and Lolei, but are on a larger scale and already show the perfection of carving in the treatment of garments, anatomy, attributes and architectural detail that characterizes sculpture of the so-called Bakheng style. They occur in other temples of Yashovarman's reign as well (see below). Their most complete embodiment is seen in a large free-standing sculpture of a female divinity [76] where pleating, first seen in panels in the devata of Preah Ko and Lolei [73], is now applied to the entire skirt, with a type of pleated front flap that would continue through the tenth and eleventh century and recur in the style of Angkor Wat. The austerity that emerged in the Kulen and Bakong styles has now been emphasized so strongly that the figure's look of detachment has almost become disdain. The pronounced slenderness of the high waist in contrast to the full breasts adds an element of voluptuousness to the body, which is ringed with beauty lines at the neck and below the breasts, but the rigid frontal stance and unyielding gaze give no hint of sensuality. Though the head is considerably damaged – the diadem and coiffure have many losses – the refinement of carving can be appreciated in the treatment of the jewelled belt with pendants, a style that had appeared in bas relief in the ninth century but not previously in free-standing sculpture.

The fine quality of carving can be seen to even greater advantage in a Harihara head [77], where the precise treatment of braided hair and jewelled tiara of the Bakheng style are epitomized in this last known representation of the dual god. Its iconic perfection exudes divine authority. A figure of Brahma [79] shows the extent of stylization of the period in the representation of pleated panels, flaring in an elaborate fishtail motif, in the front of the god's sampot.

The precinct of the temple mountain on Phnom Bakheng, in effect the area of Yashovarman's capital, was far larger than any previous enclosure, measuring 4 kilometres (2½ miles) on all sides and protected by a moat. The palace and dwellings for the population almost certainly once lay within this square (much bigger than the area of large European cities at that date), but no trace remains of what was presumably constructed in perishable materials. An inner wall protected the perimeter of the hill and was cut by gopuras, now ruined, on all four sides, leading to the axial steps ascending the pyramid. All levels were protected by lions on the staircases, diminishing in size in ascent, and two of the

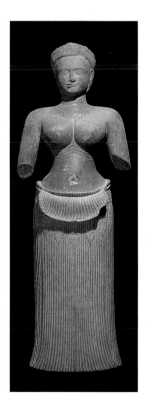

76 Female divinity. Phnom Bakheng, Siem Reap, first quarter 10th cent. Sandstone, 1.40 m (55⅛ in).
The rigidity of this figure contrasts with the voluptuousness of the body and typifies the cold perfection of the style of Bakheng, where it was found. Its majestic posture and haughty expression personify the hieratic nature of early Angkor period sculpture.

77 Harihara head. Unknown provenance, Bakheng style, first quarter 10th cent. Sandstone, 0.35 m (13¾ in).
The distinction between the Shiva and Vishnu halves on this remarkably finely carved head of Harihara is clear. Half of Shiva's third eye and the crescent moon in his headdress contrast with the octagonal crown strewn with gems or flowers on the Vishnu side. Although sculptures of Harihara were common in the pre-Angkor period, this head is the only known representation from the Angkorian period.

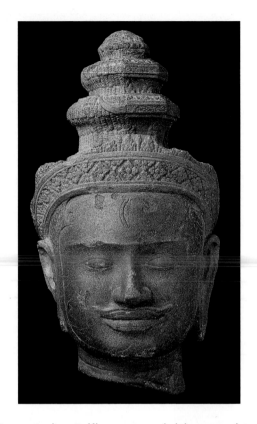

most impressive lions in Khmer art guarded the approach to the eastern gopura. As the lion has never been known in Cambodia, the ubiquitous use of this beast in many styles as temple guardian indicates the lasting influence of Indian and perhaps Chinese imagery and iconography on Khmer art. Their exotic nature partly explains the stylization of the forms.

Further evidence for the expansion of Yashovarman's kingdom can be deduced from a series of stele, found from the south of Cambodia all the way north to the area of Phnom Rung in Thailand and Wat Phu in Laos, asserting the king's authority. In addition, he constructed temples on the other hills of the area, Phnom Bok and Phnom Krom. The former, to the northeast, dominates the area between Angkor and Mount Kulen, the latter the area of the Tonle Sap lake to the south [78]. Vestiges of surrounding narrow buildings and of west-facing structures commonly called libraries are situated to the west of the chief structures, three sandstone towers aligned on a north–south axis on a common platform comprising sandstone paving on laterite

78 Phnom Krom, Siem Reap, 10th cent.

At the time of Yashovarman's transfer of the Khmer capital, then called Yashodharapura, to the area that would later be called Angkor, and the construction of his state temple mountain on Phnom Bakheng, temples were also built on two other hills dominating the Angkor region, Phnom Krom and Phnom Bok. Both comprised three sanctuaries set on the same plane on a common platform.

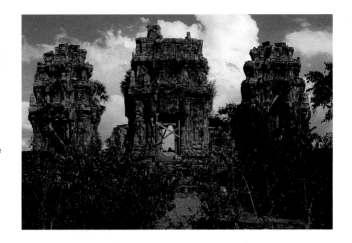

79 Brahma. Unknown provenance, first quarter 10th cent. Sandstone, 1.20 m (47¼ in).

The same hieratical posture and extremely precise carving seen in ills 76 and 77 (previous page and opposite) from Bakheng characterize this image of the four-headed god Brahma, the third god (with Shiva and Brahma) in the trimurti, or Hinduistic Trinity.

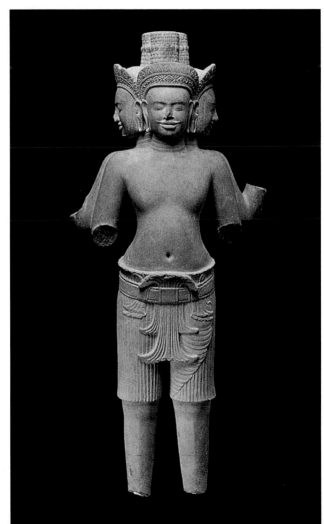

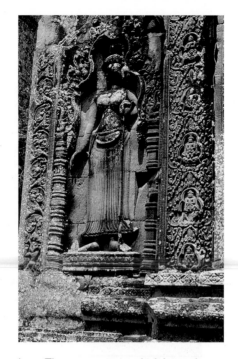

80 Phnom Bok, Siem Reap, first quarter 10th cent. Devata.
The finely carved garments and features of the guardian deity are almost identical to those on the contemporary temples of Bakheng and Phnom Bok. The precise pleats of the sarong are characteristic of Bakheng style.

base. The centre tower, which housed a statue of Shiva, is slightly larger than the others with an interior cella with sides of four metres. The south tower contained a Brahma image, the north one of Vishnu, thus the complex invoked the power of the trimurti. In a fragile state, the three statues were removed to the National Museum for preservation. The sanctuaries had four false storeys and a redented square plan like the Phnom Bakheng towers. The top stage has fallen from the side towers and two from the main tower. The decoration of devata figures in niches resembles that on Bakheng, while the base mouldings and pilasters are richly carved with interlocking fronds enclosing seated figures.

The Phnom Bok complex, on a steep hill of 235 metres (770 feet), is in a state of greater ruin than Phnom Krom, but its vestiges indicate an almost identical plan with three sanctuary towers and several annex buildings, including the remains of two libraries whose laterite walls are pierced by the same lozenge-shaped ventilation holes as those at Phnom Krom. No superstructures have survived, but the remaining walls of the three principal towers have decorations resembling those at Phnom Krom and Bakheng. Their devata figures, less eroded than those at Phnom Krom, wear the same finely pleated skirt with jewelled belt, and a heavy cuff of coiled metal adorns the arm

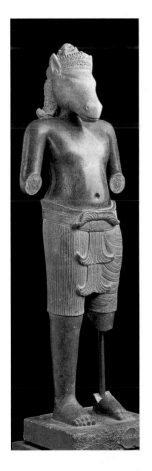

81 Vajimukha. Prasat Neang Khmau, Ta Keo, first quarter 10th cent. Sandstone, 1.06 m (41¼ in). The pleated garment with double anchor front sashes of this equine deity found in Prasat Neang Khmau identifies it as a Bakheng-style image. The head was recently reunited with the torso, explaining the difference in patina between the two sections.

whose delicately carved fingers hold a lotus stalk [80]. The niches are flanked on one side with a foliate band with trefoil frames enclosing small figures riding beasts resembling lions. Remarkably refined heads of Brahma, Vishnu and Shiva were found buried in one of the subsidiary buildings, indicating that this complex, too, was dedicated to the trimurti. The heads, now in the Musée Guimet, have the hieratic perfection characteristic of the Bakheng style and exhibit a mastery of technique that was seldom equalled in Khmer art. An extraordinary vestige of the site is an enormous linga, more than 4 metres (13 feet) in length, that is lying, partly buried, a short distance from the temple.

It is uncertain when Yashovarman died, but between 912 and 922 there are references to his son, Harshavarman I, who was succeeded in turn by his brother, Ishanavarman II, mentioned in an inscription of 925. Few details are available about the period and the reign dates remain speculative. Neither king seems to have constructed a state temple, but Harshavarman I partly built the small pyramid of Baksei Chamkrong [91] in honour of his parents. Two significant structures of the first quarter of the tenth century were constructed that emphasize Vishnu. One, to the south of modern Phnom Penh, is the sanctuary called Prasat Neang Khmau, meaning the sanctuary of the dark lady. Barely legible wall paintings depict Vaishnavite scenes, and the temple yielded two sculptures accorded great reverence by local villagers, a headless female statue with pleated garment in Bakheng style, now in the National Museum, who was presumably given the name because of the dark tone of the variety of dense sandstone, and a Vajimukha [81] carved from the same material. The cult of the dark lady is a blend of Indic goddess worship with local neak ta beliefs, while Vajimukha confirms the resurgence of Vishnu worship, notwithstanding that both Harshavarman I and Ishanavarman II had Shaivite posthumous names. Both sculptures exhibit the smooth patina consistent with countless strokings by worshippers, and both conform to the garment stylization that developed in the works of Phnom Bakheng.

The other significant temple of the first quarter of the tenth century is Prasat Kravan [82], where an inscription on the door pier records the dedication of a statue of Vishnu in 921. Seemingly without annex buildings and lacking a raised foundation, the complex comprises five east-facing brick sanctuaries aligned north–south on a common platform. The brickwork demonstrates the peak of Khmer mastery of this technique, evenly sized and baked bricks laid without mortar (a thin film of

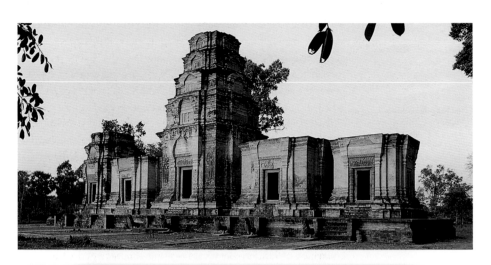

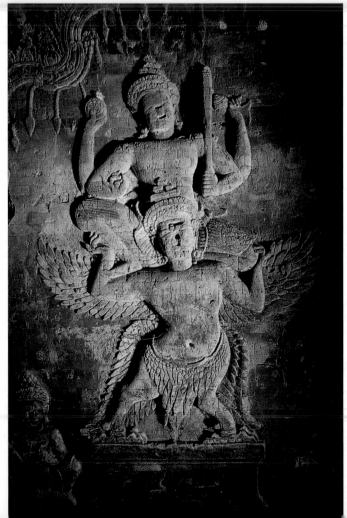

sticky vegetable sap ensured adhesion) and presenting a smooth surface that was utilized in two of the towers for deep relief carvings of aspects of Vishnu. In addition the sanctuaries housed pedestals with lingas. Three images of Vishnu are in excellent preservation in the central tower. The west wall, facing the door, presents a huge image of the supreme form of the god, the eight-armed Vishnu-Vasudeva-Narayana. The south wall shows Vishnu Trivikrama, Vishnu claiming the three levels of the universe – the underworld and water, the middle earth, and the heavens – by taking three giant strides. On the north wall Vishnu Chaturbuja (four-armed) rides his vahana Garuda, whose delicately carved hands support the god's splayed knees [83]. All three are infused with naturalism and dynamism contrasting strongly with the hieratic style of Bakheng that imbues the contemporary works from Prasat Neang Khmau. There are also relief carvings in the northernmost tower, in this case of Lakshmi, Vishnu's shakti.

Understanding the swing of power in Cambodia towards the end of the first quarter of the tenth century is complicated by the rise of the brother-in-law of Yashovarman. Married to the king's younger sister Jayadevi, he was a wealthy landholder whose territory was located more than 100 kilometres (62 miles) northeast of Angkor at Chok Gargyar, also called Lingapura and now called Koh Ker. At some point towards the end of the reign of his nephew Harshavarman, he proclaimed himself Jayavarman IV, left Yashodharapura, and from about 921 began establishing a grandiose capital in his realm. He reigned as a pretender till the death of his second nephew, Ishanavarman, in 928, at which point inscriptions officially name him as chakravartin of the Khmer kingdom, continuing to rule from Koh Ker until his death in 942.

Isolated by Khmer Rouge hostilities until the beginning of the twenty-first century, and still challenging to visit because of large numbers of residual landmines and atrocious roads that are impassible for most of the year, the huge royal complex of Koh Ker is perhaps the embodiment of a pretender's need to demonstrate great power through large-scale architecture. Everything about Koh Ker, the dimensions of its colonettes, the height of its gopuras, the size of its sculptures, is on a massive scale. The group comprises several hundred structures, many of them clumped in groups having their own enclosure walls, occupying an area of 7 by 5 kilometres (c. 4½ by 3 miles) near a small branch of the Stung (or river) Sen. Jayavarman constructed a baray, called 'Rahal' locally, which is fed by the stream and is the focal point of the various groups. Its dimensions of 1200 by 560

82 Prasat Kravan, Siem Reap, 921. Vaishnavism became increasingly important during the troubled decades when Jayavarman IV ruled from Koh Ker. The five-part brick temple of Prasat Kravan ('red temple') is notable for the reliefs on the interior walls of two of its towers of several forms of Vishnu and his spouse, or shakti, Lakshmi.

83 Prasat Kravan. Relief, Vishnu on Garuda.
This relief dominates the north wall of the central tower of Prasat Kravan and is notable for the energy expressed in the divine vahana, or mount, as he bears aloft the seated figure of Vishnu.

metres (4000 by 1800 feet) are significant, if not on the scale of the barays at Angkor.

Without doubt the chief interest lies in the complex of Prasat Thom (big sanctuary) that contains Jayavarman's temple mountain and a multitude of small sanctuaries, long galleries, subsidiary towers and gopuras. One, Prasat Kraham (red sanctuary), so called because it was built of red brick, is especially tall and elaborate and surpasses the normal size and importance of gopuras, assuming the status of a temple in its own right. The complex was enclosed with two, possibly three, massive enclosure walls of laterite and an inner wall of brick, with a wide moat separating the second and third enclosures. Descriptions by Lunet de Lajonquière in 1902 and Henri Parmentier in 1939 explain the layout, today hardly to be understood owing to the destruction that has ensued in the intervening decades, some of it resulting from Khmer engineering faults, some from the intrusion of

84 Prasat Thom, Koh Ker, Kompong Thom, second quarter 10th cent. Plan and elevation. In 921 Jayavarman IV claimed the kingship and established the Khmer capital at his estate north of Angkor at Koh Ker (Chok Gargyar) even though his nephew, Harshavarman I, and later Harshavarman's brother, Ishanavarman II, were ruling at Angkor. His state temple complex was on a massive scale, perhaps attributable to a usurper's need to demonstrate legitimacy by the overt show of power.

vegetation, some from ruthless looters. Koh Ker's isolation has left it vulnerable to furtive raids, and sculpture from its myriad structures is disproportionately well represented in museums throughout the world. It is one of the most shockingly vandalized sites in Cambodia.

The dimensions of Prasat Kraham indicate the scale of the whole Koh Ker aesthetic, its monolithic bay stones of 4 metres (13 feet) in height and almost 2 metres (6 feet) in width in suitable proportion to colonettes about 0.5 metre (1½ feet) in diameter. Its tower was seven-tiered and steeply corbelled and sheltered a colossal statue of dancing Shiva with five heads and ten arms. The statue fell, or was knocked over by looters seeking treasure below its pedestal, and was broken into innumerable fragments, of which only the damaged head and a few hands and attributes are still legible. One hand fragment measures about 0.5 metre (1½ feet), indicating that the image was more than twice lifesize. Holes on

85 Prasat Kraham, Koh Ker, colonnade.
The gopura of Prasat Kraham is so elaborate and large compared to most gopuras that it amounts to an important temple in its own right. Its size is indicative of the grandiose scale of the Koh Ker capital.

the exterior walls, consistent with the placement of armatures to maintain stucco layers, suggest that the tower was so covered.

After traversing what was once a causeway to the inner enclosure with its clusters of small ruined chapels and long galleries, another ruined causeway leads to a colonnaded avenue [85] that continues to the enclosure walls of Jayavarman IV's temple mountain, often referred to as the prang, a word common in Thai nomenclature but not in Khmer. The pyramid is seven-tiered and rises steeply to a height of 35 metres (115 feet), nearly twice the height of the upper platform of Bakong [86]. There is no indication of what the superstructure might have been, perhaps of light materials, but with that addition the monument would probably have been 60 metres (200 feet) tall. Most decoration has disappeared, with the exception of some guardian lions, and the single series of steps on the east face are in disrepair and still studded with landmines. Behind the pyramid on the east–west axis rises a steep mound, whether of natural or human origin is unknown, but thought by some to be the place where Jayavarman first placed his devaraja Tribhuvaneshvara, taken from Yashodharapura as inscriptions inform us, when he first established Koh Ker as a royal capital.

A wealth of huge sculptures guarded the steps and causeways, the latter being flanked by long nagas with raised multiple heads facing outward from the inner enclosure at both ends. Behind the nagas reared enormous figures of Garuda in dynamic stance as if in pursuit [87]. The smaller sanctuaries and the plinths of stairs yielded lions (sitting, standing and lying, a most unusual variety), other guardian figures with human bodies and heads of monkeys or elephants (the former presaging the guardians of Banteay Srei)

86 Prasat Thom, Koh Ker.
Jayavarman IV's temple mountain is 55 square metres in plan. The steep prang of the seven-stage central pyramid is 40 m (130 ft) high in its present state (see plan in ill. 108, p. 115). The proportion of its height to the area of its base makes it steeper than other temple mountains like Bakong and Bakheng.

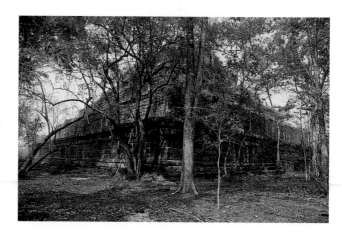

87 Garuda. Prasat Thom, Koh Ker, Kompong Thom, second quarter 10th cent. Sandstone, 2.13 m (83⅞ in).
The massive scale of the striding Garuda, vehicle of Vishnu, is typical of the monumental nature of sculpture from Koh Ker, which is also notable for its dynamic energy and refined detailing.

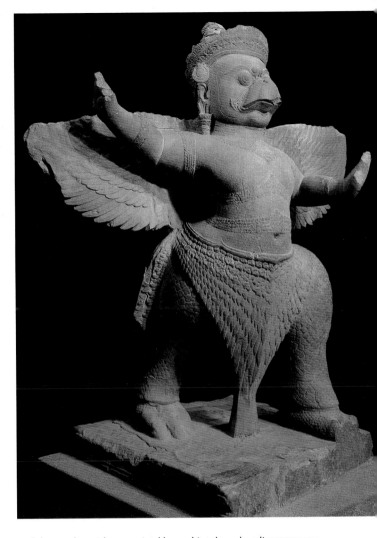

and dvarapalas with one raised knee. Lintels and pediments were richly carved, mostly with Vishnu legends, but few remain in place. Gopura II west sheltered a pair of wrestlers [89] whose expressive dynamism and refined detailing of naturalistic anatomy, costume and jewelled belt typify the mastery of Koh Ker sculptors. The same qualities infuse the massive dancing female divinity [88] that was housed in Prasat Kraham, probably in the ancillary chamber to the central sanctuary where the dancing Shiva stood.

Many of the other temples in the Koh Ker site are of impressive size also even if dwarfed by Prasat Thom. One series houses lingas, which stand in a central monument with annexes

and enclosure walls of laterite. Some are more than 2 metres (6 feet) tall. The current names are local and not the original appellations. One tall laterite sanctuary, Prasat Neang Khmau (black lady sanctuary), is richly decorated with well preserved reductions of edifice on the corners of the receding false storeys of its tower and has intricately carved octagonal colonettes of unusually large dimensions. It faces west. On its north, east and south facades there are plain vertical niches, as in Prasat O' Paong on Kulen, that resemble Cham architecture. Prasat Kong Yuan (sanctuary of the young Vietnamese), with an inscription listing slaves, has stone gable ends with upswirling curved ends reminiscent of wood structures, a treatment found again in Banteay Srei.

Prasat Koh Chen (sanctuary of the Chinese), which has an inscription in huge letters announcing its dedication to Vishnu, has a most unusual lintel where Garuda surmounts two nagas whose heads are intertwined. It was here that the colossal sculpture of the fighting ape kings Valin and Sugriva was found [90]. Other huge statues found in the area include Shiva and Uma on Nandin, and Ganesha. The variety of iconography and architectural detail, and of construction methods and materials makes Jayavarman's capital one of most fascinating, if least known of ancient Khmer settlements.

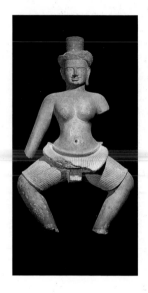

88 Dancing female divinity. Prasat Kraham, Koh Ker, Kompong Thom, second quarter 10th cent. Sandstone, 1.35 m (53⅛ in). This monumental dancing figure, legs turned out in a typical Cambodian dance stance, was found in gopura III east, known as Prasat Kraham, at Koh Ker (see ill. 85, p. 92).

89 Wrestlers. Prasat Thom, Koh Ker, gopura II west, second quarter 10th cent. Sandstone, 0.79 m (31 in). The iconography of these powerfully entwined figures is unknown, but their refined carving and dynamism are characteristic of the vital style of Koh Ker.

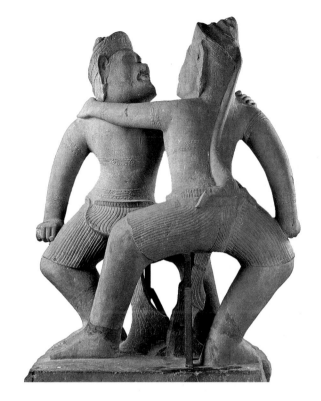

90 Valin and Sugriva. Prasat Chen, Koh Ker, Kompong Thom, second quarter 10th cent. Sandstone, 1.94 m (76⅜ in).
The rivalry of the monkey kings Valin and Sugriva, ultimately leading to the death of Valin, is recounted in the *Mahabharata* and is frequently depicted in Khmer relief sculpture. The latent energy of the struggling pair is typical of the sculpture of Koh Ker.

Jayavarman IV (posthumous name Paramashivaloka) was succeeded by his son, Harshavarman II, in 941 or 942. An inscription of 941 mentions both monarchs, so it was possibly the earlier date. Harshavarman remained in Koh Ker, but the reign was short, and in 944 his cousin, Rajendravarman (944–68), became king, whether through the death of his cousin or by usurpation is not known. As the son of an older sister of Yashovarman, he was the fourth member of his generation to claim the Khmer throne. On his father's side he may have been descended from the kings of Bhavapura. He reinstated Yashodharapura as the capital and, unusually, retained that name for the city. One of his first recorded acts was the completion of Baksei Chamkrong, the small temple mountain begun by Harshavarman I in 921 [91]. Its door pier inscription of 948 describes a gold image of Shiva installed in the sanctuary tower. The base of the pyramid, constructed in laterite, measures only 27 metres (88 feet) per side, but the proportions of its four levels, transected by steps in the four cardinal directions, are so well managed that it achieves a monumentality beyond its size, in

striking contrast to the philosophy of Koh Ker's architects. The tower, of brick with sandstone frames, false doors, colonettes and lintels, is 8 metres (26 feet) square, its decoration restrained and elegant.

During Rajendravarman's reign architecture and sculpture achieved new levels of refinement. His ancestor temple, East Mebon, was built in quincunx plan in the middle of the eastern baray, though its status as a microcosm island temple in the manner of Lolei is apparent only when the monsoon flood waters are at their height between August and October. Unlike other ancestor foundations, which were single tower sanctuaries in groups, East Mebon is a temple mountain, where its linga, Rajendreshvara, was consecrated in 953. Its inscriptions proclaim the king's virtues in the customary effulgent language, describing him as: 'like the grace of spring in the gardens, like the fullness of the moon...always in motion, attractive, omnipresent, strong, tall, opposing order to the turbulent.' Inscriptions mention the construction of a palace, but its location is unknown although, uniquely, its architect's name is not: Kavindrarimathana was one of Rajendravarman's powerful ministers, a Buddhist who constructed

91 Baksei Chamkrong, Siem Reap, 928–41.
The single-tower pyramid was begun in 921 by Harshavarman I, son of Yashovarman I, but was not completed until the reign of Rajendravarman, after the return of the capital from Koh Ker to Yashodharapura/Angkor in 944. Although relatively small, its proportions recall the verticality of Prasat Thom (ill. 86, p. 92). See also its plan in ill. 108, p. 115.

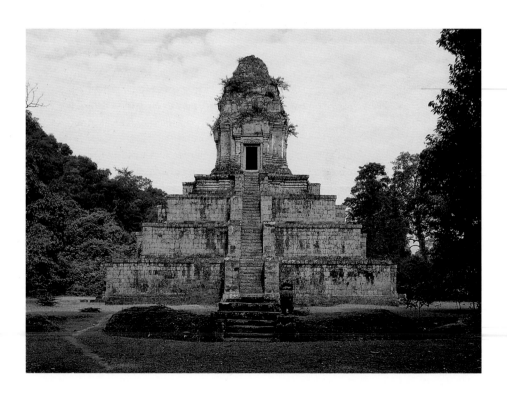

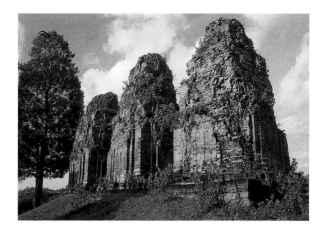

the small Buddhist shrines of Bat Chum in 960 [92], one of
the few examples of temples not built at royal behest. Its three
shrines, according to the inscription, are dedicated to the Buddha
and the bodhisattvas Vajrapani and Prajñaparamita. The period
saw a resurgence of interest in Buddhism, a tolerance that
continued until the end of the tenth century in the reign of
Rajendravarman's son.

The pace of building must have been hectic as the linga
Rajendrabhaveshvara was consecrated in 961 in the five-tiered
temple mountain of Pre Rup only eight years after the dedication
of East Mebon. The Pre Rup inscription states: 'It was play for him
[the king] to break into three a large bar of iron, by striking it
lightly with a single stroke of his sword as [if it were] a banana
stalk'. The warrior qualities of Rajendravarman were probably
vaunted in the light of a heavy attack by the Chams during his
reign. Pre Rup, built of sandstone with a slightly red tinge, is one
of the most appealing of the temple mountains [93]. Its three top
levels are set back to the west of the north–south axis of the
lower two levels. This allows a generous area to the east in which,
in the outer enclosure, there is room for four sanctuary towers,
and in the second, for two libraries, without any of the cramped
feeling of monuments like Bakheng. The management of sight
lines, ascent and circumambulation is unusually spacious and the
relative proportions of the lower towers and the miniature
monuments on the third and fourth levels compared with the
towers of the quincunx were decreed by a masterly hand. On the
lowest and second levels long narrow buildings with columns,
most in a state of advanced collapse, may indicate the emergence
of the flanking gallery form that was to play such an important role

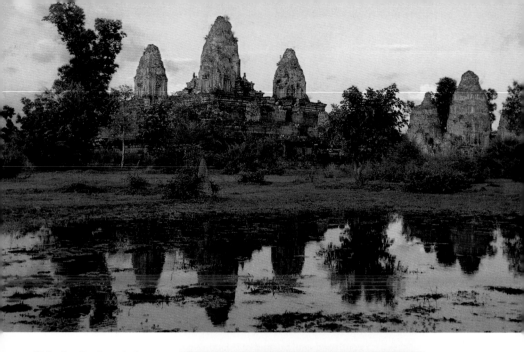

93 Pre Rup. Siem Reap, third quarter 10th cent.
Built only nine years after his first temple mountain, East Mebon, Pre Rup was the state temple mountain of Rajendravarman II (944–68). The five towers on its summit are in quincunx formation. Its name means 'turn the body', a ritual practised in burial ceremonies, so it may have had a funerary purpose. The name is now considered by some to be a corruption of Preah Vaishvarupa. See plan in ill. 74, p. 80.

94 Pre Rup. Lintel.
The elaborate lintels, doors and colonettes of Pre Rup and East Mebon are among the finest in Khmer art. The perfection of their carving is one of the determinants for the style of Pre Rup.

in Angkor Wat and the Bayon two centuries later. The towers were stuccoed, some traces remaining along with the holes pecked into the surface for its armature, and the carving of the lintels and colonettes is among the most beautiful in Khmer art [94].

A similar perfection characterizes the free-standing sculpture of the period, eponymously known as the Pre Rup style. A figure of Varuna, guardian of the west and in Vedic belief the god of the law and the world beyond, typifies the refinement of the style [95]. His mount, the four-headed hamsa or goose, has intricately carved feathers and protectively raised beaks contrasting with the smooth patina of the god's torso. The pleated flap of the sampot persists from the style of Bakheng, but the iconic expression on the face and the treatment of the navel and the pectoral muscles show a return to naturalism from the stiffness of Bakheng.

Rajendravarman's reign is notable for the documentation of dignitaries who played important roles in his kingdom. The minister-architect Kavindrarimathana has already been mentioned. There was also the Brahman Yajñavaraha, the guru

95 Varuna. Prasat Kuk Don, Siem Reap, third quarter 10th cent. Sandstone, 0.77 m (30⅜ in). The deity Varuna, in the style of Pre Rup, is shown here in his capacity as a dikpalaka, or guardian of the four cardinal points, in his case, the west. He is mounted on his vahana, or mount, the goose (hamsa), which is also the vehicle of Brahma.

96 Banteay Srei, Siem Reap. 967–69.
The excellent state of preservation of the rosy sandstone of this small temple after its complete anastylosis in 1933–36 makes it one of the jewels of Khmer architecture. Built by the high dignitary Yajñavaraha, a guru of King Jayavarman V, it is one of the rare temples not built by a monarch.

of Rajendravarman's son, who was to succeed as Jayavarman V in 968. Rajendravarman lived long enough to consecrate a temple in the old city of Ishvarapura, about 20 kilometres (12½ miles) north of Yashodharapura, that had been built through the donations of the guru's family. He did not survive to see its completion, which occurred at the very beginning of Jayavarman V's reign. Better known by its modern name, Banteay Srei (the citadel of women), this small temple is considered one of the gems of Khmer art [96]. The unusually hard quality of its rosy sandstone has aided the preservation of the carving, among the most sumptuous and detailed in existence. The profusion of foliate and floral motifs that adorn its surfaces is almost baroque.

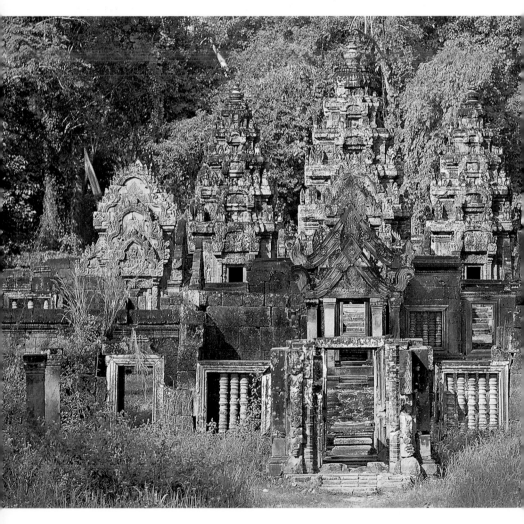

A cruciform gopura leads to a path bordered by small marker stones and once flanked by narrow buildings that have mostly disappeared, save for some transverse structures half way down the path. The temple proper has three enclosures, the outer bordered by a wall and a moat and measuring only 90 by 110 metres (295 by 360 feet), the second and third by walls only. The east cruciform gopura of the outer enclosure had remarkable pediments, one of which is now in the Musée Guimet, that set the pattern for the lavish and intricate sculpture on lintels and pediments, much of it narrative and all filled with dynamic exuberance. Many of the elements are still intimately linked with wood carving techniques, particularly the gables of the gopuras with their ends upswept as in some of Koh Ker's temples, and Khmer craftsmen were evidently undaunted by the technical challenge of applying to stone, without making stylistic concessions, details easy to shape in wood. The reliefs display with great ecumenical breadth many of the deities of both Vaishnavite and Shaivite stories and illustrate with remarkable fidelity some of the episodes of the Ramayana and the Mahabharata [97, 98]. The frames of the pediments are encrusted with intricately entwined vegetal and personage elements in a *horror vacui* density that echoes the crowded nature of the inner enclosure where the bases of the buildings almost touch each other. The iconic stillness that characterizes Khmer statuary is replaced by an uninhibited exuberance.

Among the most distinctive elements in Banteay Srei are the devata guardians in niches flanking the doors and false doors whose pervasive presence explains the temple's name [99]. Their supple grace, spirituality combined with sensuousness, and the lissom fabric of their sarongs are archaizing echoes of the fluidity of pre-Angkor sculpture. The male deva guardians exhibit the slender torso and hip-swayed stance that similarly recall the art of Sambor Prei Kuk. This detailed perfection along with the intricacy of the deep relief of the architectural decoration defines the Banteay Srei style.

While the relief carving determines the style of this unique structure, the free-standing sculpture enshrined there is more properly described as resembling the works of Pre Rup. The approach to the central sanctuary was formerly guarded by a series of half-animal, half-human figures whose smooth torsos and precisely sculpted heads are reminiscent of the Varuna [93]. Human torsos with heads of monkeys, Yaksha (demons), and lions, and with the beaked heads, wings, leg feathers and claws of Garuda [101] were deployed all round the central shrine on high carved socles.

97 Banteay Srei. Pediment with Shiva, Mt. Kailasha.
The intricate carving of the pediment from the east facade of the south library depicts the evil giant Ravana trying to shake Mount Kailasha, home of Shiva. His attempts are thwarted by Shiva, who needs only to extend his foot to counter the force of Ravana and steady the mountain.

98 Banteay Srei. Pediment. Sandstone, 1.96 x 2.42 m (77 x 95 in).
The intricacy and dynamic rhythm of the sculpture of the pediments and lintels of Banteay Srei are well illustrated in this depiction of an episode from the *Mahabharata*. Bhima, one of the five Pandava brothers, leaps in the air to strike Duryodhana, one of the hundred Kaurava brothers who are their enemies. Bhima's four brothers look on, as do Krishna and his brother Balarama (both avatars of Vishnu).

99 Banteay Srei. Devata.
The fluid lines, precise carving and charming grace of this guardian deity are repeated throughout the temple and may explain its name, which means 'citadel of women'.

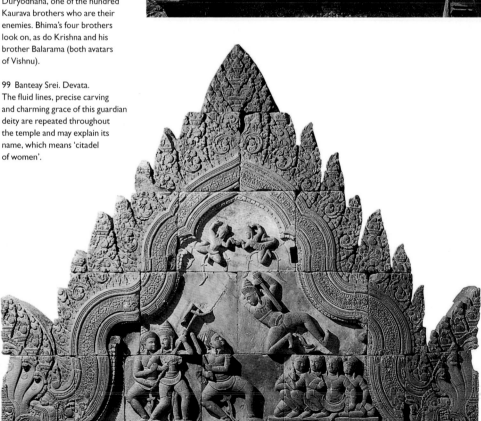

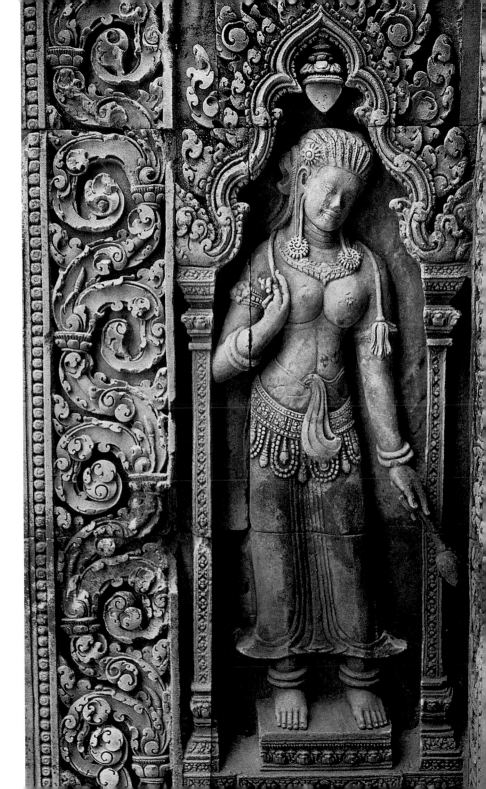

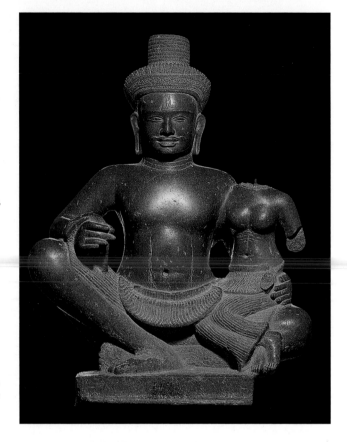

100 Umamaheshvara. Banteay Srei, gopura I west, 967. Sandstone, 0.655 m.
This touching figure of Shiva with Uma, his spouse, or shakti, on his lap, was found in gopura I west of Banteay Srei. Shiva holds a lotus in his right hand. Uma's head was stolen during the 1970s.

101 Guardian figure, Garuda. Banteay Srei, 967. Sandstone, 0.83 m (32⅝ in).
This is one of a series of half-human figures, some, like this example, paired with a half-Garuda form, others half-lion, half-monkey, or with heads of Yaksha, or giants, that were deployed around the central sanctuary of Banteay Srei as guardians. The few remaining original figures have been removed from the temple to prevent looting and destruction.

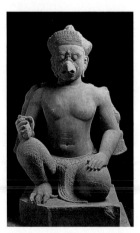

Pilfering and vandalism was so rife that the remaining original sculptures were removed for safe keeping in the late twentieth century and replaced by cement replicas. These in turn have fallen prey to looters. The central sanctuary yielded an exceptionally beautiful sculpture of Shiva with Uma on his lap [100] that also conforms to the morphology of Pre Rup. Sometimes even the protection of museums is inadequate to thwart the greed of thieves: the head of Uma, whose small hand tenderly placed on Shiva's back is one of the most appealing gestures in Khmer art, was cut off by a visitor to the National Museum in the 1970s.

Jayavarman V's reign was unusually long (968–1000/1), and since he inherited the kingship at a young age it is not surprising that senior advisers like Yajñavaraha played a prominent role in his realm. Inscriptions mention foundations established by officials to a far greater extent than in previous periods. The era seems to have been relatively stable, the Chams apparently subdued for the

moment. Jayavarman did not construct a temple mountain but perhaps laid the foundations for the royal palace on the site it continued to occupy during the height of the Angkorian period. There is even a possibility that this site might already have been the location of the palace in Rajendravarman's reign. The royal temple within the palace grounds, the Phimeanakas, was perhaps also begun during Jayavarman's reign.

One temple built early in Jayavarman V's reign illustrates in considerable detail the establishment and workings of religious foundations. This is Prasat Preah Einkosei, founded in 968 and situated near the Siem Reap river in the modern town of Siem Reap. It comprises two red brick prasats, the southern one larger than the northern, which is set back, slightly further west, in a relationship suggesting that there might have been a third prasat on the north side of the main sanctuary to balance the composition, as at Bat Chum. Both sanctuaries are square, with doors on the east and false door on the other facades, and intricately carved lintels with predominantly Vishnu themes. One depicts the legend of the Churning of the Ocean of Milk by the devas and asuras (gods and giants) to obtain amirta, the elixir of life, using the body of the naga Vasuki as the rope and Mount Mandara as the fulcrum [102]. Below is a decapitated figure of Indra on the elephant Airvata. Since only half the serpent is represented (the portion showing the devas), one can speculate that the other portion might have been represented on the missing lintel of the smaller temple. Both structures have three receding false storeys, the larger being crowned with a pyramidal element, the smaller with an elongated lotus bud, perhaps in reference to the god and

102 Preah Einkosei, 10th cent. Lintel, Churning of the Ocean of Milk.
The lintel depicts the popular Hindu legend of the Churning of the Ocean of Milk to obtain amirta, the water of eternal life. Below, Indra, king of the gods, rides his mount, the three-headed elephant Airvata.

goddess who are cited in the inscriptions, Vishnu and Bhagavati. As at Bat Chum, there is a hint of Cham influence in the proportions of the projecting cornices below the superstructure. Two inscriptions in Khmer are incised on the piers of the main sanctuary (K262), and a stele was also found that has both Sanskrit and Khmer inscriptions (K263). The information contained in these offers some evidence that two may, in fact, have been the original total of the sanctuaries, since dedications to two deities only are specified.

The information is partly repeated and partly differs, but the inscriptions complement each other to give a more detailed account. The older of the pier inscriptions, on the north pier, is dated with a Shaka calendar number that equates to 968 CE. The south pier mentions 983 so must have been incised at least fifteen years later. The stele must be dated to 984 at the earliest. We learn that the foundation was called Dvijendrapura (the old name for Preah Einkosei) and was established at the king's direction by an Indian-born Brahman called Divakarabhatta, who was married to Princess Indralakshmi, a daughter of Rajendravarman and therefore a sister of the current king, Jayavarman V. At the same time, Divakarabhatta founded another establishment at Prasat Komphus, to the north near Koh Ker, with which it shared revenues. The temples were associated with seminaries, which controlled the organization and managed the revenues. The older inscription gives a fascinating insight into the possessions of a temple. Referring to the image of Vishnu to which the sanctuary was dedicated, it lists gold adornments for the statue. The items include the attributes. The second dedication is to Bhagavati, divine equivalent of the dead mother of Indralakshmi, whose attributes are also listed, along with her jewellery. This confirms the theory that many cult idols were adorned with precious accessories during rituals. There is also mention of a palanquin with four garudas given by the king, and of one hundred and seventy-one slaves. (The term 'slaves' is open to interpretation: there is no suggestion that these are captives.)

Amplification is provided by the later texts, which provide genealogical information about the donor and the monarchs. We learn the name, size and location of lands allocated for the temple's support as well as their donors; in one case the territory was a royal gift and adjoined royal land. These lands are for the exclusive use of the people of Vidyashrama (the seminary) who live at Dvijendrapura. We also learn more detail about the precious objects, which include crowns, ear pendants,

breastplates, arm and leg bands, necklaces and rings, many with gems, as well as ritual equipment: ablution vessels, patulas, vases, water containers, and in addition seals, spittoons and mirrors. Cloth for garments is also mentioned. There is no guide to what these objects looked like apart from the details of stone carving; what remained of precious metal has been looted, sometimes in former eras but unfortunately also recently, so that Cambodia's heritage of ancient gold and silver ornaments has completely disappeared, apart from the legacy of the post-Angkorian period that is preserved in the collection of the Silver Pagoda in the Royal Palace of Phnom Penh.

Considerable space in the stele is devoted to the procedures of a land dispute, giving an insight into how such problems were resolved. An enquiry by dignitaries investigated the uprooting of boundary markers from the edge of one of the foundation's territories. Those responsible claimed that the lands allocated in the gift were mistakenly marked, but the panel affirms the limits of the territory and orders the replacement of the markers. The text also mentions the distinction between riverine rice fields and dry rice fields, and declares that the former are for the exclusive use of the guardians of flocks. We are therefore informed about some aspects of social organization and the management of temples and agriculture that are not available from purely royal foundations.

The proliferation of non-royal foundations (albeit many of them are connected in some way to royal relatives) attests the growing complexity of Khmer society and also the increasing resources of wealth, organizational ability and advice that were available for the ruler in the consolidation of power and stability, the resistance to attack from outside, and the possibility of expanded territory.

Towards the end of Jayavarman V's reign the rich variety of architectural and sculptural styles that had been generated in the tenth century began to taper off. There are many gaps in our understanding of the last years of the century, and Jayavarman's successor was confronted by one of the most pervasive dynastic upheavals in Khmer history, a confused period that lasted a decade, before the rulers of the eleventh century ushered in a dramatic expansion of Khmer hegemony.

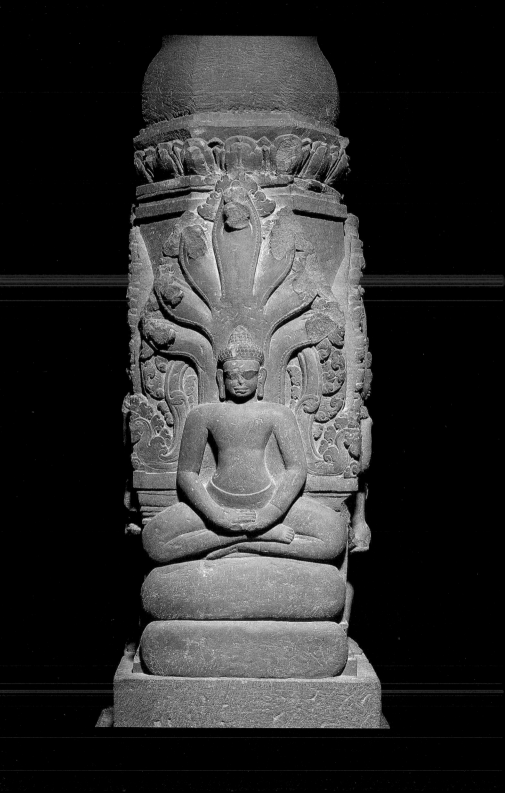

Chapter 5 The Sun King and the Baphuon: the eleventh century and the expansion of empire

The end of a day, a lunar month, a season, or a year, are divisions marking the ineluctable rhythms of our universe. The end of a century, or of a millennium, is an arbitrary cæsura where the human need to categorize imposes a desire for definition and tidy endings. So there is no reason to interpret the lack of orderly progress from the apparent stability of Jayavaman V's Cambodia at the beginning of the eleventh century as an inevitable changing of the old order. In any case, the Khmer calendar was based on the Indian-derived Shaka system (seventy-eight years earlier than our reckoning), so our imposition of time frames is relevant only as an aid to our understanding of change. The lull in grand building projects and the less assertive sculptural production that characterised the last decade of Jayavarman's reign could signify stability, but it could also be interpreted as presaging stagnation.

The style that emerged, with no particular beginning or end, derives its name from two structures built to the east of the Royal Palace in Yashodharapura in the late tenth or early eleventh century, the Khleang (Khmer for 'emporium'). Some scholars have suggested that they might have been treasury buildings of some kind, and possibly secular. The only stone structures that can be interpreted as secular are the walls and terraces of the royal palace, and later of Angkor Thom (and even these have a sacred connection, in that the life of the monarch was closely identified with his protecting deity), so it is highly unlikely that the Khleang were secular. Some have speculated that they were connected with visiting dignitaries. The north building, more than 40 metres (130 feet) in length, is older and more finely finished, its seven-balustered window screens in a fine state of preservation. It attests, with its meticulously carved lintels, that sculptural skills

103 Chaitya. Kbal Sre, Banteay Meanchey, late 10th cent. Sandstone, 2.30 m (90½ in). This is one of the earliest known Khmer examples of a chaitya ('sanctuary'), placed at the four cardinal points of the compass to define the boundaries of Buddhistic sanctuaries. Its four faces present images to aid in the Mahayana quest for enlightenment: the Buddha himself, protected by the naga; Vajrin, the multi-headed deity representing the Tantric path; Prajñaparamita, goddess of transcendental wisdom; and Lokeshvara, bodhisattva of compassion. The unadorned top represents a stupa. It is in the style of the Khleang.

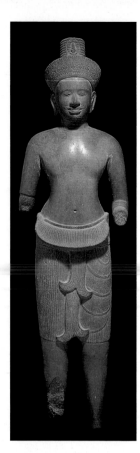

were well maintained in the last decade of the tenth century, the likely date of its construction. There is no trace of corbelling in this long rectangular building, the roof almost certainly having been of tiles supported by wooden beams and rafters.

The perfection of the carving has a somewhat dry quality that also infuses many of the works in the round designated as being in Khleang style, such as a Shiva image of unknown provenance [104] where the fine detailing retains something of the refinement of the Pre Rup style, including the persistence of the finely pleated garment with large front flap. There is at the same time a certain slenderness and naturalness of anatomy that is predictive of the Baphuon style that would emerge later in the eleventh century. The same qualities are embodied in an imposing statue of Brahma [105], which, like the Shiva statue, has a heightened hieratic presence and, despite the beautiful patina, a similarly rather blank expression.

Applying the criteria of Khleang style to an imposing chaitya, one of the earliest known Khmer Buddhist sanctuary markers [103], is not unreasonable, since the level of technical skill and iconic expression of Khleang works is compatible with the definition, and they share a certain reductive quality. But there are elusive fine points of difference, and attributing works to this style seems somewhat arbitrary, including as it also does disparate architectural works that are linked more by their roughly contemporary creation than any inherent similarity (see below). The chaitya, crowned by a stupa, is an interesting affirmation of the renewed importance of Buddhism in the late tenth century, and in addition establishes the presence at that time of Tantric Buddhism, for which such monuments, sanctuaries in miniature, aided the pursuit of meditation. This was effected through the invocation of the powers of Prajñaparamita, Avalokiteshvara, Hevajra and the Buddha himself, all of whom are represented on the faces. A monolith of impressive proportions and refined facture sculpted from a reddish sandstone, its costume details abandon the pleated flap of the tenth century and anticipate the scooped line of the garment at the waist that would dominate the eleventh century in the Baphuon style.

The dating of the buildings of the royal palace in Angkor, including its ritual pools, walls, gopuras and the temple mountain of Phimeanakas [106], is uncertain, as is that of the great temple mountain of Ta Keo [107]. With any sacred monument there is always the likelihood that the site chosen already had religious associations and that the stone structure was a translation into

104 Shiva. Unknown provenance. Khleang style, late 10th–early 11th cent. Sandstone, 1.07 m (42⅛ in). The finely carved pleated sampot with flap, the conical crown and jewelled diadem relate to the earlier Pre Rup style, while the smooth naturalism of the anatomy and the complex treatment of the pleats at the back of the garment anticipate Baphuon style.

105 Brahma. Phnom Prasat Reach, Mongkol Borei, late 10th cent. Sandstone, 1.10 m (43¼ in). Free-standing sculptures of Brahma, whose four heads gaze in all four cardinal directions, are relatively rare in Khmer art. This image demonstrates a transition between the hieratic perfection of the Pre Rup style and the naturalism of the Baphuon style.

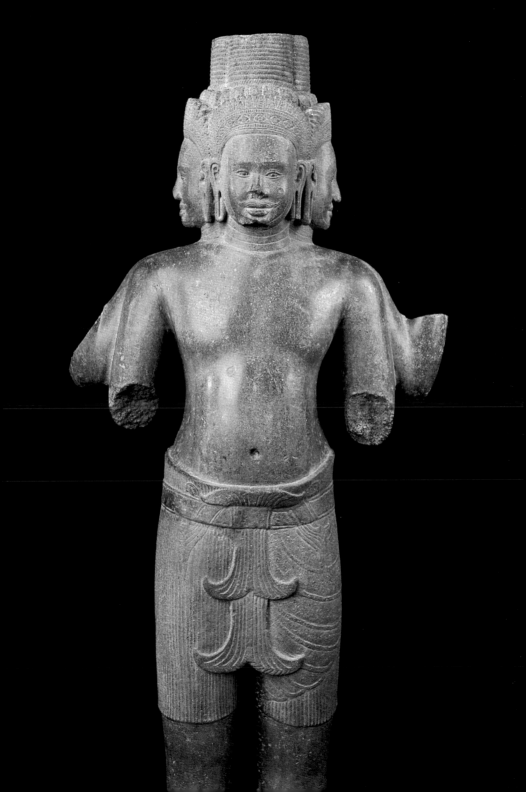

permanent materials of an existing building. Such a practice continued in Cambodia well into the era of Theravada Buddhism, when Buddhist structures were added on to existing Brahmanistic temples, and was certainly similar to the practice followed during the construction of mediæval cathedrals in Europe. As the lines of succession from Jayavarman V to Udayadityavarman I, who is mentioned in inscriptions in 1001 and 1002 but not again, and then to Jayaviravarman (1002–10) and the simultaneous claims to the throne of Suryavarman I (1002 or 1010–49) are blurred, it is difficult to attribute the monuments of the last years of the tenth century and the early years of the next to a specific king. This is even more difficult in light of the relatively short reigns of Udayadityavarman and Jayaviravarman, since buildings like these take several years to complete.

It is sometimes asserted that both Phimeanakas and Ta Keo can be categorized as Khleang in style. It is true that the treatment of the bay balusters and the severe moulding of the profiles of the foundations of both are reminiscent of the North Khleang, as is the sober detailing of colonettes, piers and pilasters. Indeed, the massive smooth surfaces of Ta Keo – one meaning of its name is 'crystal tower' – and the restrained simplicity of the stonework impart a classical severity to this temple that is unique in Khmer architecture. The tailoring of the massive blocks of laterite and sandstone is unusually precise and the ordering of the courses far more even than is typical for Khmer architecture. However, since it is clear that the initiating monarch, possibly Jayavarman V, but perhaps Jayaviravarman, did not complete the monument, the possibility emerges that the minimalism is simply the result of incompleteness. Another meaning of its name is 'Ancestor Keo'; the name, like most Khmer names for temples, is a later appellation and should not imply an ancestor temple designation.

The resemblances between Ta Keo and Phimeanakas are balanced by profound differences, most notably the discrepancy in sizes. Ta Keo, a five-level pyramid [74], measures 100 by 110 metres (328 by 360 feet) at its lowest level and reaches a height at the top level of 22 metres (72 feet); it would have been higher when the missing superstructure of the central sanctuary was included. The three terraces of Phimeanakas (which translates as 'aerial palace') ascend from a base of only 35 metres (115 feet) east–west and 28 metres (92 feet) north–south to the remains of a single sanctuary, rising from the top platform in two stages, to achieve a height of 12 metres (39 feet) in all [107]. The stairs are flanked by lions, with elephants guarding the corners at the top level. The sanctuary is

placed at the intersection of the north–south axis of Bakheng and the east–west axis of East Mebon; from later sitings it is clear that cosmological directions were important for the Khmer.

Ta Keo is in quincunx plan, Phimeanakas single-towered, with a cruciform sanctuary. That said, it is interesting to note that both have narrow galleries surrounding one level completely (the second at Ta Keo, the third at Phimeanakas) that are too shallow and low to have served the circumambulation purpose of the later examples at Angkor Wat and Bayon. The exterior wall of the galleries at Ta Keo (and some at Phimeanakas) are blind, with balusters suggesting the presence of windows, and open only to the interior. It is a curious fact that no entrance was provided to the gallery space at Ta Keo. Collapse of some parts makes entry possible today, but as the sill of the bays was originally very high, entering this space was clearly not intended. Both temples give a greater impression of height than their actual dimensions justify, explicable by the increased steepness of the mass resulting from exceptionally narrow platforms on some terraces. Ta Keo's third and fourth levels are almost too narrow to walk along, for example, and the same is true for the first and second levels of the smaller pyramid. The ascent is punishingly steep in both cases, exacerbated at Phimeanakas by a shallowness of treads that necessitates a sideways climb and at Ta Keo by the sheer height of the risers, which ranges from 40 to 30 centimetres in a single breathtaking flight. The powerful looming of the quincunx towers of Ta Keo is amplified by the close proximity of their bases. These corner towers are relatively important vis-à-vis the central tower: the corner towers have bases of 3.5 metres (11½ feet) and the central tower, raised on a high plinth, has both base and height measuring 4 metres (13 feet). All five have portals open at all cardinal points.

Phimeanakas lies within the precincts of the royal palace, a site that seems to have filled that function during many reigns. Most traces of residential structures are limited to vestiges of brick and tile with occasional wood fragments, and it is not known from which period the huge pools within the grounds date, though they were probably constructed later. They are walled by laterite, the larger measuring 125 metres (410 feet) in length and having thirteen steps leading to its paved bottom 5 metres (16 feet) down. Its walls are charmingly carved with fish and sea monsters, suggesting that it was a symbolic cosmic ocean at the foot of the cosmic mountain, represented by the pyramid of Phineanakas. The ground levels within the compound, which occupies 15 hectares

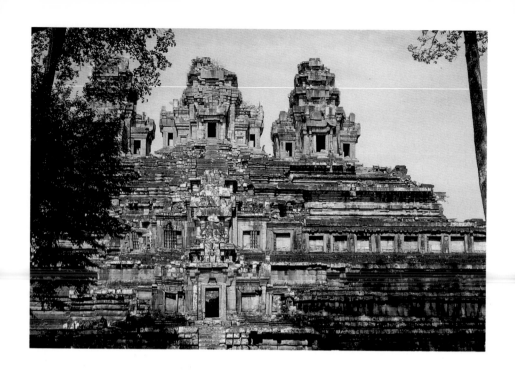

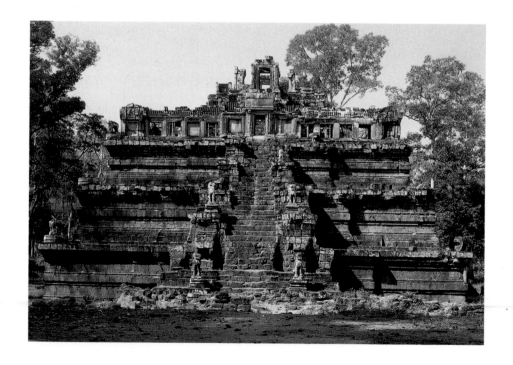

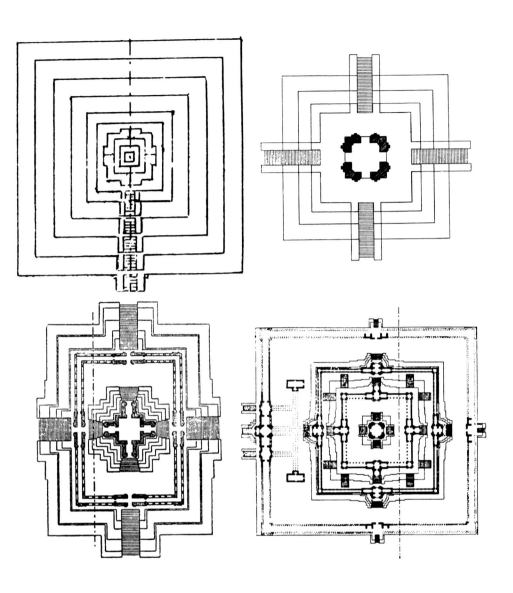

106 Phimeanakas, Siem Reap, late 10th–early 11th cent.
This temple mountain was built inside the royal palace
grounds, perhaps begun by Jayavarman V (968–1000/1) but
certainly modified by Suryavarman I (1002/10–49), who
was responsible for the elaborate gopuras (ill. 109, p. 117).

107 Ta Keo, Siem Reap, c. 1002–10.
Begun by Jayavarman V but not completed by his death
around 1000 CE, Ta Keo is exceptionally steep and
imposing. Its name means 'Ancestor Keo' or, as Prasat
Ta Keo, 'tower of crystal' (see plan in ill. 74, p. 80).

108 (clockwise from top left) Phimeanakas,
Baphuon, Baksei Chamkrong and Prasat Thom. Plan.
The single-towered pyramid was a royal chapel.
According to the Chinese envoy Zhou Daguan, who
visited Angkor in 1296–97, every evening the king
was obliged to ascend the temple and couple with
a nagini, feminine embodiment of the serpent king,
to ensure the prosperity of the realm.

(37 acres), have varied at different periods for no known reason. Whether Phimeanakas was ever a state temple is also unknown, but from the eleventh century it seems clear that it was a royal chapel. A potent myth that emphasizes the importance of the naga in Cambodian history is associated with it, and was reported by Zhou Daguan in the account of his late thirteenth-century visit. Every night, according to the legend, the soul of the nine-headed naga, the lord of the earth, takes on the form of a woman who waits on the summit of the temple for the king. He must visit her and couple with her every night before retiring with his wives and concubines, or misfortune will befall the kingdom. Should the naga princess fail to appear, the death of the king will follow. It is possible that Phimeanakas is the 'Hemasringagiri' (Mountain of the golden horn) alluded to by Zhou Daguan. From references like this it is clear that many of the temples were decorated, not only with stucco, but with painted and gilded surfaces. It is also possible that the upper constructions of some of the central sanctuaries were made of wood, which could have been gilded, or of precious metals.

The puzzle of the simultaneous claims to the throne by Jayaviravarman and Suryavarman I is not solved, but it seems clear that the former inherited the title from his predecessor, though his genealogy depends on the legendary ancestors Kaundinya and Soma rather than any precise quotations of historical figures. Suryavarman gradually moved into the capital region from further east, perhaps from the region of the ancient capital of Sambhupura, his genealogy too having a somewhat tenuous connection to the royal line, as a descendant of the maternal line of Indravarman. By 1010 he seems to have been triumphant, as references to Jayaviravarman cease. Perhaps his security was not altogether certain, however, since the royal compound was protected by towering walls during his reign, the first such structure initiated by a Khmer monarch. These walls, 5 metres (16 feet) high, are pierced by two gopuras on both north and south walls and one very important gopura on the east [109]. The multiple wings of this ceremonial entrance and its elaborate tower, like the other four gopuras, conform in style with the sober elegance of Phimeanakas and Ta Keo. Meticulously carved lintels and delicate cornice carvings on the interior as well as the precise structure of its corbelled roof render it the quintessential example of the best of Khleang style. The persistence in these structures of this style from an earlier reign makes it abundantly clear that stylistic expressions transcend political boundaries.

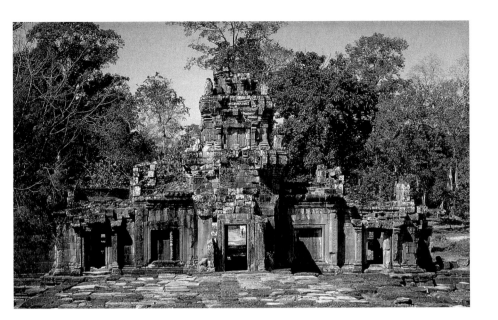

109 Royal palace, Angkor Thom, gopura, first half 11th cent. Suryavarman I, consolidating the Khmer realm after years of turbulence, built the elaborate gates and walls of the royal palace as well as modifying Phimeanakas. The palace compound has bathing pools and traces of the foundations of structures that were presumably built from impermanent materials such as wood.

The royal palace gopura gives important information about Suryavarman I in a long inscription in Khmer dated 933 Shaka (1011 CE) comprising an oath of loyalty to the king. The signatories listed, more than four thousand of them, swear, with the cutting of hands, to offer their lives to the sovereign, who, the text significantly asserts, has been 'in complete enjoyment of sovereignty' since 1002 CE; this was presumably to establish that the reign of Suryavarman's rival, Jayaviravarman, was not legitimate. They pledge not to revere any other king, to fight and risk their lives in the king's wars, and that those who evade the obligation will be reborn 'in the thirty-second hell as long as the sun and moon shall last' in 'this world and the next'. If their oath is fulfilled, they anticipate from the king the maintenance of their holy foundations and the sustenance of their families. This oath was found in several locations, indicating the spreading of Suryavarman's territory.

Suryavarman, whose name means 'Protected by the Sun' (Surya is the Brahmanistic god of the sun), was an outsider. His choice of dynastic name perhaps implies a strong elemental focus, more rooted in cosmological forces and autochthonous beliefs and less in the specific powers of the gods of the trimurti, usually Shiva but sometimes Vishnu, that were incorporated into other monarchs' names. In the traditional Khmer affirmation of power, he might have been expected to build a temple mountain as

affirmation of his status, as Jayavarman IV had done at Koh Ker, or even the more credibly descended Rajendravarman had done with both East Mebon and Pre Rup. Though Yashovarman had impeccable credentials, he too had asserted his dominance in the beginning of the tenth century with the temple mountain on Phnom Bakheng. Yet Suryavarman, with one of the longest reigns in Khmer history, built no grandiose temple mountain in the Khmer capital. It may be that his decision not to do so sprang from an ability to comprehend the wider scene and to see that empire depended less on extravagant architecture at court and more on prudent attention to the components of his kingdom. There are many references in inscriptions to a multitude of officials, many of whom had public responsibilities and private foundations and presumably a stake in the maintenance of stability. This argues for a growing complexity of administration and society. There are also inscriptions that reveal promotion of new families and the undermining of the authority of some of the old, including the descendants of Shivakaivalya, the hereditary protectors of the devaraja. One decision, to remove the chief priest from the cult by marrying him to the queen's sister, may have been particularly adroit, making it possible for the king to install his own choice to fulfil the ritual function that lay at the heart of royal legitimacy while avoiding offence. On the other hand, it may simply reflect appreciation of a special ability. On removing Sadashiva from his religious position, and renaming him Jayendrapandita, Suryavarman put him in charge of all construction and public works. Considering the excellence of architecture in the sun king's reign, this might have been an informed decision.

Suryavarman extended the boundaries of the Khmer territory as far as the former Dvaravati lands in Thailand: Louvo, now known as Lopburi. He also established lingas of gold at the outposts of his realm, those at the four cardinal extremities being called Suryameshvara, and it was at these places that he promoted important architectural projects, often choosing a hilltop and sometimes expanding an existing religious foundation. In the west he built Wat Ek (1027), which housed the western Suryameshvara linga, as well as Wat Baset (1036) near Battambang, for example. To the northeast he instituted the beginnings of the large establishment of Preah Khan of Kompong Svay, a vast quadruple enclosure of more than 4 kilometres (2½ miles) per side. The eastern Suryameshvara was established at Ishanathirtha, probably on the Mekong near Sambhupura. Two of the period's most spectacular temples were established at the northern and

110 Preah Vihear, first half 11th cent.
Although Suryavarman I did not construct a state temple mountain, he marked the farthest borders of his kingdom by monumental temples. Preah Vihear lies on a promontory of the steep escarpment of the Dangrek range to the north of Cambodia that forms the present-day border with Thailand.

111 Preah Vihear, plan and elevation.
The huge complex, facing north because of site restrictions, ascends the steep slope leading to the sheer drop at the edge of the Dangrek escarpment by a series of staircases linking terraces, gopuras and temples.

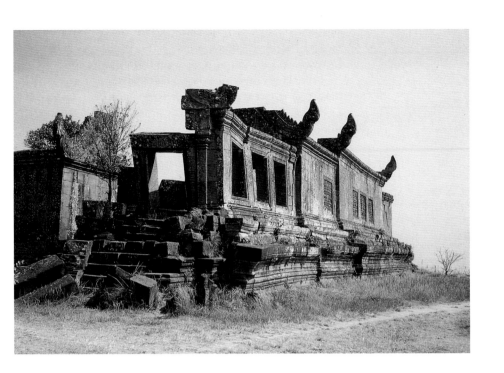

0 50 100 150 200 m.

N

southern limits of his empire, Preah Vihear on the escarpment of the Dangrek range that now forms the Thai–Cambodian border, and Phnom Chisor near the ancient capital of Angkor Borei.

Prasat Preah Vihear, meaning sacred temple or monastery [110], occupies one of the most spectacular natural sites of any religious monument. Not surprisingly, the narrow promontory rising steeply to the escarpment that drops sharply to the plain 547 metres (1795 feet) below was the site of sacred establishments from the earliest days, perhaps as far back in Khmer history as the eighth century. It continued to attract royal attention until the thirteenth century, but it seems that its present state is substantially the work of Suryavarman I's reign. Originally access to the site required an arduous climb from the plain below on steps carved from the solid rock, an ascent that would have conferred merit on the pilgrim, but today it is approached from the north where a small stream separates Thailand from Cambodia. It has been the subject of dispute between the two countries since the beginning of the twentieth century, when France, as protecting power for Cambodia, negotiated the return of territory controlled by the Thai for many centuries. After a bitter case at the International Court of Justice, it was confirmed as Cambodian territory in 1962. Between 1975 and 1998 the area was inaccessible because of Khmer Rouge hostilities and landmines, and although the temple is now open to visitors, from time to time political squabbles still cut it off from the Thai side.

The linear configuration of the temple is dictated by the terrain [111]. The contemplative and merit-gaining circumambulation of pyramidal temples like Bakong and Bakheng, microcosms of Mount Meru, is replaced by a literal ascent that extends for almost a kilometre (½ mile) up the steep slope of the promontory from south to north. The climb begins with almost two hundred steps leading to the lowest gopura [110], a redented cruciform structure with the mountain-shaped pediments characteristic of the temple and reminiscent of the gopuras of Banteay Srei. The peak of the arch is quite acute and is bounded on the lower edges by scrolled terminals with flame-like projections, a lozenge set below the peak in a pattern that is repeated throughout the monument. The gopura (the outer, or fifth gate) opens on the south to an ascending causeway, flanked by a naga balustrade and boundary pillars, that leads to the next gopura. Another causeway continues up the hill to the third gopura, the longest and best preserved, that is flanked by several large galleries.

A third naga balustrade terminates at the fourth-level gopura (gopura II) which opens to a courtyard and where inscriptions from Suryavarman I are to be found, confirming that the northern Suryameshvara linga was established here. The courtyard contains a complex of seven buildings, including a colonnaded hall of 9 by 13 metres (29 by 42 feet) and two so-called libraries, which open to the central axis. The final level comprises a cruciform mandapa and collapsed central sanctuary tower surrounded by a court flanked by corbelled galleries. In the manner of Ta Keo, these are open to the sanctuary, have high sills and no entrance doors (although there are two doors opening to the exterior of the temple, a unique occurrence). They are just high and wide enough to walk through, so a step closer to the evolution of Angkor Wat's generous galleries. The final gopura is at the northern extremity of the temple, and is blind, so that the prospect of the plunging escarpment is not visible.

There has been extensive collapse and erosion, but many of the details of garlanded cornices, foliate-edged pediment borders, and lintels where kala heads spit out thick swathes of vegetation, indicate the refinement of sculpture in the Khleang manner. Several of the lintels and pediments also depict narrative scenes drawn from the *Mahabharata* and *Ramayana* and from Hindu mythology, particularly a fine relief of the Churning of the Ocean of Milk. There are several reliefs where Krishna struggles with adversaries; the serpent Kaliya, the mad elephant Kuvalayapida and the horse Kesin, also Krishna raising Mount Govardhana. Further Vaishnavite reliefs include Vishnu on Garuda, Vishnu Anantashayin and Rama on his return to Ayodhya. In spite of the predominance of images of avatars of Vishnu, the temple was dedicated to Shiva, in the form of Shikhareshvara, lord of the summit, and there are depictions of Shiva with Uma on Nandin (Umamaheshvara).

Phnom Chisor in the south of Suryavarman's territory is also situated on an escarpment of a hill of 120 metres (395 feet). The Khmer word 'Chisor' is the equivalent of the Sanskrit Surya, sun. The temple was originally known as Suryadri or Suryaparvata, mountain of the sun, which is an exact translation of Phnom Chisor and a direct affirmation of Suryavarman's southern manifestation of power; it is the place where the southern Suryameshvara linga was installed. An inscription of 1029 CE on one of the libraries records an offering of slaves by the king to the religious foundation. As at Preah Vihear, the relief carvings of lintels and pediments are predominantly Vaishnavite. The central

complex, with a redented sanctuary, is surrounded by open galleries, on a much larger scale than ever before [112]. The projecting porch on the east face overlooks the plain below, where the approach causeway of more than 200 metres (656 feet) is flanked by cruciform buildings at the foot of the cliff and at mid-point and terminates in a large pond, affirming that the approach to the temple was from the lower ground and involved a steep climb.

Suryavarman did not neglect the heartland of the original Angkor on Mount Kulen. Among the most spectacular sculptures ever conceived exploiting a natural site to miraculous effect were created about the middle of the eleventh century in the bed and on the banks of the Stung Rusei, a tributary of the Siem Reap river [113]. An inscription of 1054 describes how a minister of Suryavarman I ordered the decoration of the site, so the project must have been conceived during his reign, although most of it was probably executed during the reign of his successor. Another inscription, of 1059, attests the installation of a linga by Udayadityavarman II. There are, in various numbers and formations, hundreds of lingas (the river is sometimes known as the river of the thousand lingas) which sanctify the water flowing over them. This water eventually flows to many of the temples of the Angkor region, a living connection between the symbolic cosmic mountain, home of the gods, and the sanctuaries where they are worshipped. The presence of Vishnu is also important, and there are many carvings of Vishnu Anantashayin (Vishnu in cosmic sleep on the back of the serpent Ananta at the end of one of the cycles of existence, where Brahma is shown in a lotus rising from Vishnu's navel to recreate the world). There are also isolated

113 Kbal Spean, Siem Reap, 11th cent. Relief, reclining Vishnu. The water of a tributary of the Siem Reap River flows over hundreds of lingas and other images carved into the rocky bed and banks of the stream. There are fifteen representations of Vishnu reclining in cosmic sleep. The water, which eventually reaches the reservoirs and temples of Angkor, is sanctified by its course over the lingas.

sculptures such as a standing male figure on the back of a crocodile to which varying legends have been attached by local inhabitants. It was probably at this time also that the huge stone monolithic animals near Prasat Thma Dap, on the east of the Kulen plateau, were carved.

Opinion varies about whether the construction of the huge western baray (8 by 2 kilometres/5 by 1¼ miles) was initiated by Suryavarman, or later. Certainly the management of water was considerably developed during his reign, so it is not unlikely that this was his project. Excavations have revealed many water basins hundreds of metres long flanking the causeways of the capital from this period, with evidence of sophisticated conduits linking them and connecting them as well with temple moats. Such projects are also mentioned in the text of the Sdok Kak Thom inscription of 1052. Instigating a project on the scale of the western baray would furthermore be consistent with the fulfilment of the monarch's obligation to carry out public works, especially considering the visionary outlook of the monarch who occupied the Khmer throne for almost half a century. The style that was named for a monument not built until about 1060, Baphuon [114], has much

114 Baphuon, Siem Reap, c. 1060. The enormous temple mountain built by Udayadityavarman II (1050–66) lends its name to the style dominating most of the 11th century. It is currently undergoing complete anastylosis (see plan in ill. 108, p. 115).

earlier origins, evolving gradually from the cool perfection of the early Khleang to the supple and graceful expressions of the style that dominated most of the century, including the time of Suryavarman I.

There have been suggestions that Suryavarman I forged alliances with China and with Champa, in particular to oppose the Dai Viet in northern Vietnam, but the evidence for this is tentative. What seems certain is the relatively peaceful nature of his reign, a stability reflected in the extension and consolidation of Khmer territory. The date of his death is not certain, but he disappeared from the records in 1049; his posthumous name was Paramanirvanapada. His successor, Udayadityavarman II (1050–66) was not a blood descendant but a relative of Viralakshmi, Suryavarman's principal queen. Inscriptions suggest that Udayadityavarman's reign was plagued by uprisings, as dramatic texts describe the triumphant feats of his favoured general, Sangrama, in combat against the king's enemies.

One of Angkor's most ambitious temple mountains, Baphuon, was begun in about 1060 as Udayadityavarmans's state temple. Inscriptions state that the king saw 'a mountain of gold in Jambudvipa, the home of the gods' (was he referring to Phimeanakas, whose uppermost sanctuary was reported by Zhou Daguan to be gold?) and determined to build one in its likeness in his own city. After a triple cruciform gopura, a long causeway (about 200 metres/656 feet) elevated on circular columns leads to

a second cruciform pavilion flanked on the north and south by platforms and ponds. A paved forecourt leads to the base of the pyramid, which measures 100 metres (330 feet) on the north–south axis and 120 metres (395 feet) on the east–west axis, nearly double the dimensions of Pre Rup. Five terraces, surrounded by galleries on all sides on the first, third and fifth levels and broken only by gopuras, lead to the upper platform at a height of 24 metres (79 feet). The central sanctuary was originally cruciform but later modified to a square. The monument is now dismantled. In the 1960s French archaeologists undertook a complete anastylosis, but the process was halted during the long civil disturbances, and resumed only a few years ago, the task complicated by the loss of important documentation. When restored it will appear as one of the most magnificent of Khmer temples, a happy combination of grand design with intricately carved, modestly scaled and highly naturalistic reliefs that define the grace and fluidity of the Baphuon style.

As well as constructing Baphuon, Udayadityavarman built a temple in the middle of the western baray, the West Mebon. Set on an artificial island, it comprised a high and pavilioned wall and rampart around a pond of 100 metres (330 feet) per side. A platform of sandstone stood in the middle of the pond, pierced by a well of 2.7 metres' (8.85 feet) depth that was connected to the water of the baray and was an indicator of the water level. In the ruins of this ingenious construction some fragments of what would have been a 6-metre (20-foot) statue of Vishnu [116] were discovered in 1936. This enormous figure, by far the largest bronze ever cast in Cambodia, is one of the great masterpieces of Khmer art. It depicts Vishnu in cosmic sleep, and despite the missing elements – not only a large portion of the torso, two of the four arms and both legs, but also the inlays of precious metals and stones that would have filled the hollows of the eyebrows, eyes and moustache, and the crown for which the fixing hooks are visible – the figure radiates the serene spirituality implicit in one of the world's most beautiful creation myths. It also epitomizes many of the features that typify Baphuon style, such as a rather round skull, with high forehead and full cheeks, broad shoulders and slender limbs. These characteristics also mark the imposing figure of a standing male divinity from the same period [115]. Visible here is the ubiquitous Baphuon-style low-scooped pleated garment that reveals the navel, and the elaborate belt and panel of a sash that falls in a fishtail at the front and is tied in a spectacular butterfly-like bow at the back.

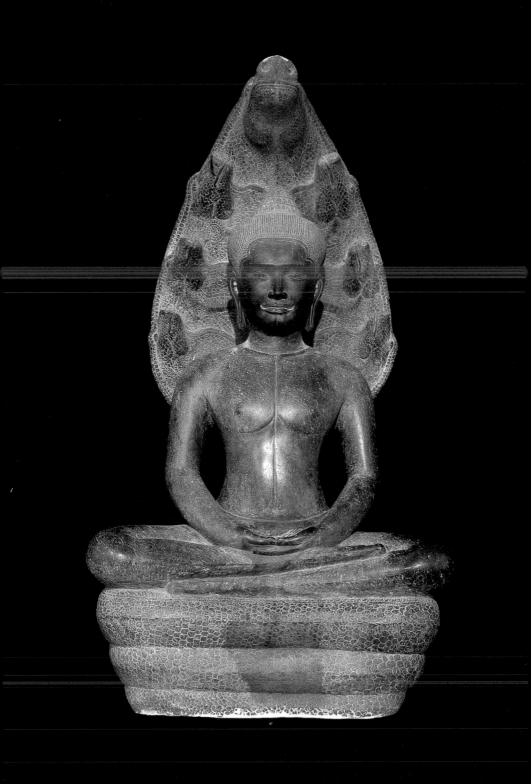

The serenity that suffuses the mien of the great Vishnu also imparts great spirituality to a figure of the Buddha seated on the coils of the naga Muchilinda [117]. Although the Buddha is crowned, by a tiered arrangement of spiral curls behind a tiara, he is naked save for a thin robe that lies gracefully over his body and legs and clings to reveal their naturalistic contours. The details of torso, with mid-abdominal line and pectoral muscles clearly indicated, and the benign gaze of the noble and gentle face contribute to one of the great works in the Khmer canon. Completely different in mood, being infused with dynamism, is a bronze image of the Tantric deity Hevajra that is probably contemporary [119]. This god is the chief entity in the pursuit of enlightenment through Tantric rites, his dancing pose signifying the trampling of the four Maras, the four evils that impede enlightenment, seen here beneath his feet, to achieve freedom from the bondage of the material world. Hevajra has eight heads, the upper five of which represent the five Jina, or supreme Buddhas, with Vairochana at the top. The lower three heads signify the triad often represented in bronze sculptures from this period onwards, comprising the Buddha flanked by Avalokiteshvara and Prajñaparamita. His sixteen arms carry the attributes that Tantric texts assign to him, and his four legs (represented by grooves incised into the limb) trample the Maras.

The identity of the graceful kneeling bronze figure [118] whose upturned palms are making an offering is not certain, but the characteristic front-plunging pleated sarong, jewelled belt, elaborate ear pendants and necklace and slender torso and limbs epitomize Baphuon style. Equally typical is the form of a sandstone standing deity, possibly Lakshmi because of her headdress, establishing that the style pervaded stone sculpture as well as bronze [120]. The graceful outward flip of her sarong lends this iconic figure a certain fluidity, an element in the features that distinguish Baphuon dignity from the rigidity of styles like the Bakheng that would reappear in the twelfth century in the style of Angkor Wat. Another feminine deity reveals a similar refinement of carving, particularly in the corded and jewelled fastenings of the belt, and a similar small-breasted, somewhat elongated torso. The elongation is carried even further in a standing male deity, though the more rigid treatment of the legs robs it of grace. An imposing figure of Shiva seated at royal ease (identifiable through his jatamukuta and third eye) [121] illustrates that monumentality can infuse Baphuon figures even though their size remains modest compared with the works of, for instance, Koh Ker or Bakong.

117 Buddha seated on naga. Peam Cheang plantation, Kompong Cham, second half 11th cent. Sandstone, 1.14 m (44⅞ in). The representation of Buddha on the naga was very popular in Cambodia from the Baphuon period onwards. The image invokes the legend of the shelter offered by the naga Muchilinda to the Buddha as he meditated for many days through torrential rain.

118 Kneeling female divinity. Banteay Chakrey, Prey Veng, late 11th cent. Bronze, 0.09 m (3½ in). The frontally dipping pleated garment of this animated figure suggests a Baphuon-period date. Her kneeling posture and outstretched open hands indicate a gesture of offering.

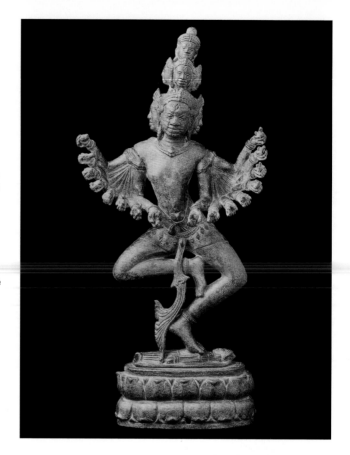

119 Hevajra. Banteay Kdei, Siem Reap, second half 11th cent. Bronze, 0.30 m (12 in).
Hevajra is the most important deity in the pantheon of Tantric Buddhism. His cults offer help in the path to enlightenment through rituals, including dance, and prayer.

120 (opposite, above left) Female divinity. Prasat Trapeang Totung Thngay, Siem Reap, second half 11th cent.
The slender torso, youthful naturalism and graceful curve of the finely pleated skirt epitomise the style of Baphuon. The elaborate jewels of the belt and the artifice of the headdress suggest a divine being, possibly Lakshmi, shakti of Vishnu, but the absence of attributes prevents positive identification.

121 (opposite, above right) Shiva seated at royal ease. Bassak, Svey Rieng, second half 11th cent. Sandstone, 1.48 m (58¼ in).
The proportionately large head is characteristic of Baphuon style figures, as are the delicate lines of the brows and the cleft chin under expressive full lips. The holes in the eyes, including the third in Shiva's forehead, would have been studded with gems.

122 (opposite, below) Stele with Shiva, Uma. Palhal, Battambang, 11th cent. Inscriptions K449 and K1069. Sandstone, 1.06 m (41¾ in; without tenon).
The stele depicts Shiva seated with his shakti, Parvati or Uma, kneeling on his lap. The text, on both sides of the stele, is partly in Sanskrit, partly in Khmer, and reports the erection of a linga in 1069 CE during the reign of Harsavarman III (1066–80). The genealogical details inscribed have provided important cultural information.

The intensely personalized facial features with their delicately arched brows and incised eyelids, curving full lips with curled moustache and neatly modelled nose are all characteristic of the Baphuon morphology, which persisted through several decades.

The costume details and the high rounded forehead of another Shiva, on a stele with an inscription that quotes the date 1069, place that carving in the Baphuon period also [122]. Uma (or Parvati) conforms to the canon also, despite the loss of her head, and is kneeling on Shiva's thigh, a rather unusual pose for an Umamaheshvara group. The text, in both Sanskrit and Khmer, announces the installation of a linga called Shri Tribhuvaneshvaradeva. Inscribed during the reign of Harshavarman III, the successor of Udayadityavarman II, the stele records many important genealogical details despite the execrable quality of its Sanskrit excoriated by the great scholar George Cœdès.

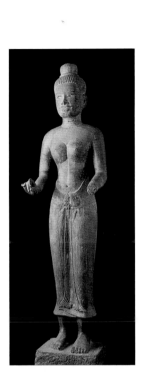

An impressive example of the fluid dynamism of Baphuon relief carving can be seen in a lintel from about the middle of the eleventh century [123]. An energetic image of the youthful god Krishna is shown tearing apart with both feet and hands the multiple heads of the evil serpent Kaliya as punishment for his poisoning the waters of the sacred river Yamuna. The vigour of the god's thrusting legs and arms and the expression of triumphant joy on his face are accentuated by a remarkably detailed frame of the layered naga heads, themselves issuing from the formidable fangs of chubby-armed kala monsters whose tails, changing to

123 Lintel. Prasat Pen Chung, Kompong Thom, c. mid-11th cent. Sandstone, 0.71 × 1.38 m (28 × 54⅜ in).
The undulating and swirling movement of foliate motifs transmogrifying into demons' bodies and winged creatures encloses the depiction of Krishna dancing in youthful triumph on the evil serpent Kaliya, whom he has torn apart as punishment for poisoning the water of the Yamuna River.

garlands, surge and curve up before flowing down to the edge of the lintel. The rhythm of their movement and the foliate elements swaying to left and right of the central image lend the deep carving tremendous fluidity, emphasized by the sharply upcurled wings of the two garuda figures, traditional foes of snakes, that stand guard over the head of the god. The balance of mass and void, of subsidiary to main forms, and the centralization of the architectonic flow of the garland to a focus on the narrative centre offers a masterly example of the consummate sculptural skills of the Baphuon period.

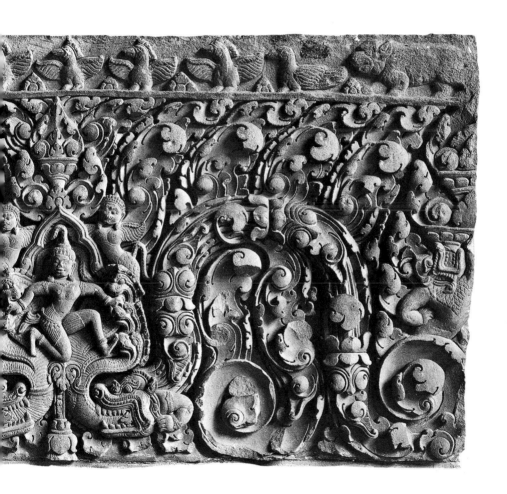

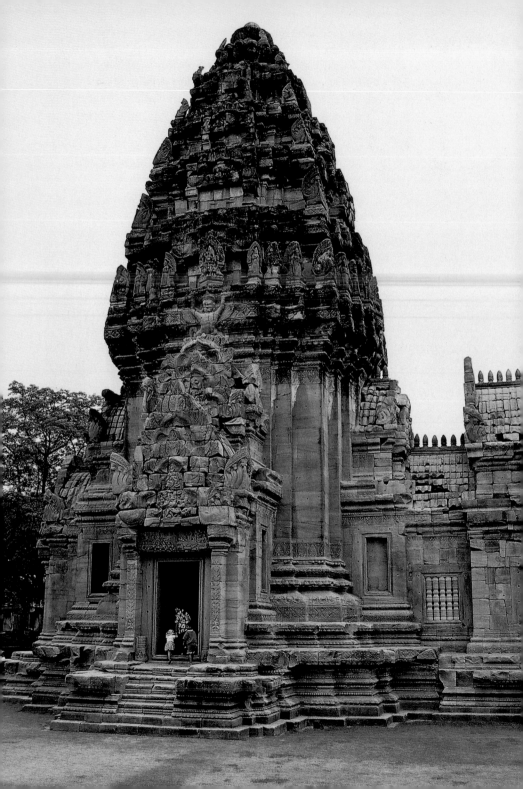

Chapter 6 Angkor Wat and the Height of Empire: the twelfth century and Suryavarman II

Although Angkor Wat is just one of the great monuments of Cambodia, its sheer scale and the perfect resolution of its complex architecture have dominated the world's impression of that country. The words 'Angkor Wat' have also been applied to a whole era of Khmer culture and its eponymous style, an era that was presided over for most of its existence by the powerful figure of Suryavarman II (1113–45 or later). In fact, the roots of the Angkor Wat style go back to the late eleventh century and the reign of Jayavarman VI (1080–1107). While sculpture continued to be shaped by the morphology of the Baphuon style long after the troubled reign of Udayadityavarman II (c. 1050–1066) and into that of his brother and successor Harshavarman III (1066–80) – as is demonstrated in the stele with Shiva and Uma [122] – a new dynastic line emerged that would expand the empire and change the stylistic norms of Cambodia was emerging in the north. There the Mahidharapura family ruled an area north of the Dangrek range, in what is now northeastern Thailand, probably in vassalage to the king ruling at Yashodharapura. The region had a long history of Mahayana Buddhism, dating back before the creation of the Prakhon Chai bronzes in the eighth century [56, 57], a religious bent that would affect the future Khmer dynasty.

Not much is known about the reign of the apparently peace-loving Harshavarman III, and no monuments are associated with his reign. Contemporary inscriptions mostly yield information about the high officials of his reign and about the religious foundations they established. It seems probable that he was overthrown by his successor, Jayavarman VI, a prince of the Mahidharapura family, whose inscriptions made no claim of genealogical connections with the line of Harshavarman; such a silence would be unusual in the case of a legitimate inheritance.

124 Prasat Phimai, Thailand. Late 11th cent. The temple was built in what is now northeastern Thailand at the height of the expansion of the Khmer empire. The form of its tower is predictive of those at Angkor Wat. It was located at the western end of the so-called Royal Way, the 12th-century pilgrimage route that began at Bayon.

The first mention of Jayavarman VI occurs in an inscription of 1082 at Prasat Phnom Wan, a Khmer temple in what is now Nakhon Ratchasima province in Thailand. It has been suggested that Jayavarman ruled from this region, having stayed in Yashodharapura only to be consecrated. A later inscription (from Ta Prohm in 1186) says he 'obtained supreme royalty at Yashodharapura' but 'fixed his residence at Mahidharapura'. This may explain the grandeur of the architecture of the region, which far exceeds what might be expected for a provincial capital. There are many Khmer temples in the area (as well as in other provinces of Thailand) and although they are too numerous for the scope of this book, three have particular relevance for the evolution of the Angkor Wat style: Prasat Phnom Wan for its inscription, and Prasat Phimai [124] and Prasat Phnom Rung [125] for their stylistic precedents.

Like many temples in this area of Thailand, Prasat Phnom Wan's eleventh-century edifice is based on earlier constructions on the site that may date back to the ninth century and that attest to the early presence of Khmer influences. The 1082 inscription mentions Jayavarman VI and the local Mahidharapura dynasty from which not only he but also subsequent kings, including Dharanindravarman I and Suryavarman II, were descended. While the style of Phnom Wan itself is clearly Baphuon, the inscription also mentions the nearby city and temple of Vimayapura, the Sanskrit form of Phimai, a temple that is stylistically predictive of Angkor Wat. This large temple, built during several Khmer reigns from the late eleventh to the late twelfth centuries but substantially the work of Jayavarman VI, was reconstructed during the 1960s. It marks the end of the pilgrimage route, or Royal Way, whose other end lies in Angkor 225 kilometres (140 miles) away to the southwest. Phimai is mentioned in the inscription of 1191 at Preah Khan as the destination of one of Jayavarman VII's imperial roads and was clearly a major affirmation of extended Khmer hegemony.

There are three enclosures at Prasat Phimai. The rectangle contained by the outer laterite wall measures 1020 by 580 metres (3350 by 1900 feet) and is protected by a moat, a prototype for the plan of Angkor Wat, though somewhat smaller. Although we surmise from inscriptions that the huge outer enclosures of Khmer temples formerly housed thousands of people, the structures were of perishable materials, and today the compounds are devoid of buildings and have usually been reclaimed by the forest. At Phimai, however, a flourishing small town lies between the outer (third) wall and the second enclosure and offers an

insight into old relationships between sacred and secular society. The temple faces south (though not true south), a most unusual orientation for which there is no certain explanation. Though south is the direction of Angkor, a likelier explanation, as for the disposition of Preah Vihear, is geographical. A curving stretch of the Se Mun, an important Thai river, and its tributary Klong Chakrai almost surround the temple and impose a natural southerly development. Rainy season floods often turn the site into an island, which would have had implications of the symbolic cosmic ocean surrounding Mount Meru.

Phimai, despite being a Mahayana Buddhist foundation, foreshadows many of the features of Vaishnavite Angkor Wat. The axes of its second (274 by 220 metres/900 by 720 feet) and inner (83 by 74 metres/272 by 242 feet) enclosures are set slightly north of the centre of the outer enclosure; its inner enclosure is preceded by a cruciform structure with four pools; sandstone balusters imitating turned wood fill the windows of surrounding galleries; most strikingly, the form of its central sanctuary tower has a smooth conical profile presaging the form of the multiple towers of Angkor Wat and other temples of the twelfth century. It is not clear exactly when the main temple was built, though the walls and gates date from late in the twelfth century, but it must have been early in the twelfth century. It would be reasonable, on the precedent of former monarchs' practices, to assume that Jayavarman VI ordered its construction early in his reign. The latest date mentioned in an inscription is 1112 CE (on the pier of the south gopura of the inner enclosure) that records the installation of an important image of the Tantric deity Trailokyavijaya in 1108.

The temple is constructed of red and white sandstone, strikingly contrasted in the gopuras, with laterite employed for enclosure walls and some subsidiary towers. While the interior reliefs of the three-part central sanctuary depict Buddhist subjects, the external pediments and lintels treat episodes from Indian epics – including a scene from the *Ramayana* showing Rama and Lakshmana bound in the coils of snakes metamorphosed from the arrows of their foe Indrajit – and present images in the appropriate places of Brahmanic deities of direction such as Varuna, the guardian of the west. The precision and realism of the carving is notable, and the fusion of Buddhist and Hindu subjects is typical of the ecumenical nature of Tantric Buddhism.

There is no doubt that the clearest indication of Angkor Wat style can be seen in the tower, which rises a little more than

28 metres (92 feet) above ground level. The impression is amplified by the continuous upward line, where close-set, multiple and relatively short redentations of steeply receding storeys mask the square plan of the tower. Its five tiers soar from the projecting cornice of the actual sanctuary and are seemingly pushed upwards by the triple ascending pediments of the tall porches over the three doorways of the tower. The line is enhanced by elegant flame-like antefixes on the redentations, their delicacy lending an impression of weightlessness.

Prasat Phnom Rung, like Phimai, evolved over several centuries and reigns, possibly beginning in the eighth century. The existing monument was probably built slightly later than Phimai, to the southeast of that temple in Buriram province and on the Royal Way to Angkor. Like Preah Vihear, Phnom Chisor and, in Laos, Wat Phu, it takes advantage of a dramatic natural site. Crowning a steep volcanic peak, it has a linear plan, like the temples mentioned above, with the approach to the central sanctuary comprising an ascent of 500 metres (1640 feet) by multiple stairs and terraces with naga-flanked balustrades. There are eleven inscriptions giving considerable historical information. One, installed in 1150 by a certain Hiranya, describes how his father Narendraditya, a member of the Mahidharapura family (and therefore related to Jayavarman VI, Dharanindravarman I and

125 Prasat Phnom Rung, Thailand. Early 12th cent. Buddhistic like Phimai, this temple was built in an area in present-day Thailand that was once part of the Khmer empire. Dramatically situated on a mountain peak, it is linear in plan.

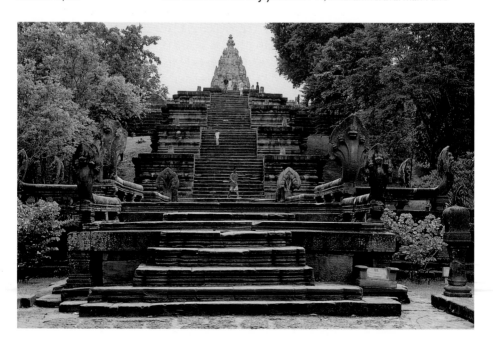

Suryavarman II), had been affirmed as ruler of the territory because of his success in overthrowing the enemies of the last of these kings.

Like Prasat Phimai, Phnom Rung has several elements in common with Angkor Wat, including cruciform terraces, of which there are four. These are flanked by naga balustrades, the rearing five-fold heads of the serpents carved in remarkable precision with highly expressive faces and sharply peaked hoods, a profile typical of Angkor Wat style. The ubiquitous presence of the naga on these elevated terraces invokes the role the snake plays as a link from the mundane world to both the underworld and the world of the gods. The naga balustrade, with the body of the serpent forming a rail, is sometimes referred to as a rainbow bridge, since the rainbow (like the naga, a phenomenon of water) also links heaven and earth. The largest of the cruciform terraces has four pools in its quadrants, echoing the platform in front of Phimai's inner enclosure and presaging the interior cruciform courtyard at Angkor Wat.

The exterior reliefs of Prasat Phnom Rung show the same vitality and finesse as those at Phimai, two of the most striking being on the pediment and lintel of the eastern facade of the mandapa of the central sanctuary. The pediment shows a dynamic Shiva Nataraja (Lord of the Dance), while the lintel beneath it depicts Vishnu Anantashayin lying on a creature that resembles a dragon more than the usual serpent Ananta, an alternative form that seems to have appeared first at about this time and probably signals influence from China. The lintel offers one of the few happily resolved stories of looted architectural elements. Stolen in the 1960s while the temple was being restored, it was sold to an American collection and lent to the Art Institute of Chicago. Negotiations led to its being returned to Thailand in time for the completion of restoration in 1988.

Interior and exterior sculpture at Phnom Rung is Brahmanic, predominantly Shaivite, and includes images of meditating ascetics, both yogis (rishis) and Shiva himself in rishi form. In addition, in the mandapa (which for an unknown reason has a floor a metre lower than the floor of the tower and the hall that links it to the mandapa) there is a Nandin sculpture surrounded by eight hip-high stone pillars at the cardinal and subcardinal points. Each is carved on its flat upper surface with the appropriate directional guardian on his mount in lively and naturalistic relief. Indra, guardian of the east and king of the gods, is mounted on the three-headed elephant Airvata. Proceeding in the ritually appropriate

clockwise, or pradakshina direction, the visitor comes next to Agni, god of fire, on a rhinoceros, and then to Skanda (Karttikeya, Kumara), the guardian of the south and god of war, on a peacock. To the southwest and northwest the figures are missing. To the west Varuna, god of water, atypically rides a naga; on the north Kubera, god of wealth, sits sideways with bent knees on a lion with elephant head; while to the northeast, the most sacred direction, the supreme god Shiva is mounted on Nandin.

While the tower of Prasat Phnom Rung is less tapered than that at Phimai, it too predicts the profile that would characterize Angkor Wat style, where the set-back steps of the rising storeys are concealed by antefixes on the redented corners that impart an impression of continuity. The tower's relation to the mass of the sanctuary as a whole (the inner sanctum below the tower, the connecting hall and the mandapa) is solid and calm, the precision and proportions of its pediments and antefixes harmonizing with the mountain-shaped frames of the triple pediments of the porches and doors. It is perhaps an indication of the stylistic innovation of the tower that it is illustrated in two reliefs in the temple: once in the pediment over the western door of the inner sanctum, and once in a pediment two levels higher on the same facade. This echoes the appearance in a pediment over the eastern door of the inner sanctum at Phimai of the waisted and slender tower of that monument. The assured aesthetic and technique of the towers' designs represent one of those defining moments in the history of form when a new idea transforms the status quo in a seemingly inevitable way.

Apart from the information in the inscriptions mentioned above, not much is known about Jayavarman VI. Whether or not he ruled from Phimai, he did not reject the imperial legitimacy of Yashodharapura/Angkor, as an inscription tells us that his chief priest, or purohita, was Divakarapandita, who was already a dignitary in the court of Udayadityavarman II. His high title of Vrah Guru indicates the continuing use of both Khmer ('Vrah') and Sanskrit ('Guru') nomenclature. Indeed, Divakarapandita was also to consecrate Dharanindravarman I and Suryavarman II, reinforcing the importance of ritual continuity. The status of women is also attested in the inscriptions, which attribute semi-divine standing to a woman called Tilaka who was the mother of a sage called Subhadra. Jayavarman's designated heir was apparently his younger brother, referred to in inscriptions as Yuvaraja (a title meaning 'Crown Prince'), who predeceased him. Before his death he recommended that Jayavarman marry Vijayendralakshmi, the

outstanding woman who was soon to become his widow. Perhaps she had important political connections or property rights as well as outstanding virtues and graces, since she became the wife of another king when Jayavarman was succeeded on the throne by his older brother, Dharanindravarman I (1107/8–12). This elderly man was persuaded to leave his monastic existence to assume a kingship about which little is known. One can speculate that he was urged to do so because the kingdom was under some threat, and this may have been because the faction of the deposed Harshavarman III was still contending for the throne.

As most of the inscriptions from Harshavarman's reign are found in the vicinity of Angkor, and those from Jayavarman's and Dharanindravarman's from the trans-Dangrek area further north, it has been postulated that royal authority was split in the turbulent decades between about 1080, when Jayavarman VI claimed the throne, and 1113, when Suryavarman II, who was his great-nephew, assumed power. This would account for the twelfth-century inscription of Ban That that relates that when the young Suryavarman completed his studies (at about fifteen years old) he was 'in the dependency of two masters'. Among the allusions to his conquest of the Khmer kingdom is one that describes his leaping on the head of the elephant carrying the enemy king, whom he killed. Another states that Dharanindravarman was 'despoiled of his kingdom, which lacked defence, by Shri Suryavarman' in a combat that lasted only one day. Since Dharanindravarman was Suryavarman's great-uncle, the term 'enemy king' seems inappropriate, whereas Harshavarman, from a completely different dynasty, could well have been so termed.

Suryavarman II's crowning achievement was without doubt the creation of Angkor Wat, but several other temples of distinction were built during his reign of at least thirty-five years. In addition he added structures to existing monuments like Preah Vihear and Wat Phu. The small temple of Thommanon [126] was one of the earliest structures in Angkor Wat style in Yashodharapura/Angkor itself. The remains of a laterite wall surround an enclosure of 40 by 65 metres (130 by 210 feet) within which a single-towered sanctuary, preceded by a mandapa measuring 3 by 5 metres (10 by 16 feet) and an antechamber, is flanked on east and west by gopuras – triple-chambered on the west, cruciform on the east, where the base abuts the base of the antechamber – and by a library on the south. The tower, which has two-tiered porches on south, west and north, has four receding storeys with the close-

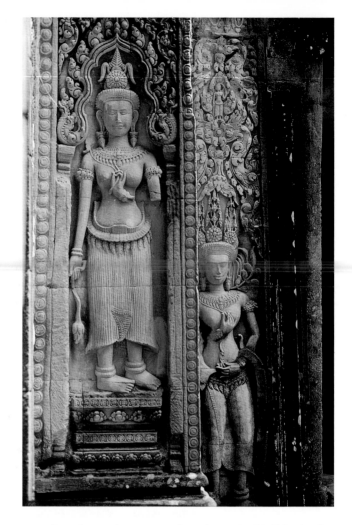

126 Thommanon, Siem Reap. Apsara relief, first half 12th cent. The hieratic perfection of the sculptures of apsara figures (heavenly nymphs) in elaborate niches in the small temple of Thommanon and the almost identical temple of Chau Say Tevoda nearby is characteristic of the Angkor Wat style.

set redentations and corner antefixes that evolved in Phimai and Phnom Rung and that would become one of the defining elements in Angkor Wat style, where towers are characteristically ogival in profile rather than stepped as in earlier temples.

The dimensions and layout of Thommanon are very similar to those of Chau Say Tevoda, which lies a few hundred metres to the south. The latter has an additional library (probably intended, or perhaps built and entirely lost, at Thommanon) and four gopuras, and may have been constructed later. The plan, essentially the same as the central area of Phimai and Phnom Rung, was later the basis for Banteay Samre, another Angkor Wat style temple that will be discussed later. All are distinguished by remarkably refined

relief carving that is masterfully subsumed into the architectonic unity that is another of the outstanding characteristics of the style. Both Thommanon and Chau Say Tevoda have narrative lintels and pediments of both Shaivite and Vaishnavite themes. The former depicts Ravana menacing Mount Kailasha (south face of the tower), Vishnu on Garuda battling asuras (west gopura), and Vishnu on Garuda (interior lintel of antechamber), and the latter shows the struggle between Valin and Sugriva from the *Ramayana* and the group of Shiva with Uma on Nandin (pediments of the mandapa), among others. Both have large relief carvings of devatas of extraordinary variety and grace [126] set in intricately carved niches on piers and pilasters. They wear elaborate headdresses, tiaras, necklaces, bracelets and heavy jewelled belts that would appear on their counterparts at Angkor Wat, and embody a precision and refinement that characterize the sculpture of the period, notwithstanding the somewhat awkward treatment of the feet, parallel and turned sideways from the frontal pose of the deity.

When Suryavarman II assumed power in Cambodia in 1113 it had been more than fifty years since the construction of a temple mountain, Baphuon, in 1060. Grandiose and complex though that monument was, nothing on the scale and complexity of Angkor Wat had ever previously been attempted. Unlike the siting of many previous foundations, which in accordance with the importance for the Khmers of cosmological factors were often carefully aligned with the axes of existing monuments as well as with compass points, Angkor Wat's location in the Angkor area does not seem to be predicated on previous spatial relationships [127]. It is oriented to the west. A few Khmer temples exceptionally face north or south, when topographical considerations predominated (as at Preah Vihear and Phimai respectively), and some face west, including most of the annex buildings known as libraries, but most face east. It has been speculated that, as west is the direction of death, Angkor Wat might have been destined as a funerary monument for its founder, but there is no evidence for this. A likelier reason is its dedication to Vishnu, sometimes associated with the west.

The external measurements of the vast complex, defined by its 190-metre (623 feet) wide moat on four sides, 1300 metres (4265 feet) on the north–south axis and 1500 metres (4920 feet) on the east–west axis, place it among the world's largest religious foundations, with an area of 200 hectares (494 acres). The moat, which is more than 5 kilometres (3 miles) in circumference, is bordered with laterite and sandstone steps and coping, and bridged

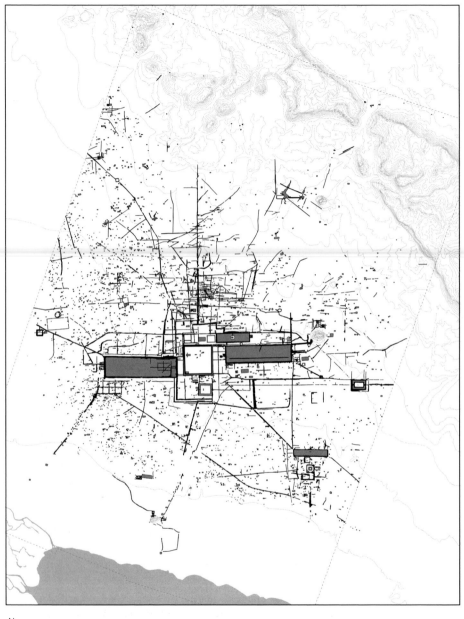

N

| 0 | 2.5 | 5 | 10 kilometres | | Reservoirs | | 10 metre Contours |

at east and west ends. To the east it is crossed by a simple earthen ramp, but to the west a 12-metre (39-feet) wide causeway on sandstone columns bricked in by a laterite wall in places, is paved with sandstone. The southern half of the pavement has been restored. Halfway along its 200-metre (650-feet) length a transverse platform flanked by a naga balustrade and protected by huge outward-facing guardian lions has steps leading down to the water.

An external wall of laterite, 4.5 metres (14 feet) high, lies 40 metres (130 feet) inside the inner bank of the moat at the edge of the outermost of the temple's four enclosures and prevents any sighting of the main mass of the monument until after passage through the gopuras. The wall is pierced by a single gopura at the midpoint of the north, east and south sides and by five gopuras on the west, the ceremonial entrance to the temple. The northernmost and southernmost of these are unusually high and broad to allow traffic of elephants and horses, and are usually referred to as the elephant gates. The gopuras stretch more than 200 metres (650 feet) across the facade and were once crowned by towers, of which only three tiers remain. Like the surviving intact towers on interior structures, these must certainly have been ogival in the characteristic Angkor Wat form.

Each gopura has a cruciform central space, and eight bays connect the three laterally to each other and to the galleries connecting with the elephant gates. They are preceded by porches on both east and west facades, double in the case of the central gopura. The galleries between the central and elephant gopuras, which are open to the exterior, have corbelled semi-vaulted roofs and massive square support columns 2 metres (6 feet) in height. The carving of capitals and bases, with vegetal motifs and apsaras, is impressive, as is the system of window balusters, turned in the manner imitating timber bars as at Phimai and Phnom Rung, that mask the blank wall facing the monument's interior in a *trompe l'oeil* manner. The portals and porches are crowned with double pediments, and each set-back storey of their towers once also bore a pediment. Many of these have crumbled or disappeared, but those that remain bear witness to the remarkable quality of the relief carving, particularly a scene of Vishnu Anantashayin facing west.

If there were nothing more than the structures of its perimeter, Angkor Wat would still rank as major architecture, but the sheer scale and complexity of the monument surpasses all expectations as one walks through the western gopura to the

127 Greater Angkor, first half 12th cent. Plan.
The plan shows the extent of the Angkor area, as well as the Roluos group. The city reached its apogee in the late 12th century when Jayavarman VII built the capital city of Angkor Thom. The former location of the now dry eastern baray can be seen (large rectangle, centre right of the plan). Angkor was the most populous pre-industrial city in history.

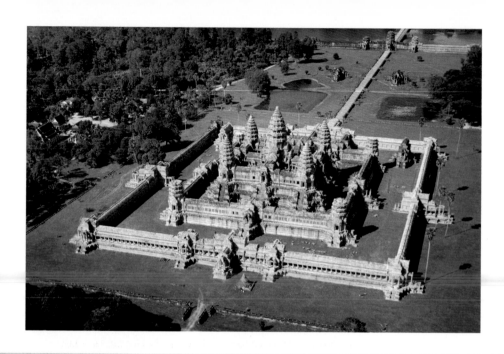

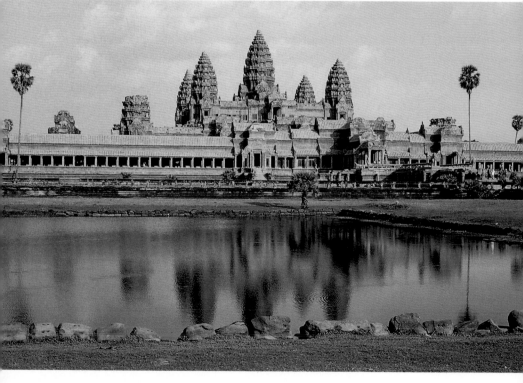

prospect of the inner structures [128]. The fourth, or outer precinct, covers an area of more than 80 hectares (200 acres). Although today it is mostly overgrown, it was probably once filled with the buildings in impermanent materials that comprised Suryavarman's capital city. Its west–east axis is crossed by a 350-metre (1150-feet) sandstone-faced causeway, raised on an embankment 9.40 metres (30 feet) wide and flanked by naga balustrades. Six transverse terraces, also with naga balustrades, terminate in steps leading to the ground level. To the north and south of the fourth of these lie the two libraries, unusually opening on all four sides and comprising a cruciform central hall flanked by a square chamber to east and west giving an interior measurement of 27 metres (89 feet). Square porches project from all four doors and double pediments framed by flame-like flanges surmount the entrances. The steps of the fifth transverse terrace lead to a pair of pools that reflect the monument [129], although only the northern one retains its water in the dry season.

A large cruciform, naga-balustraded terrace on two levels connects the causeway to the vast platform that forms the base of the pyramid comprising the third, second and inner precincts, all enclosed by galleries that together offer almost 1.5 kilometres (1 mile) of relief carvings. The terrace was probably used for ceremonies and has recently been used for dance performances. The third set of galleries (counting from the centre of the temple), sheltered by a corbelled roof supported by a row of pillars, is divided into eight segments by the portals at the cardinal points. These lead down to the open space of the third precinct, empty save for another pair of libraries. Each segment of the gallery offers a continuous relief that in several cases reads from left to right, suggesting that this monument was to be circumambulated in anti-clockwise, or prasavya, direction. Turning south from the three-chambered gopura at the eastern end of the cruciform terrace, the visitor first sees the animated relief of the *Mahabharata* battle of Kurukshetra fought between the families of the Kauravas (on the left) and the Pandavas (on the right). At the southwest corner a pavilion offers multiple reliefs of extraordinary vitality that mostly depict Vaishnavite scenes, though there are some Shaivite images. Like many of the reliefs of Angkor Wat, these are severely threatened today by several factors, including the nature of the sandstone itself, the engineering of the construction that did not solve the problem of water infiltration, and the misguided methods of conservation attempted in the 1990s.

128 Angkor Wat, aerial view from east-northeast.
The Vaishnavite complex of Angkor Wat built by Suryavarman II is one of the largest religious monuments in the world, occupying 200 hectares (495 acres).

129 Angkor Wat. General view from west.
The orientation of the temple to the west has led to the supposition that it may be a funerary temple, since this is the direction associated with death. The west is also associated with Vishnu, however, and a likelier explanation for the orientation is probably connected to the temple's dedication to that god.

The relief on the western part of the south gallery is of great historical interest, as it shows the army of Suryavarman, including troops from Siam, passing before the king, who is much larger than other personages and who appears twice, once on top of Mount Shivapada in an elaborate palanquin borne by a crowned elephant and protected by fifteen parasols [142], and once standing on the back of an elephant. In addition the procession shows twenty dignitaries who are identified by small inscriptions. The king is referred to by his posthumous name, Paramavishnuloka, perhaps indicating that the phrases were added at a later date, perhaps when the reliefs of the northeast quadrant were completed in the sixteenth century. A little in front of the second representation of the king, the high priest is shown in a litter that is preceded by an elaborate vessel born aloft and containing the sacred flame, identified by an inscription in Khmer (Vrah Vleñ). Its location before the king in the procession indicates its role as one of the most important emblems of the kingdom. Inscriptions from as early as the ninth century indicate that there was a cult of the sacred flame and it seems likely that maintaining the fire in perpetuity was part of the high priest's (rajahotar) responsibilities.

The eastern relief of the south gallery shows Yama, the god of death, judging who should go to heaven and who to one of the

130 Angkor Wat, relief, south gallery, east wing, heaven and hell. The complex narrative reliefs of the third enclosure are 2 m (6½ ft) high and extend for about 800 m (875 yds) around the temple. This segment depicts Yama, god of death, dispensing judgment about where souls should be directed when their lives are over. There are thirty-two hells, where guilty souls are sent according to the nature of their offence, and the punishments awaiting the condemned are illustrated in stark detail, as depicted below.

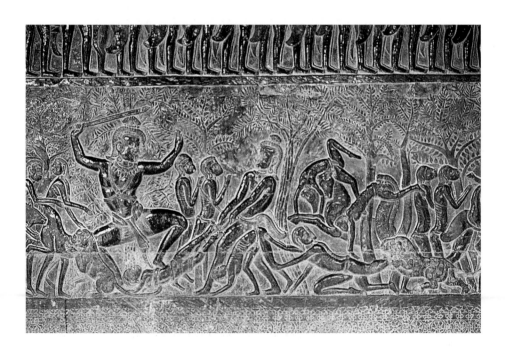

thirty-two hells, which are derived from Buddhist rather than Brahmanic mythology [130]. The inventiveness and expressiveness of individual figures is set within a masterly architectural command of the overall setting. Around the corner, on the south part of the eastern gallery, a dramatic presentation of the Churning of the Sea of Milk offers an extraordinarily architectonic management of myriad forms depicted in great detail yet subsumed into a sweeping rhythm. There are multiple representations of Vishnu and his avatars, including Krishna and Kurma, his tortoise avatar, lying on a serpent and supporting Mount Mandara as it is used as the pivot for the churning. The two later reliefs of the northeast quadrant depict the defeat of the asuras by Vishnu and Krishna and are of less skilful execution. The western relief of the north gallery shows another battle and depicts many of the gods of direction and of the constellations on their appropriate mounts. The pavilion at the northwest corner is almost entirely dedicated to scenes from the *Ramayana*, while the northern relief of the west gallery shows the battle of Lanka from the same epic. The sculptural mastery and iconographic richness of the reliefs is impossible to describe here, but there are several studies that analyze them in detail.

A fascinating recent study by Eleanor Mannikka has added new insights to the complexity of planning and iconography that underlie the entire structure of Angkor Wat and enrich its meaning in spatial, temporal and thematic ways. A painstaking analysis of measurements based on the cubit and applied to every component of the monument has led her to see the whole temple as being based on numbers and combinations of numbers of immense symbolic and cosmological importance: there are frequent uses of 108, for example, which is a highly propitious number in Khmer thinking. The theories are far too detailed even to be summarized here, but she makes a strong case for the monument's being coded in several dimensions to yield historical facts (the dates of various episodes in the king's life, for example), and demonstrates how double interpretations of images and their relative placement imply deliberately drawn parallels between the king and Vishnu. Meticulously calculated alignments link the temple with astrological events and make it, in effect, a cosmological observatory. The dimensions of the causeway and scenes showing the Churning of the Sea of Milk are interpreted as part of an allegorical representation of time as it progresses through cosmic cycles, the ultimate message being that Suryavarman II has succeeded in ending the negative cycle of the

131 Angkor Wat, section showing core.
The diagram shows that the shaft of the foundation is equal in depth to the height of the central sanctuary tower, forming a symbolic axis mundi in its penetration of the lower world by way of the middle world to the upper world of the heavens.

kali yuga (the current cycle of existence, initiated by the destructive war of the *Mahabharata*) and reintroducing the benign conditions of the kirta yuga (the first and most perfect age).

From the western end of the central axis of the third enclosure an elevated cruciform courtyard, where cloister-like walkways surround four depressions that were once filled with water [128], leads to the steps rising to the second gallery. It is perhaps here that the unique quality of the manipulation of mass and void, of the relationship of the overall sequence of spaces with their framework, becomes apparent. The links between Angkor Wat's monumental spaces are forged by elements that bridge discrepancies of volume and height by harmonious connecting forms, like the ascending roof series that rise from the cruciform gallery to the level above in a telescope effect. They supply visual continuity while never disrupting the harmony of the whole.

The second gallery, in complete contrast to the third gallery and the cruciform courtyard, is rather dark and claustrophobic, offering an appropriate separation between the accessible level of the narrative reliefs and the transitional openness of the cruciform courtyard with its elegant columns and pools, and the sacred realms of the inner sanctuary. The dim and somewhat severe gallery surrounds the second precinct within which a third, very small, pair of libraries is reached by elevated terraces. Beyond them rise the extremely steep flights of stairs, three to each facade, that lead to the first (inner) gallery surrounding the central sanctuary. At an angle of 70 degrees, their dizzying ascent strongly invokes the image of the cosmic mountain that the temple embodies.

The upper level galleries are uniquely open on both sides, where the turned balusters filling the spaces permit breathtaking views of the lower levels of the temple and the surrounding countryside. The galleries provide links between the corner towers of the quincunx with base measurements of 60 metres

(200 feet) square. Four gopuras at the galleries' axial points lead to the central sanctuary, once open on four sides but closed in later centuries by walls with Buddha sculptures erected when the monument was designated a Buddhist foundation. Presumably the sanctuary originally contained an image of Vishnu. The central tower rises 42 metres (138 feet) above the level of the sanctuary [131]. Excavations in the 1930s revealed the central well below the floor of the sanctuary. It penetrates downwards the same distance that the tower's interior space rises above the terrace level [132]. This equivalence, like that in the eighth-century Prasat Ak Yum, is no doubt a representation of the axis mundi that links the earthly world with the lower and upper worlds.

In addition to being enriched by the profusion of carvings on lintels and pediments, and on columns and cornices, the monument is graced by deep relief carvings of myriad devata figures, almost two thousand in number, on piers, pilasters and interpilaster walls. These captivating figures epitomize the delicacy and inventiveness of Angkor Wat's sculpture [1, 133]. The variety of

132 (opposite, below)
Angkor Wat, sanctuary tower. The four entrances to the central sanctuary that would have housed an image of Vishnu were originally open to the four cardinal directions. When the temple was converted to Buddhistic worship after the abandonment of Angkor by the court in the 15th century, the bays were sealed. The south entrance was re-opened by French archaeologists in 1908.

133 Angkor War, apsaras.
The many hundreds of apsaras carvings present an astonishing variety of attitude, dress, coiffure and expression of the heavenly nymphs who dance to honour the gods. Their grace has come to epitomise the Angkor Wat style; but the refined perfection of the carving of these animated figures is vulnerable to delamination. This and erosion threaten the integrity of these incomparable images and present a major challenge to conservators.

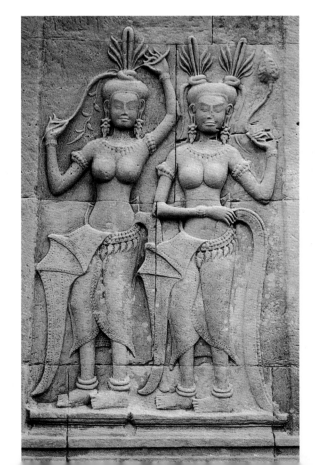

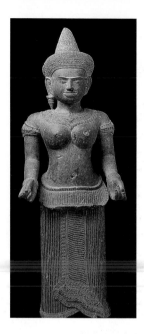

expression, of headdress, of gesture, of accoutrements, is seemingly inexhaustible and without duplication. The animation of the figures and the positions of their arms suggest that these divine guardians are apsaras figures, celestial dancers who please the gods.

It is an inexplicable anomaly that the architectural sculpture of Angkor Wat should have attained such mastery of architectonics, dynamism and grace while the free-standing sculpture of the era is characterized by a certain rigidity [134]. The quality of the carving is meticulous, however, with the details of tiaras, necklaces and finely pleated garments presented in classical perfection. The hieratic dignity of Shiva with two shakti [135] is somewhat cold compared to the natural grace of the temple's devatas, and although the treatment of the facial features, crowns and pleated garments is refined, the carving of legs and feet is marred by the same clumsiness seen in the devatas of Thommanon.

134 Female divinity. Angkor, Siem Reap, first half 12th cent. Sandstone, 0.865 m (34¼ in). The style of Angkor Wat sculpture in the round reverts to the somewhat rigid formalism of the styles of the early Angkorian period, with great perfection of carving technique but little individualism in the representation of the human form.

135 Shiva and two spouses. Provenance unknown, 12th cent. Sandstone, 0.82 m (32¼ in). The hieratic nature of the deities, the precise folds of their pleated garments and the conical shape of the crowns rising above their diadems are all characteristic of the Angkor Wat style. Shiva is flanked by two spouses, perhaps Uma and Ganga.

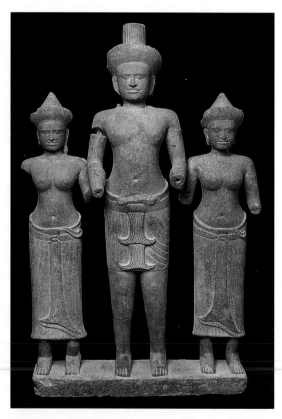

136 Vaishnavite monument. Preah Khan, Kompong Svay, Kompong Thom, third quarter 12th cent. Sandstone, 1.05 m (41⅜ in). The multiple representation of Vishnu images – 1,020 in all, probably a propitious number – suggests the omnipotence of the god, who is also represented in four guises on the upper section of the monument: the eight-armed Vishnu, sometimes implying the supreme form of the god, Vishnu-Vasudeva-Narayana; Vishnu Chaturbuja (four-armed); Vishnu Anantashayin (in cosmic sleep); and Vishnu riding his vehicle Garuda.

The formal hieratism of images such as these perhaps works best when applied to symbolic objects with architectural qualities like the votive monument dedicated to Vishnu [136]. Two hundred and fifty-five miniature representations of the god in his chaturbuja (four-armed) version are arranged in fifteen rows on each of the four faces for a total of 1,020. Awareness of the importance of numerology in Khmer belief makes it likely that this number held a special meaning. Each face of the monolith is surmounted by a scene in deeper relief set in a foliate frame terminating at the corners in an upreared five-branched naga head. The reliefs show four versions of Vishnu: chaturbuja is repeated, and in addition there are, clockwise from this, Vishnu Anantashayin (in cosmic sleep), Vishnu on Garuda, and Vishnu-Vasudeva-Narayana, the supreme cosmic Vishnu.

Bronze casting in the lost-wax method achieved a technical and aesthetic mastery during the age of Angkor Wat that was probably never surpassed in Cambodia. The skills of precision apparent in stone sculpture were of even greater importance in the minutely detailed figures that proliferated at this time. An image of Vishnu-Vasudeva-Narayana [137] embodies the control of proportion, the attention to the particularities of dress and jewels and the harmonious proportions that distinguish the finest expressions of the Angkor Wat style. The figure has sometimes been interpreted as Harihara, because of the presence in the forehead of a third eye, and of the symbol for 'Om' inscribed in the coiffure, which itself resembles Shiva's jatamukuta rather than the conical headdress that was usual for Vishnu at this time. However, the attributes in the god's hands are all Vaishnavite. In addition, the normal division of the figure into the Vishnu and Shiva halves of a Harihara was vertical, not horizontal, as is the case here. The Pancharatra sect of Vishnuism was important in Cambodia; it espoused the power of Narayana to end the cycle of existence through meditation. The symbols of such meditation were the third eye and the syllable 'Om', often associated with Shiva. But the association should be perceived as deriving from Shiva as a yogin, rather than as an intrinsically Shaivite characteristic, and therefore applicable to other deities too. As further, albeit circumstantial evidence that the figure is not Harihara, it can be noted that this god seems to disappear from the Cambodian pantheon after the eighth century.

After an almost complete absence of Buddhistic images for more than three centuries, towards the end of the eleventh century they began to reappear, perhaps because of the growing importance of the monarchs from Mahidharapura, from which Mahayana Buddhism had never disappeared. Whether or not something of the humanitarian nature of Buddhism influenced the style is hard to say, but in the figure of the seated Buddha from Sisophon [139] the classical perfection of the Angkor Wat style is infused with a more naturalistic treatment of the torso and limbs and a serene facial expression that bespeaks reflection rather than detachment. The same impression is given by the bronze of the seated Buddha from the Silver Towers in Vietnam [138]. Despite the considerable damage it has sustained, this figure is one of the most compelling Buddha images in the pose that was to become one of the most ubiquitous representations of the Sage in Cambodia (and in Lopburi, Thailand). The importance in Buddhist lore of the episode referred to, when the serpent Muchilinda slid from his lake to shelter the Buddha from torrential rains with his expanded hood during his prolonged

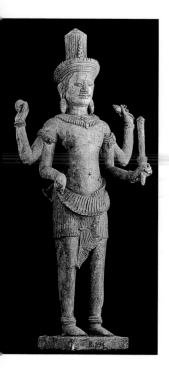

137 Vishnu-Vasudeva-Narayana. Kapilapura, Siem Reap, first half 12th cent. Bronze, 0.435 m (17⅛ in).
This image, which features the orb or globe, the disk, the conch and the mace, traditional attributes of Vishnu, also bears a third eye and a crown of twisted locks, characteristics of Shiva, which has led some to classify it as a Harihara image. But the disposition of the attributes differs from the usual arrangement in the dualistic god, and the figure is more likely to represent Vishnu-Vasudeva-Narayana, the supreme form of Vishnu.

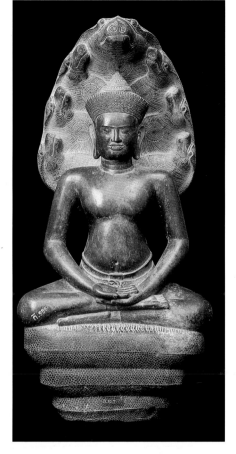

138 (below) Buddha seated on naga. Silver Towers, Binh Dinh, Vietnam, third quarter 12th cent. Bronze, 0.46 m.
This bronze image was discovered at the Silver Towers (Binh Dinh) in southern Vietnam. Its refinement epitomises the skill of Khmer bronze-casters.

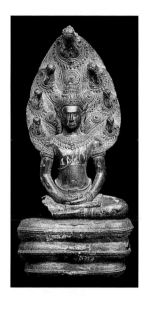

139 (right) Buddha seated on naga. Cave, Sisophon, Banteay Meanchey, first half 12th cent. Sandstone, 0.885 m.
This image of the Buddha protected by the naga Muchilinda is one of the most beautiful images in the Angkor Wat style. The depiction of the Buddha with a crown appears in the 12th century, eventually evolving to a being adorned in royal garb complete with jewels, a style pervasive in Thai art of this period and perhaps an indication of influence from Louvo (Lopburi), an important part of the Khmer empire.

meditation after enlightenment, is doubly significant in Cambodia because of its preoccupation with the naga.

The same gentler morphology infuses the standing bronze Adorned Buddha from Angkor Wat itself [140]. The delicate facial features and the naturalism of the torso, along with the subtle management of the casting to suggest the thin and supple garment revealing the form of the limbs below, temper the iconic stance to make this figure one of the finest fulfilments of the Angkor Wat canon. It is interesting to note that the monastic simplicity of the Buddha depicted in the Baphuon period sculpture [117] has been modified, first in the Sisophon image where the sage wears a tiara, though still attired in an ascetic's cloth, to the richness of the elaborate jewellery and robes of the Silver Towers image. This development of the Adorned Buddha probably also reflects influences from the Dangrek area of Suryavarman's family, and

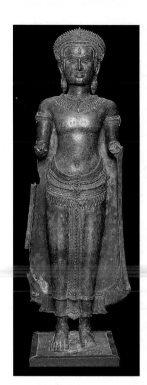

accords well with the conception of the divinely sanctioned status of the universal monarch.

One of the most charming and dynamic bronze images in the Angkor Wat style is a figure with upraised knee and hands stretched above her head to support a screen or mirror [141]. Although the sculpture might have been used in a religious ceremony, it is one of the few objects of a secular nature in Khmer art. The same could be said of the intricately fashioned finial of a chariot [143]. Its function is illustrated on the historical relief of the third galleries at Angkor Wat where a similar head adorns the corners of the elaborate palanquin in which Suryavarman II is riding [142]. The reverence accorded the king, however, raises any object destined for his use above the level of the merely secular. Similarly, although it is a utensil, a magnificently detailed incense burner's association with religious ceremony elevates it to ritual, even if not sacred, status [144]. The abundance of bronze images from the Angkor Wat period argues for a more prosperous

140 Adorned Buddha. North Library, Angkor Wat, Siem Reap, second half 12th cent. Bronze, 0.79 m (31⅛ in).
This is one of the largest and finest bronze representations of the Buddha in Khmer art, showing him as king of kings.

141 Kneeling female figure. Bayon, Siem Reap, first half 12th cent. Bronze, 0.39 m (15⅜ in).
The upraised arms of this expressive small bronze once held a flat object, perhaps a mirror or screen. Its apparently secular nature is rare in Cambodian art.

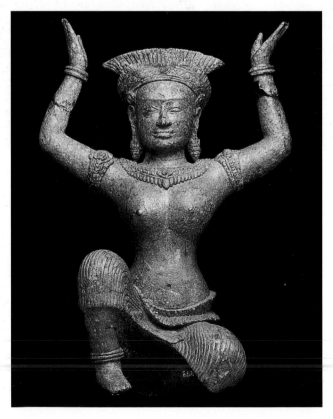

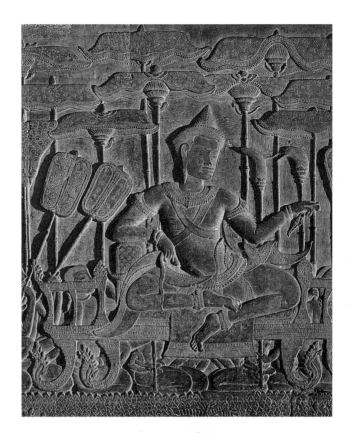

142 Angkor Wat, relief,
west section, south gallery,
Suryavarman II's chariot.
The relief shows Suryavarman II
riding in procession in a chariot
with finials similar to the one
shown in ill. 143 (below left).

143 Finial of chariot. Banteay Srei,
Siem Reap, first half 12th cent.
Bronze, 0.33 m (13 in).
The intricately wrought naga once
formed part of the trappings for
a ceremonial chariot like those
depicted on the reliefs of Angkor
Wat (see ill. 142 above).

144 Incense burner. Unknown
provenance, 12th cent. Bronze.
The refined details of this ritual
vessel demonstrate the perfection
of bronze casting in the Angkor
Wat period.

145 Banteay Samre, Siem Reap, first half 12th cent.
The temple, situated on the eastern edge of the former eastern baray, offers some of the finest examples of pediments and reliefs in the Angkor Wat style.

society and a wider range of influential people who wished to gain merit by the presentation of images to a religious foundation or by the creation of votive images for private devotions.

Suryavarman was undoubtedly one of the greatest builders in Cambodian history. The construction of Angkor Wat probably lasted for most of his long reign, and was his crowning achievement. It was not his last, however, as at least two more temples of great importance were erected during his time. One, Banteay Samre [145], was built near the east extremity of the eastern baray and extensively restored from 1936 to 1944. Like Angkor Wat, it was preceded by a long causeway with naga balustrades, but little of it remains today. A lack of inscriptions makes it impossible to date exactly, but it was probably begun slightly later than Angkor Wat. It has much in common with Prasat Phimai, particularly its single conical tower that has a waisted impression as it rises from a projecting cornice above the inner sanctuary. The layout is similar to that of Phimai, Phnom Rung, Thommanon and Chau Say Tevoda, with gopuras at the axial points connected by continuous galleries forming the inner enclosure. The plan is linear, with two libraries facing west to left and right of the antechamber of the central sanctuary, and the enclosing wall of the second precinct is 6 metres (20 feet) high, blocking all sight of the temple except at the four axial cruciform gopuras. Although it is on a much smaller scale (its inner precinct measures only 44 by 38 metres/144 by 125 feet, and the interior space is very crowded), the intricacy and dynamism of the pediments and lintels at Banteay Samre are reminiscent of their equivalents at Angkor Wat. The scenes are mostly drawn from the *Ramayana* or from Vishnu legends, but interestingly there is one pediment depicting a scene from the *Jataka*, or lives of the Buddha. Also strange in the context of other Angkor Wat style temples is the absence of devatas, except for a few preliminary incisions, suggesting that Banteay Samre, like so many other Khmer temples, was never finished.

The last major architectural project of Suryavarman's reign was the construction of the huge temple of Beng Mealea ('Pond of Garlands', like most Khmer temple names a later appellation) about 80 kilometres (50 miles) to the northeast of Angkor, at the southeastern flank of the Kulen plateau. It was once probably linked by sophisticated hydraulic works to the Kulen streams and to a canal, with an embankment that is still visible in places, that led to the Tonle Sap lake. The moats that, as at Angkor Wat, border the site measure 4 kilometres (2½ miles) in circumference and enclose 108 hectares (267 acres). Although its multiple gopuras

were crowned with towers, of which the largest rose above the central sanctuary, the temple was not a cosmic mountain but built on one level. It is, however, not in a simple linear plan in the manner of other non-pyramid temples, but of a complexity involving lateral constructions and no fewer than three sets of multiple courts, two cruciform and one double. While the three inner precincts are all surrounded by half-corbelled galleries with outer pillars, as at Angkor Wat and later the Bayon, they are not carved with reliefs. Such relief carving as exists is mostly at the bases of pillars and on the cornices and is predominantly Vaishnavite. Although the temple is obviously of great importance, it is in a state of such ruin that even visualizing the layout is difficult. The collapse of the central tower and of many other edifices is so extreme that deliberate destruction, rather than gradual decline from the neglect and the invasion of vegetation as at other sacred sites, can be suspected. A highly expressive seated figure of Avalokiteshvara was found here [146] but has no apparent iconographic connection with the temple. Despite the quality of its carving, consistent with high Angkor Wat style, the humanistic quality of this bodhisattva image has more in common with the Buddhistic style of the Bayon that was to evolve in the last quarter of the twelfth century, and it may have been a transition work placed in the temple in the reign of Suryavarman's successor, his cousin Dharanindravarman II, who was Buddhist.

Suryavarman II continued to push at the boundaries of his empire throughout his reign. No fewer than six times he waged war against either the Dai Viet in northern Vietnam or the Chams in central Vietnam. In all cases but one his forces were defeated, though his control of the regions of present-day northeastern Thailand and even further to the west seems to have remained unchallenged and the pace of his building projects continued unabated for nearly half a century. Perhaps the building and military campaigning undermined the resources of the kingdom, but the events of the years following Suryavarman's death remain rather obscure. The last mention of him in inscriptions comes in 1145, but he was possibly still on the throne as late as 1150. His successor Dharanindravarman II, like Suryavarman a great-nephew of Jayavarman VI, was succeeded by a relative whose exact connections are unknown, Yashovarman II, who seems to have tried to maintain stability. In circumstances that are unclear, he was overthrown by a usurper, Tribhuvanadityavarman, who reigned until a disastrous Cham invasion in 1177. Only one inscription is known from the years between 1145 and 1180, so historical certainty is elusive.

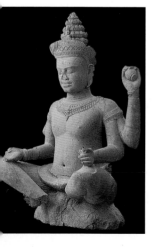

146 Seated Avalokiteshvara. Beng Mealea, Siem Reap, 12th cent. Sandstone, 1.38 m (54⅜ in). The humanity expressed in the face of the bodhisattva of compassion suggests that it may date from the beginning of the more spiritual style of the Bayon period that emerged in the second half of the 12th century.

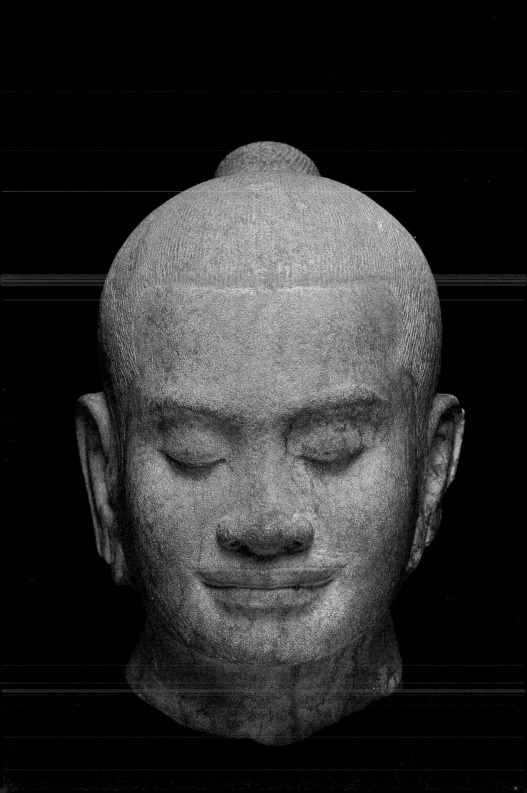

Chapter 7 Jayavarman VII:
the Bayon period and the triumph
of Buddhism

147 Jayavarman VII, head. Preah
Khan, Kompong Svay, Kompong
Thom, late 12th–early 13th cent.
Sandstone, 0.415 m (16½ in).
One of the most famous images
in Khmer art, this serene head
epitomises the spirituality and
humanity of the Bayon style and has
been widely accepted as a portrait
of the Buddhist monarch. The
deliberate references to the
Buddha were presumably intended
to suggest that the king embodied
the wisdom and compassion of the
Great Sage.

Like so many questions of inheritance in Khmer history, the
accession of Yashovarman II (ruled c. 1160–65), whose relationship
to his predecessor, Dharanindravarman II (ruled c. 1150–c. 1160),
is unknown, is a puzzle. Dharanindravarman had a son of suitable
age to succeed him, but this prince, who was later to become
Jayavarman VII (1181–?1218), had to wait more than twenty years
before the throne was his. The dearth of inscriptions dating from
this period means that information about it comes from later
epigraphy, mostly of Jayavarman VII's time. It seems that
Jayavarman, a Buddhist like his father, was in Champa during the
reign of Yashovarman. On hearing of the coup by Tribhuvanaditya
(1165–77), about whom almost nothing is known, he is said to
have returned to Cambodia to help Yashovarman, but too late.
For the next twelve years he apparently made no further move,
during which time the Chams made two unsuccessful attacks on
Khmer territory by land, in 1167 and 1170. In 1177 the Chams
invaded by sea, then up the Mekong and Tonle Sap rivers to the
Tonle Sap lake, defeated the Khmer forces, killed the king and
sacked Angkor/Yashodharapura. Jayavarman must then have begun
consolidating his forces, as in 1181 he defeated the Chams in
a naval battle and drove the enemy forces out of Cambodia,
assuming sovereignty when he was probably more than fifty
years old.

The Khmer kingdom was in a state of considerable disorder
and lawlessness, 'plunged into a sea of misfortune' as the
inscription of Phimeanakas says, as a rebellion occurred in
Malyang, in the west of Cambodia, just one year after Jayavarman's
accession. This was put down and the king gradually achieved
hegemony over the widest sweep of territory in Khmer history.

At the height of his empire, according to Chinese records, there was at the least a state of suzerainty, if not administrative control, from the present border between Myanmar and Thailand on the west, to Champa on the eastern coast of Vietnam. After unsuccessful attacks in 1193 and 1194 on Vijaya, the Cham capital, Jayavarman was finally victorious in 1199 and for the next two decades Cambodia governed its ancient foe's kingdom. To the north Cambodian power extended as far as the region of Vientiane in Laos, and in the south to the sea. Much of our knowledge of this long reign comes from inscriptions, many of them extensive, notably those from pier inscriptions or stele at Ta Prohm (1186, written by one of the king's sons, Suryakumara), at Preah Khan (1191, written by Virakumara, son of a queen called Rajendradevi), at Phimeanakas (undated but later than the former two, written by Jayavarman's second queen, Indradevi, whom he married after the death of his first queen, Jayarajadevi, Indradevi's younger sister), and at Banteay Chmar (also undated, but from late in Jayavarman's reign).

As for the previous period in Khmer art, with the eponymous Angkor Wat style, the art of Jayavarman VII's time is named for the principal temple of his reign, the Bayon. Whether from the benign influence of Buddhism, which became the state religion, or from the cultivation of the persona of the king in a way that had never before been attempted, sculpture in Bayon style dramatically emphasized the human basis of images of the gods, the Buddha and his bodhisattvas, and of the king himself [147]. The Phimeanakas inscription relates that Indradevi had erected images of the king, of her deceased sister and other members of the royal family in many parts of the kingdom. In fact, several versions exist, found in Thailand as well as Cambodia, of a statue that almost certainly is a portrait of Jayavarman intended to reinforce the king's authority and enhance the perception of him as a humane ruler devoted to the well-being of his people [148]. 'It is the suffering of the people that causes the suffering of kings, and not their own' states an inscription on the stele of Say-fong, one of the many hospitals established by Jayavarman. Certainly the impression made by this sculpture and its copies is one of humility and spirituality, where the monarch has eschewed the crowns and jewels of royal privilege in favour of a meditator's loin cloth and the short hair and cranial protuberance resembling the image of the Buddha. While invoking the parallel between the Buddha and himself can hardly be described as modest, the simplicity and individualized humanity of these portraits makes the king seem far

148 Seated Jayavarman VII in meditation. Krol Romeas, Angkor Thom, late 12th–early 13th cent. Sandstone, 1.35 m (53 in). This deeply moving image has come to symbolize the Khmer identity for many Cambodians. Many copies of it were made and distributed throughout Jayavarman's empire; several can still be found in present-day Thailand.

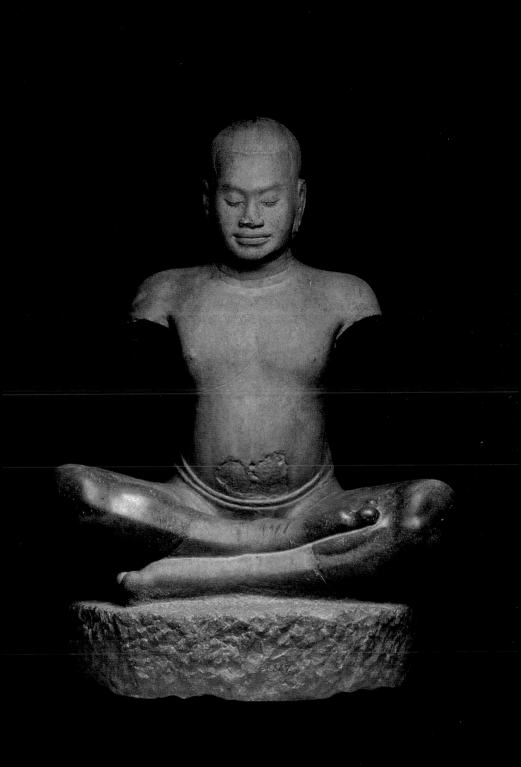

149 Kneeling Tara (?). Preah Khan, Siem Reap, late 12th–early 13th cent. Sandstone, 1.30 m (51 in). The image has been identified with Jayavarman's first wife, the deeply pious Buddhist Jayarajadevi, who is thought to have been important, with her sister, in the king's dedication to Buddhism. The slenderness of the figure has been interpreted as indicating the frail physical condition of the queen, who died at an early age.

150 Lakshmi. Preah Ko, Roluos, Siem Reap, late 12th–early 13th cent. Sandstone, 1.88 m (74 in). Identifiable through the two lotuses she holds, this image of Lakshmi may also be a portrait of Queen Jayarajadevi, shown here in Brahmanistic guise in an ecumenical way that is characteristic of the reign of Jayavarman VII.

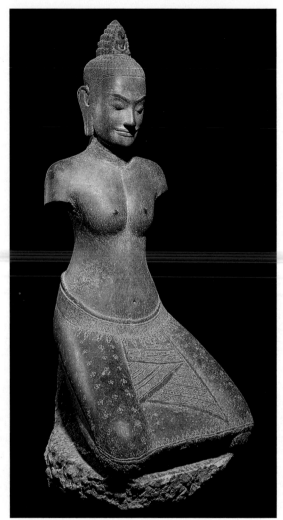

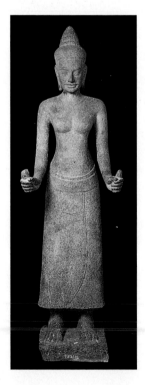

more accessible than the iconic majesty of, for example, the sculptures from Bakong that might also have been intended to associate the ruler with a deity.

The highly particularized image of a kneeling deity (Tara or Prajñaparamita, since the Amitabha Buddha is seated in her coiffure) probably also falls into the category of portraiture [149]. Like the statue of the meditating king, this sculpture was duplicated. Several examples still exist, and it was probably installed in many parts of the realm. From the slightness of the torso – small-breasted and thin by Khmer standards – the figure can be perceived as frail, which would be consistent with a

depiction of the deceased queen, Jayarajadevi. The queen was noted for her devotion to Buddhist scriptures, and according to the inscription of Phimeanakas her pious deeds 'earned her glory in all the worlds'. A strong resemblance between this figure and a standing image of Lakshmi suggests that it, too, depicts Jayarajadevi [150]. The apparent anomaly of the queen's likeness being presented as both a Buddhist figure and the Brahmanic Lakshmi is in fact an indication of an ecumenical approach to religion during Jayavarman's reign that will be further discussed in an analysis of his temples.

The temple of Shri Rajavihara ('holy monastery'), also referred to as Shri Jayarajachudamani (the name of Jayavarman's mother) and now known as Ta Prohm ('the ancestor Brahma'), was dedicated in 1186 and posthumously honoured Jayavarman's guru and his mother. This enormous and complex foundation, south of the southwest corner of the eastern baray, has come to epitomize the invasion of Khmer temples by the strangling growth of the tropical forest. Seeds of the banyan (ficus religiosa) and the cotton tree (ceiba pentandra) have produced hair roots that lodge in joints and cracks. Swollen to serpentine coils, these now romantically clutch the stones in an embrace that has become the structures' armature [151]. The symbiotic tangle of roots, trunks and temple has led to collapse and distortion to the extent that it is difficult to comprehend the plan. To add to the problem, the plan is of great complexity, with a profusion of small sanctuaries branching off from the main galleries, and free-standing towers complicating the relationships among the connecting courtyards.

A lost statue of Prajñaparamita was installed in the central sanctuary, invoking this deity of transcendental wisdom who, with Avalokiteshvara (Lokeshvara), the bodhisattva of compassion, embodies the components that together make possible the perfection of the Buddha. Both can be recognized from the figure of the Buddha Amitabha seated in the headdress. Together with the Buddha, they were often presented as a triad in the Bayon period. It was said that the sculpture for Ta Prohm was in the likeness of the king's mother, so it can be inferred that Jayavarman was fulfilling part of the royal architectural requirements by building an ancestor temple. The temple proper, with three enclosing galleries, a moat and an outer fourth wall, is set in a huge walled outer precinct of 60 hectares (148 acres). The four-sided foundation stele informs us that this land was once inhabited by 12,640 people. Thirteen of these were high priests, among others, and there were more than six hundred dancers. The foundation

was served by 3,140 villages and 79,356 people outside the temple, which owned five tons of gold vessels. The stele extols the king's pious donation of 260 statues of deities and the erection of numerous buildings of a sacred or charitable nature.

The enclosures of Ta Prohm temple itself are crammed into a relatively small space, just 250 by 220 metres (820 by 720 feet). The walls are pierced by gopuras on all four cardinal points; that on the eastern side of the fourth enclosure is the most important. Now ruined, its tower was once crowned by a four-faced head, perhaps the most notable of the architectural elements that distinguish the Bayon style, but this and the corresponding towers on the other gopuras may have been added later, at the time of the construction of Angkor Thom that continued into the thirteenth century. On the east and west of the inner side of the fourth enclosure wall, between it and the moat, stand small ruined buildings that may have been meditation cells. To the right of the cruciform eastern gopura of the fourth enclosure stands a ruined building that may have housed the sacred flame, while the causeway crossing the moat is wide enough to support a large terrace on which stands a quadruple-court structure surrounding a central long space where friezes of apsaras have led to its designation as the Hall of Dancers.

Inside the third enclosure stand several free-standing towers and a long building, in the southeast corner, that may have been a library. To the north and south of the axis of the central sanctuary stand two walled subsidiary temples, taking the complex plan of Beng Mealea a step further. Like that Angkor Wat style temple, Ta Prohm is linear and on one level, with added importance being given to the north and south annexe temples by the introduction of many subsidiary structures. The southern structure was dedicated to the king's guru, Jayamangalartha, the northern to the king's older brother. A confused series of small cellas lie inside the eastern end of the galleried second enclosure, perhaps destined to house the myriad images the king is reported to have erected. Linked corner sanctuaries and axial gopuras or chapels form the inner enclosure and surround the three-part central sanctuary that occupies only 30 square metres (323 square feet).

The plan of Ta Prohm is understood more clearly in the context of the less ruined, though even more complex plan of Preah Khan ('sacred sword'), built five years later to the northwest of the northwest corner of the eastern baray in 1191 [152, 153]. It was originally called Nagara Jayashri, or city of victory. Here Jayavarman completed his ancestral obligations, as the

152 Preah Khan, Siem Reap, 1191. Eastern causeway.
This large temple ('sacred sword') may have served as the residence of Jayavarman VII during the construction of his capital, Angkor Thom, after the devastation of Yashodharapura by the invading Chams in 1177. The foundation stele informs us that it was dedicated to Dharanindravarman, the king's father, and a statue of Lokeshvara in his likeness was consecrated in 1191. Some 97,840 people served the temple, of whom a thousand were dancers.

153 Preah Khan. Siem Reap, 1191. Plan.
The immense complexity of the plan of Preah Khan comprises several subsidiary groups of temples within the third enclosure. Although the temple is Buddhist, two of the annexe temples are Brahmanistic, being dedicated to Vishnu (to the west) and Shiva (to the north).

temple is dedicated to his father, Dharanindravarman II, whose likeness was incorporated into the image of Lokeshvara, in the name of Jayavarmeshvara, in the central shrine. Its stele (four-sided and 2 metres/6 feet high) informs us that in addition the king erected 515 other statues as well as a rest house for pilgrims and a hospital. The 97,840 people serving the religious foundation, of whom a thousand were dancers, lived in the outer area, which measures 800 by 700 metres (2625 by 2300 feet). Reference on the stele to 'a lake of blood' suggest that this was the site of the battle where Jayavarman defeated the Cham king and might also have been the site of the palaces of the two preceding Khmer monarchs. On each of the four axial approach causeways stands a series of statues, shockingly decapitated by looters, with giants (asuras) to the right and deities (devas) to the left, each row holding the body of a naga in the manner of a rainbow bridge [154]. Such causeways characterize Khmer cities, such as Angkor Thom, rather than complexes that were purely religious in nature, and their presence here suggests that Preah Khan was in fact a royal city as well as a temple, and may have been Jayavarman's capital

154 Naga and deva, balustrade. Preah Khan, Siem Reap, 1191. Sandstone, 4.25 m (14 ft). Like the city of Angkor Thom, Preah Khan is approached by avenues lined with balustrades of guardian devas and asuras (deities and giants) holding the body of a giant naga. The balustrade terminates in a upreared multiple naga head. This one was formerly situated in front of the gopura of the third enclosure.

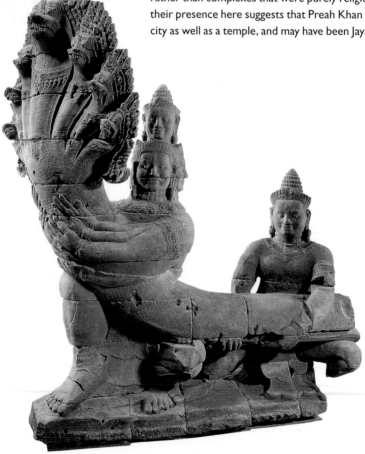

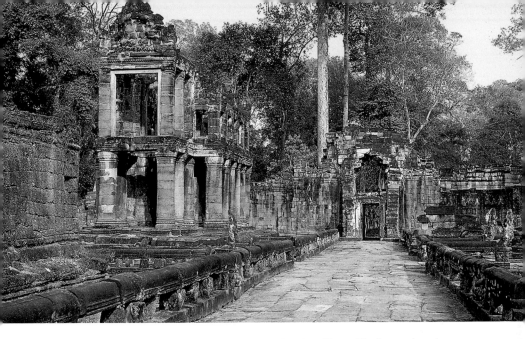

155 Preah Khan, two-storeyed structure.
The function of this rare two-storeyed structure is unknown, but some have suggested that it might have housed the sacred sword, the palladium of the kingdom. Also unusual are its round supporting columns. No access stairs exist to the second floor, leading to the supposition that they might have been of perishable materials.

before the completion of Angkor Thom. The Jayatataka, a huge baray (now dry) measuring 3.5 by 0.9 kilometres (more than 2 miles by ½ mile) that lies to the east of the temple, would have been a suitable fulfilment of the king's obligation to carry out public works.

A landing terrace on the western bank of Jayatataka leads to an avenue bordered by boundary markers. Their bases are decorated on all four sides with fantastic creatures having lion head, human body and garuda legs that support the upper sections. These were once carved with reliefs of the Buddha, but all but two have been defaced, probably in an iconoclastic period of the later thirteenth century when the state religion reverted to Brahmanism under Jayavarman VIII. At the end of the avenue, a few shallow steps lead to a broad sandstone-paved terrace flanked by the rows of devas and asuras. Each line of figures is preceded by the giant rearing head of the naga whose body they are holding, its sevenfold heads towering above the causeway to left and right [154]. To the east and north of the avenue stands a building whose function is not certain but which may be another example of a building to house the sacred flame.

The eastern gopura [152] of the third enclosure of Preah Khan is five-chambered and on a grand scale. The laterite wall, more than 5 metres (16 feet) high, is guarded every 50 metres (160 feet) by a standing Garuda brandishing a naga, the traditional enemy of

Garuda, in each hand; there are seventy-two of these powerful deep reliefs, including the versions that wrap the corners. Beside the path through the gopura's northern portal stands a structure unique in Khmer architecture whose purpose is uncertain [155]. Two-storeyed with round columns, it may have housed the palladium of the Khmer empire for which the temple complex is now named, the sacred sword.

Directly to the west of the portal on the central east–west axis is a similar construction to that in the same location at Ta Prohm, a large open hall between four courtyards where reliefs of apsaras at the cornice have led to its designation as the Hall of Dancers [156]. Its corbelled span would have been the largest span achieved by this technique, but it has long since collapsed. Following a path to the west to the second and inner enclosures, the same dense and rather claustrophobic concentration of galleries, gopuras and chapels found at Ta Prohm is revealed along the path leading to the inner sanctum, where a stupa has replaced the original statue of Lokeshvara. The cornices are finely carved

156 Preah Khan, Hall of Dancers. From the size of this unusually large space in the eastern section of the temple it has been speculated that ceremonies, including ritual dance, might have taken place there. The theory is supported by the reliefs of dancing apsaras figures in the lintels. The columns once supported a corbelled roof.

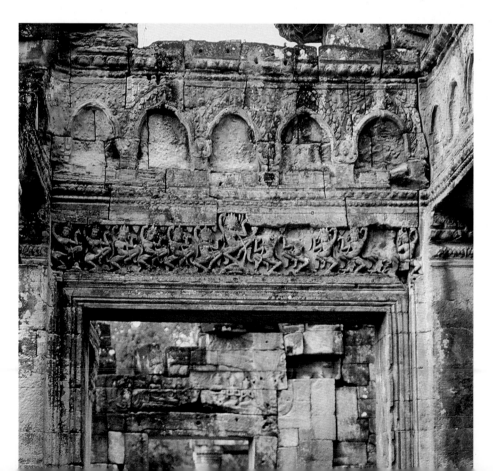

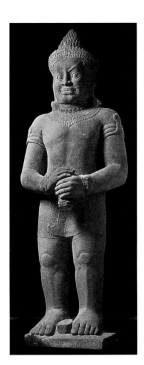

157 Dvarapala. Preah Thkol, Preah Khan, Kompong Svay, Kompong Thom, late 12th–early 13th cent. Sandstone, 2.68 m (105 in). Typically, dvarapalas ('guardians of the gate') were carved in relief and set in niches to left and right of entrance doorways, but monumental free-standing versions were often installed in Bayon period temples. The guardian on the proper right of the gate usually had a benign expression and wielded a trident; that on the left, like this example, wore a fierce expression and held a club.

with foliate and floral motifs and would once have supported wooden ceilings; their disappearance leaves exposed the massive and crude blocks used for the corbelled vaults of the roofs. The fairly regular disposition of small holes in the stone of the sanctuary walls indicates the fixture points for the plaques that formerly lined them, many gilded bronze examples of which have been found. Some inscriptions even refer to glittering jewels studding the walls. In addition, recent restoration work has revealed traces of pigment indicating that some of the surfaces were painted.

Although pilasters flanking the doors and windows of the multiple chambers of the second and inner enclosures still bear relief carvings of devatas and devas like those in the niches of temples like Preah Ko and Banteay Srei, massive free-standing dvarapala figures are also used here and at Ta Prohm to guard the entrances [157]. Like the excellent pediments and lintels that decorate Preah Khan's portals, the deva and devata reliefs have been heavily pillaged.

The presence of subsidiary temples within the third enclosure, tentatively initiated at Beng Mealea and further developed at Ta Prohm, is taken even further at Preah Khan and offers another example of the ecumenical nature of religion under Jayavarman VII. Some might argue that it was not so much ecumenical as a prudent defence against possible offence to a deity still held in reverence by some. There are three annex temples here, one each in the north, south and west. That to the north is dedicated to Shiva and has pediments depicting Vishnu in cosmic sleep and the trimurti, with Shiva standing between Vishnu and Brahma. The temple to the west is dedicated to Vishnu (a with which direction he is associated) and presented reliefs of Vishnu avatars: Krishna lifting Mount Govardhana and an inscription describing now missing statues of Rama, Lakshmana and Sita. The temple to the south was dedicated to former monarchs.

In the middle of what was once the lake of the Jayatataka stands the fascinating small temple of Neak Pean ('twined serpents'). When the baray contained water, this temple would have been in the same position as the island temples of East and West Mebon in their respective barays. Its complex iconography centres on Lokeshvara, who, it is suggested, should be identified with the cleansing of the Khmer kingdom from the stain of the Cham invasion and despoiling. The temple may have attempted to invoke the compassion identified with this bodhisattva to protect the realm. It stands on a round island in the middle of a square

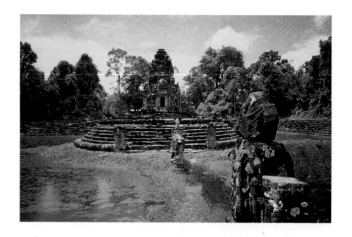

158 Neak Pean, Siem Reap, late 12th cent.
The small temple of Neak Pean ('entwined nagas') forms an artificial island surrounded by ponds in the middle of Jayatataka, the 3.5 x 0.9 km (approx. 2 x ½ mile) baray of Preah Khan that lies to the temple's east. According to the stele of Preah Khan, Neak Pean, dedicated like Preah Khan itself to Lokeshvara, could cleanse the sins of those who performed ritual ablutions. The central pond symbolizes Lake Anavatapta, the sacred lake in the Himalayan city of the gods.

pond with stepped sides of seventy metres flanked on the cardinal axes by smaller square ponds that might have functioned as ablution ponds for pilgrims [158]. Conduits link the central pond with the annexes via mask-heads (of an elephant, a lion, a horse and a human being) in small chapels on the axes.

The stele of Preah Khan describes the temple on the islet as a 'lotus rising that carries the image of the supreme god', a clear reference to the birth of Brahma from Vishnu's navel at the end of his cosmic sleep on the serpent Ananta. The symbolism of the rebirth of the Khmer kingdom after the Cham invasion is clear and offers a further example of the ecumenical embrace of different religions during Jayavarman's reign. The pond itself represents Anavatapta, the lake with sacred curative waters in the homeland of the gods in the Himalayas. The temple's name derives from two nagas, their tails entwined on the western side and their heads framing the eastern approach, that encircle the base of the island. They may represent the sacred nagas associated with Anavatapta, the nagarajas Nanda and Upananda.

The sanctuary of Neak Pean with its false-two-storeyed tower has pediments showing several scenes from the life of the Buddha, including the Great Departure, the meditation under the bodhi tree and the cutting of the Sage's hair. The four doors of the cruciform structure were once open, but except on the east are now closed with large panels carved with tall reliefs of Lokeshvara. This alteration may signal a change of symbolism to intensify the role of Lokeshvara at the sanctuary later in Jayavarman's reign. A cruciform platform of which only traces remain once surrounded the island and bore sculptures. The surviving example represents Balaha, a version of Lokeshvara as a flying horse. He is shown

rescuing the trader Simhala and his companions, who cling to his tail to escape from an island inhabited by ogres; the group is remarkable for its vitality and humanism.

Two other temples that were possibly associated with Preah Khan must have been built in the last decade of the twelfth century or early in the thirteenth. These are Ta Som and Krol Ko. The former, decorated with Bayon face towers like Ta Prohm's, has three enclosures and a central sanctuary with four porches and two libraries surrounded by galleries with corner towers and gopuras on the axes. Its devata figures are of great charm, often smiling with the benign innocence that typifies the expression of the Bayon style. The latter is a single-chamber sanctuary with similar relatively large devata figures in niches at the corners of the redentations.

Jayavarman VII had fulfilled his royal obligations to build ancestor temples and public works, of which the Jayatataka was only one: he also erected many hospitals and hermitages throughout his kingdom, often on the main routes than crossed his realm. But his state temple was only begun late in the twelfth century and took many years to complete, if in fact it was ever finished: the complex and mysterious Bayon with its multiple towers and their enigmatic faces [159]. There were said to be forty-nine towers, but many have fallen and some of the faces have not been completed. The identity of these faces has been the subject of many theories. The suggested personae include the four-headed god Brahma (though this would be inconsistent with the Buddhistic nature of the temple); Lokeshvara multiplied in the cardinal directions to protect the kingdom; the protectors of the cardinal directions; and the king himself [160]. Since Lokeshvara seems to have been central to the iconography of Jayavarman VII's era, that is the most convincing interpretation. The effect of the multiple faces' gaze is compelling, lending an almost palpable presence that makes this temple resonate with ineradicable spiritual power.

The steeply ascending terraces of Bayon signal a return to the invocation of Mount Meru consistent with a state temple. The chapels that radiate from the central sanctuary, 25 metres (82 feet) across on the upper platform, make it appear circular and add to the stupa-like impression of the upper segment of the temple. The plan is confused, having been altered at least once in the course of constructions, and in some cases the terraces and galleries are so closely set that there is no room to pass between them. The general plan conforms in principle to the usual

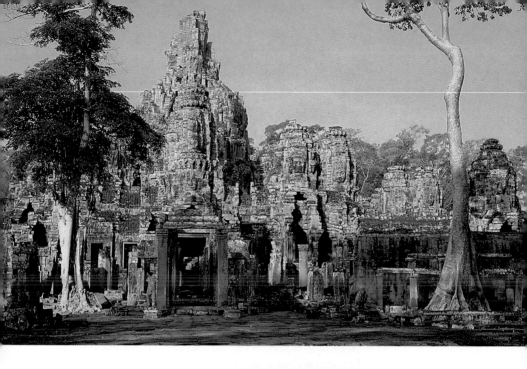

159 Bayon, Angkor Thom, Siem
Reap, late 12th–early 13th century,
general view.
The state temple of Jayavarman VII,
Bayon is the most enigmatic of the
temples of Angkor. Built on the
foundations of an earlier temple,
and altered during construction,
its complex plan is dominated by
towers sculpted with a head on all
four cardinal faces. Although
Buddhistic, it is ecumenical, having
chapels and sculptures devoted to
the Brahmanistic pantheon as well
as to the Buddha, Lokeshvara and
other Buddhist entities.

160 Bayon, tower.
The identity of the face on the
Bayon towers is unknown. Some
suggest it is the bodhisattva
Lokeshvara, some say it is Brahma
and some perceive the divine
guardians of the cardinal directions.
Others believe it is the face of
Jayavarman himself, or the king
configured as the bodhisattva.

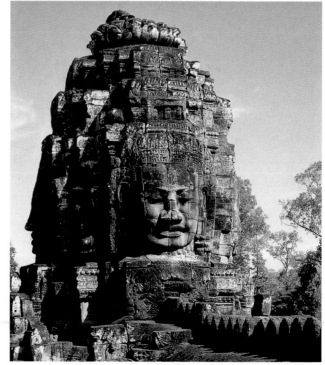

disposition of concentric enclosures, except that there is no fourth enclosure. This was no doubt because Bayon was set at the heart of Jayavarman's capital, Angkor Thom ('great city'), which had its own formidable walls, so there was no need for the outer precinct. A lion-guarded entrance path (the beasts have a highly stylized mane and eyes and muzzles strongly influenced by Chinese style) flanked with naga balustrades leads to the ruined east gopura. Through it stands the wall of the outer (third) enclosure, 4.5 metres (15 feet) high and 140 metres (460 feet) north–south by 160 metres (525 feet) east–west. This was once surrounded by galleries with half-vaults, now collapsed, supported on an outer row of pillars as at Angkor Wat. This is the site of the remarkable reliefs that provide not only historical information but the best available insight into the daily life of the Khmers at the end of the twelfth century.

Turning to the south and following the upper register of the reliefs reveals several battle scenes [161]. As at Angkor Wat, processions of the army show generals with swords over their shoulders riding in elaborate howdahs on elephants, sheltered by umbrellas indicating high rank and surrounded by armed troops. There are horses, musicians, followers, in settings that suggest lush tropical trees. Naval battle scenes depict elaborate naga-prowed ships and many versions of teeming marine creatures in the water. The identity of these scenes is not certain, but they probably represent the battles against the Chams and perhaps the revolt of Malyang. The disposition of the massed troops and ships is well planned and controlled, although the quality of the reliefs, sometimes arranged in two registers, sometimes more, is less meticulously maintained than at Angkor Wat and there is less

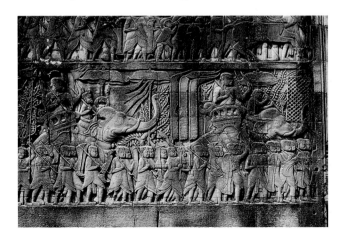

161 Bayon, relief: general in procession.
The third and second enclosures of the Bayon are lined with galleries carved in narrative reliefs. Some depict scenes from Hindu mythology, some present episodes from Cambodian history, while others show scenes from daily life. This relief shows a Khmer general riding an elephant in a procession during combat against the invading Chams who sacked Angkor in 1177.

individualizing of the personages in the processions. In many areas, particularly on the walls of the west and north galleries, large areas of the relief remained unfinished, sometimes are barely sketched in.

Without doubt the chief interest of the outer gallery reliefs lies in the glimpse they give of everyday life. Khmer dwellings are shown, of wood with carved gables much like today's village structures. Inside are scenes where people sit and chat, work, cook, eat, attend women of status, care for children, search for lice on each other's heads and even attend a woman in childbirth [162]. Outside subjects include men killing buffaloes, hunting deer, carrying provisions, being attacked by wild beasts and pulling carts that resemble those still used by Cambodian farmers today. There are market scenes and depictions of chess games, cock fights and wrestling matches, in short, a broad representation of the social life of Jayavarman's subjects. Of particular interest on the west wall is a scene showing the construction of a temple. Workmen are shown drilling the blocks of stone with poles to create the

162 Bayon, relief: woman in childbirth.
This panel, showing a woman in childbirth attended by helpers in a small pavilion, is one of many Bayon reliefs offering information about daily life in Cambodia in the 12th century.

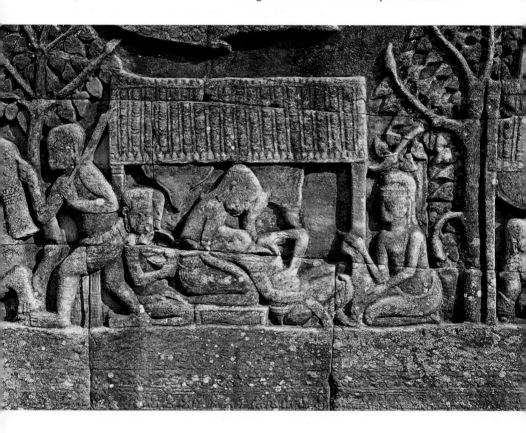

holes into which bamboo wedges were driven and lashed with vines. When wet, these would swell and become firmly fixed, thus offering a purchase so the stones could be raised by what seems to have been a block and tackle technique.

The third enclosure wall is pierced by sixteen entrances to the space between it and the second enclosure wall. These once led to chapels that were pulled down during the thirteenth century, rubble-strewn evidence of the many changes made during the course of construction. The only remaining buildings in this space today are libraries in the southeast and northeast quadrants. The second enclosure wall, like the third, is richly endowed with reliefs, but these are of a completely different nature and were probably carved later. Following the series of gopuras and redentations of the second enclosure, they are broken into small segments depicting a wide range of subjects, some of them hard to identify but probably drawing on legends well known at the time, including the story of a king who contracted leprosy. There are scenes of palace interiors, further battles, naga-headed boats on lakes, ascetics meditating, Vaishnavite scenes including Vishnu on Garuda and the Churning of the Ocean of Milk and Shaivite scenes including Shiva Nataraja, Shiva battling Kama, Shiva on Mount Kailasha threatened by Ravana, Shiva with Uma and Shiva in several scenes from the *Mahabharata*. The carving is dynamic and full of charming details like a man persuasively holding a woman by the wrist and a woman clutching a container that seems to hold small vessels for the betel nut ceremony. Whether the Brahmanistic subjects indicate additions made after Jayavarman's Buddhism had been abandoned, or whether they are further indications of the inclusive and syncretic approach to iconography practised at the time, it is impossible to know.

Diverging from the steps to the upper level entails penetrating narrow and dark corridors in seemingly random confusion, any overview of the plan being restricted by support walls for differing layers of additions to the original upper construction that leave insufficient space for a person to penetrate. The upper level itself is open and yet intimate, ringed by towers on the outer edge at the cardinal points entered by short walkways. On the inner edge it is closely surrounded by the shrines that cluster around the central sanctuary. In receding layers, more like caves inserted into the body of a stupa, these rise up the tower to its final vertical thrust. Balustrades separate the platform from partially concealed pediments of portals that were once in the open but are now at a level below the pavement of the upper terrace. One of these

portrays a particularly fine image of Lokeshvara. Supple devatas in the humanistic Bayon style decorate pillars and interpilaster spaces, and overhead the towers over the galleries and gopuras loom mysteriously on all sides, their enigmatic faces gazing commandingly in all cardinal directions.

Bayon is a particularly egregious example of the faulty engineering that has led to the collapse of many Khmer monuments. Although their foundations and cores, often of laterite, which is not only strong but has excellent drainage qualities, were soundly constructed, and although the sandstone blocks of the upper portions were well cut and dressed, they were not stacked with alternating vertical joints nor bonded between courses, so that load was not distributed in a sound structural manner. The quality of the sandstone itself was also a factor in deterioration. As a sedimentary rock it may have inherent composition discrepancies between layers. These may lead to differing rates of absorption and drying out (particularly in the case of bentonite), which can produce deep delamination over time. Imperfect control of corbelling, itself structurally vulnerable, and the practice of placing pillars with the grain vertical exacerbated the capillary action of water, which meant that water accumulating during the rainy season weakened the stones from within.

The shrines of the central sanctuary of Bayon were dedicated to many deities, according to short inscriptions on their piers. These were both Buddhistic and Brahmanistic. The idol of the central tower was said to be a Buddharaja, and may have been another of the likenesses of Jayavarman VII. Excavation on the upper terrace in 1933 revealed the fragments of a Buddha sculpture 3.6 metres (12 feet) tall, which may have been the original image. It has been reconstituted and stands under its own pagoda to the south of the road leading through Angkor Thom to the city's Gate of Victory. Scholars have theorized that Bayon, with the Buddha as its central image, completed the triad of temples honouring the three elements of Buddhist perfection: Lokeshvara, personifying ultimate compassion, had been incorporated in Preah Khan. Prajñaparamita, embodying the perfection of wisdom, had been invoked in Ta Prohm. The Buddha himself, uniting the qualities of the two, was embodied in Bayon, which also paid tribute to many other gods in the pantheon.

As has been mentioned, sculpture representing these three beings of the Buddhist triad were very widely made in the Bayon era, particularly in bronze. One of the most beautiful examples,

larger than most, exemplifies many of the characteristics of Bayon style, with pronounced arched eyebrows in a continuous line over the nose, which is rather long, almond-shaped eyes, oval face with wide mouth and an expression of benign tranquillity [163]. The downcast gaze suggests meditation, which such figures aided when in votive use. Both Prajñaparamita and Lokeshvara hold lotus buds and palm leaf books, signifying purity and the wisdom of sacred texts, and in addition Lokeshvara holds a flask containing the water of immortality and a rosary. The Buddha, under whom is inscribed a Sanskrit character meaning 'great', sits on the triple coil of the naga in half lotus position and holds a small container signifying that he is the Buddha of healing, Bhaishajyaguru.

All have a third eye, signifying perfection, on the forehead. The extraordinarily refined facture of the group, with meticulously rendered details of the naga's scales and expressive faces, the lotus petals that cup the Buddha, the coiffures, jewels and richly decorated garments of the figures, epitomizes the highest achievements of late twelfth-century sculptors.

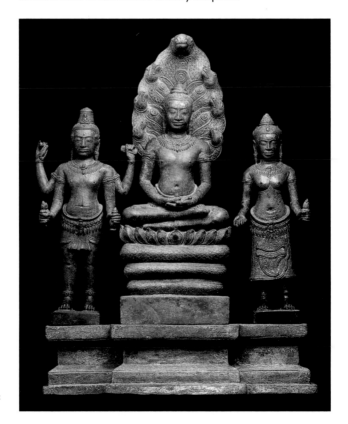

163 Buddhistic triad. Prei Monti, Roluos, late 12th–early 13th cent. Bronze, 0.495 m (19½ in).
The Buddha sits on a lotus cushion on the coils of the protective serpent Muchilinda. He is flanked by Lokeshvara (a version of Avalokiteshvara) and Prajñaparamita, each embodying one of the two components of the Buddha, infinite compassion and perfect wisdom. Each has a third eye, symbolizing spiritual perfection. Such triads were important icons during the Bayon period, and embody the humanistic morphology of that style.

164 (below) Lokeshvara. North Khleang, Angkor Thom, Siem Reap, late 12th–early 13th cent. Bronze, 0.44 m (17⅜ in).
Lokeshvara, lord of the world, was identified in Jayavarman VII's reign with the king's father. This image has lost some of the attributes of the bodhisattva (a flask of the nectar of life, a lotus bud, a book signifying wisdom and a rosary), as well as the seated figure of the Amitabha Buddha in his headdress, but the hollow in the coiffure where it was once attached is visible.

165 (opposite) Radiating Lokeshvara. Preah Thkol, Preah Khan, Kompong Svay, Kompong Thom, late 12th–early 13th cent. Sandstone, 1.13 m (44½ in).
The image of Lokeshvara with radiating arms, sometimes as many as thirty-two (as at Banteay Chhmar), is unique to Khmer art and was common in the Bayon period. The myriad small figures of the meditating Buddha that cover his torso signify the compassionate power of the Buddha radiating throughout the universe. The expression of the face epitomises the famous Bayon smile.

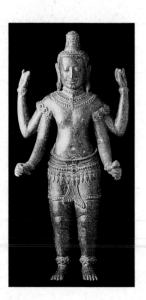

A powerful figure of Lokeshvara shares many characteristics with the triad [164]. Though some of his attributes have been lost, they would have been the same as those held by the triad Lokeshvara. The elaborate detailing of jewelled belt, necklace and armbands as well as the naturalistic treatment of the torso typify Bayon style, as do the heavy limbs. The same features distinguish an image of Lokeshvara with radiating arms [165]. This version of Lokeshvara, known as cosmic or radiating Lokeshvara, is one of the distinctively Khmer forms that emerged in the Bayon period and emphasizes the great importance of this bodhisattva during Jayavarman VII's reign. The cosmic Lokeshvara offers another example of the ecumenical embrace of Jayavarman's Buddhism, expressed in the diverse nature of the attributes held in his eight hands. In addition to the book, rosary and flask expected for Lokeshvara, he holds emblems associated with Brahmanistic symbols: elephant goad, disk, sword and vajra, the lightning bolt symbol also associated with Tantrism and the Diamond Way. An Indian text in praise of Lokeshvara states that he bears the universe in his body, where his skin pores are microcosmic and radiate as miniature images of the Buddha, who also appears in larger forms encircling his waist as well as dominating his chest in this example. Like the bronze versions, this sandstone figure has the broad forehead and oval face, with slanted almond-shaped eyes and wide full mouth, that characterize Bayon style.

The heart of Jayavarman's empire was Angkor Thom, at whose centre sits the state temple of Bayon. No other Khmer monarch went to such lengths to develop a planned capital, and the present form of the city is still defined by Jayavarman VII's concept [167]. The walls of the city, 3 kilometres (1.86 miles) on each side, enclose an area of 900 hectares (2225 acres) and are bordered by 100-metre (328 feet) wide moat. They are almost 8 metres (26 feet) high and are reinforced on the interior by an earthern rampart that forms a broad road around the interior of the perimeter. At the subcardinal points are temples dedicated to Lokeshvara (all called Prasat Chrung) with four porches projecting from a cruciform sanctuary with two-storeyed tower. Ubiquitous Bayon-style devatas and windows with balusters and false blinds decorate the walls, and each temple contains a four-sided stele with inscriptions likening Angkor Thom to Indra's capital, the cosmic mountain that is home to the thirty-three gods and is surrounded by the cosmic ocean. The assembly hall of the gods is equated by Bayon with its multiple deities.

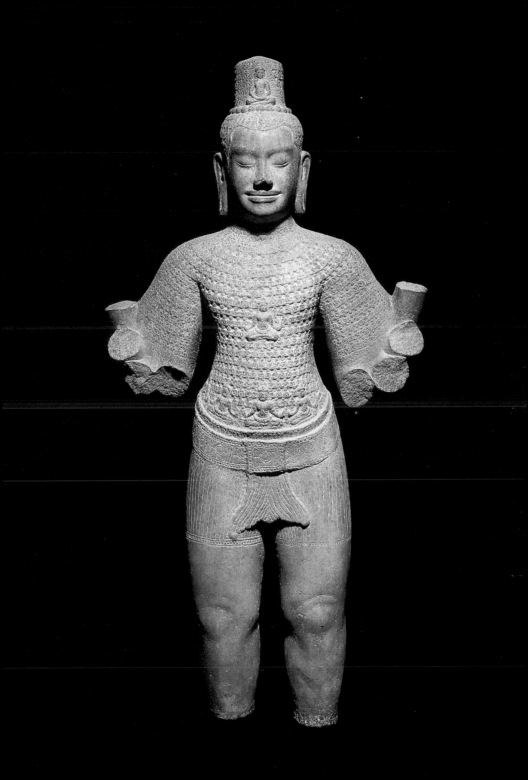

166 Angkor Thom, Srah Srang.
The royal bathing pond is ringed
around its perimeter with steps
giving access at all water heights.

167 Angkor Thom ('great city'),
causeway and south gate.
The causeways crossing the moats
at each of Angkor Thom's five gates
are lined by 54 guardian figures
bearing the body of a naga whose
head rears at the front.

168 Angkor Thom, west gate,
north face.
The same mysterious faces that
dominate the towers of Bayon
surmount the towers of Angkor
Thom's monumental gates.

At the four cardinal points, on both axes of Bayon, the moat is
crossed by a causeway. As at Preah Khan, it is lined with rows of
giant guardian figures holding nagas, fifty-four of each making a
total of one hundred and eight, that most propitious of numbers
for the Khmer. The path ends at the towering gate with four faces
that penetrates the wall [167]. A fifth gate with the same
construction, called the Victory Gate, crosses the moat on the
axis of the royal palace with the East Mebon and Banteay Samre.
As with the figures at Preah Khan, the identity of the giants has
been the subject of many hypotheses. The similar disposition of
figures pulling on a naga in the scene of the Churning of the Ocean
of Milk has led some to interpret them as illustrating that myth,
suggesting that the search for the water of immortality was part of
the symbolism of the city and the well-being of the king. Others

believe, in the absence of any representation of the pivot of Mount Mandara that was crucial to the Churning, that they should be seen as constituting the rainbow bridge that leads from the mundane world to the abode of the gods. Jean Boisselier, in one of the most convincing interpretations, suggests that the reference is to the Indian story where Indra was attacked and temporarily defeated by the asura whom he had ejected from his heaven. His retreat was unintentionally turned back by encounters with many garudas who happened to be flying in the sky. Indra's movement appeared to the asura as a counter-attack, causing them to flee. To protect against further attack, Indra had his heaven defended by nagas, by two families of yaksha (minor deities who were protectors of property), by the four protectors of the cardinal directions, and by Indra himself on his three-headed elephant, Airvata, at the sub-cardinal points. Every element in Boisselier's theory is in fact present, though not all components remain at all gates. As at Bayon, the enigmatic faces on the towers impart an unforgettable image of power and watchfulness [168].

Water management continued to play an important role in Cambodian administration, certainly for ceremonial purposes and presumably also for utilitarian civic and agricultural reasons. There is evidence that the Khmer changed the course of the Siem Reap river several times over the course of the centuries, and that they continued to build canals to link their barays and moats to the water supply of the region's rivers. The slope of the land in Angkor Thom was slanted from the northeast to the southwest corner, where a pond communicated with the river-fed waters of the moat outside through five tunnels that pierced the rampart and the wall. While such public works were being created, probably during the completion of the building of Bayon and Angkor Thom in the thirteenth century, Jayavarman also catered to the public image of the monarchy by building ceremonial structures such as the terraces to the east of the royal palace along the vast open space (550 by 200 metres/1800 by 656 feet) where parades and festivities took place. Zhou Daguan, in his 1296 account, describes elaborate fireworks and ceremonies that took place there. Royal processions, where up to five hundred palace dancers with flowers in their hair and candles in their hands preceded a parade of dignitaries and princesses in palanquins and carriages, lasted all night. Last in the procession came the king, protected by innumerable white parasols with gold handles, standing on the back of an elephant and holding aloft the Sacred Sword.

Known as the elephant terrace for the huge reliefs carved on

169 Angkor Thom, elephant terrace.
In front of the royal palace a high platform almost 300 metres long, once covered with structures in impermanent materials, offered a viewing place for the royal party and dignitaries to watch public spectacles and processions. Several flights of steps give access to the platform, while huge elephants and garudas in relief decorate the walls.

its supporting walls, the main terrace is more than 300 metres (985 feet) long, with five projecting terraces where steps, some flanked by triple-headed elephants, lead to the upper level [169]. At some places the reliefs are of garudas. Structures in perishable materials formerly stood on top. Near the north end of the terrace stands another platform, 25 metres (82 feet) square and 6 metres (20 feet) high, whose walls are densely sculpted with registers of fantastic creatures and apsaras. For unknown reasons the exterior wall conceals and forms an enclosure of the central solid body of the terrace, separated from it by a space scarcely wide enough to walk through, both walls richly sculpted in the same way as the exterior. The platform may have served as a cremation place but no inscription confirms this. It acquired the misleading name 'Leper King Terrace' because a sculpture erroneously so called was found there.

Tantric Buddhism, in which the individual path to enlightenment can be accelerated under the guidance of a guru, generated many votive images in the Bayon style. One of the most unusual and explicit is a small bronze shrine containing the figure of a dancing sixteen-armed Hevajra, the principal deity of the sect, dancing on a prostrate figure with multiple heads on the platform of an eight-petalled lotus blossom [170]. Around him dance six (of

170 Shrine with Hevajra. Unknown provenance, late 12th–early 13th cent. Bronze, 0.205 m (7⅞ in). Hevajra, chief deity of the Tantric path to enlightenment, dances on the four Maras, the embodiment of the four chief evils preventing enlightenment. He is surrounded by yoginis, female emanations of Hevajra who aid enlightenment through yoga practices. Six remain of the original eight figures, who number the same as the cardinal and sub-cardinal directions.

171 Prajñaparamita. Unknown provenance, second half 12th cent. Bronze, 0.15 m (6 in).
A seated Prajñaparamita is relatively rare in Khmer sculpture. This figure has eleven heads, some frontally shown, some in profile, in two tiers, with the Amitabha Buddha in the upper front head. Her twenty-two arms hold attributes, some of which can be identified as lotus buds. Eleven is a significant number in the listing of elements important in gaining enlightenment on the Tantric path.

the original eight) yoginis. The refinement of this masterpiece of bronze casting is found also in a rare image of Prajñaparamita with twenty-two arms and eleven heads [171]. Bronze images of many kinds proliferated in the late Bayon period, including many vessels such as the vajra and bell associated with both Buddhist and Brahmanic rituals.

While the statuary of Jayavarman's reign was predominantly Buddhistic, in the light of the inclusive attitude to religion that characterized the period it is not surprising that many Brahmanistic works were also created at the time. Ganesha was a popular subject [173], demonstrating that the cult of Shiva was extant, as does a sandstone image of Ardhanarishvara, the representation of Shiva in his androgynous form [172]. This manifestation of Shiva is rare in Cambodia; Bayon morphology is unmistakable in this example, including the characteristic clumsy treatment of the limbs. Vaishnavite images were also created, such as a powerful figure of Narasimha, Vishnu's lion avatar. In addition, while most temples were dedicated to Lokeshvara, or at least were Buddhist in their principle iconography, some of the structures at Preah Pithu, a group of temples at the north end

172 Ardhanarishvara. Prasat Sra Nge, Roluos, 12th–13th cent. Sandstone, 0.783 m (30 in). This image of the androgynous version of Shiva, the male portion depicted on the figure's right and the female, or Uma half on its left, is rare in Cambodia. It illustrates the somewhat clumsy treatment of limbs that is frequent in Bayon style sculpture.

173 Ganesha. Unknown provenance, late 12th–early 13th cent. Bronze, 0.255 m (10 in). Ganesha's bracelets, the cord over his chest and the noose in his upper left hand are formed from snakes. His upper right hand holds his broken-off tusk, missing from his right jaw. Endowed with magical powers, he is a popular icon of protection.

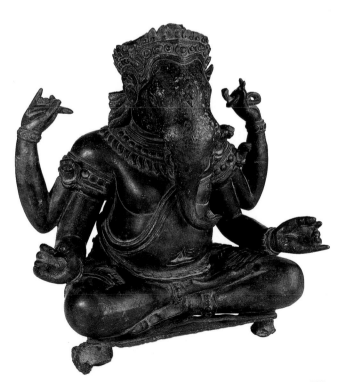

174 Pediment. Preah Pithu,
Siem Reap, first half 13th cent.
Sandstone, 0.87 × 1.34 m
(34¼ × 52¾ in).
This narrative relief from Preah
Pithu, to be read from the viewer's
right to left, shows Parvati
meditating to be worthy of
becoming Shiva's bride. She plugs
her ears to block out the
derogatory remarks about Shiva
being uttered by an ascetic; the
ascetic is none other than Shiva,
testing her loyalty. After the
revelation of his identity, Parvati
kneels in ecstasy at his feet.

177 (opposite below) Banteay
Chmar, late 12th–early 13th
century, gopura, relief with
Avalokiteshvara.
This enormous temple in the
northwest of Cambodia was
dedicated to the son of Jayavarman
VII who was killed in battle against
the Chams. Four chapels are
dedicated to the four generals who
served him, all of whom the prince
saw killed. Ruthless looting has
threatened its sculptures, including
the reliefs of Lokeshvara with
thirty-two arms flanking the
gopuras of the third enclosure.

of Angkor Thom, have pediments with reliefs of Brahmanistic
scenes [174]. The five temples and the traces of approach
causeways and enclosure walls seem to have been built at various
times from the twelfth to the thirteenth centuries and, with their
high receding storeyed structure, could be described as small
temple mountains. The relationship among the buildings is not
clear from their relative citing and little is known about them.
Their pediments offer scenes of Shaivite, Vaishnavite and, in one
temple, Buddhistic subjects. They merit further research.

The liveliness and naturalism of the Bayon style is well
demonstrated in the bronze terminal of a military standard in the
form of a monkey with vigorously upraised leg [175]. The reference
could be to the monkey army of the *Ramayana* and was clearly
frequently invoked, as can be seen in a relief from Bayon showing
an identical figure [176].

Although it is a smaller structure, the temple of Banteay Kdei
is enclosed in an outer wall almost as long as that of Ta Prohm,
whose layout it resembles, but on a less grand and complex scale.
The four gopuras are distinguished by typically Bayon style towers
with faces. The inner portion comprises two galleried precincts
and a hall of dancers. On its walls can be found the characteristic
devatas, supple and graceful figures with the famous Bayon smile,
as well as reliefs of Brahmanistic subjects. This temple has aroused
considerable recent interest because an important cache of

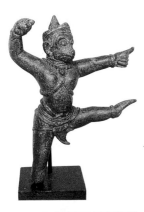

Buddha images was discovered in the course of restoration. The possibility exists that they were buried to protect them from the depradations of the iconoclastic reign of Jayavarman VIII.

One of the last of the great architectural projects of Jayavarman VII's reign was the huge temple of Banteay Chmar ('citadel of cats'). Built about 150 kilometres (93 miles) to the west of Yashodharapura/Angkor not far from the present border with Thailand at the foot of the Dangrek range, it was on the road that led to Phnom Rung and Phimai. Its outer walls enclosed an area almost as large as Angkor Thom (which was exceeded in size only by the vast twelfth-century complex of Preah Khan of Kompong Svay to the east of Angkor), and like Ta Prohm and Preah Khan, it was linear and built on one level. Dedicated to Lokeshvara and the son of Jayavarman VII who was killed in battle against the Chams, it is in a state of profound ruin and has recently been subjected to systematic and drastic looting. The presence of some towers with faces marks it as a Bayon-style structure, and its reliefs, like those of Bayon, offer a mixture of sacred and historical scenes. The most remarkable images are the enormous figures of Lokeshvara with thirty-two arms that flank the gopuras of the third enclosure [177]. The extent of the collapse of this complex foundation, like the deterioration of many other temples of Jayavarman's kingdom, can partly be attributed to the haste in which many of the buildings were constructed. The hewing of blocks, the care with jointing, and the details of relief carving were all executed with much less precision than in the Angkor Wat era, and in many cases relief carving was left unfinished.

175 Standard in monkey form. Prasat Phnom Bayang, Ta Keo, late 12th cent. Bronze, 0.177 m (7 in). The monkey character may refer to the monkey army led by Hanuman that helped Rama in the battle against Ravana as narrated in the *Ramayana*. The thick chain around chest and shoulders is a sign of high rank.

176 Bayon, relief showing standard with monkey. The relief shows a military standard of the kind shown in ill. 175 (above) being carried in battle.

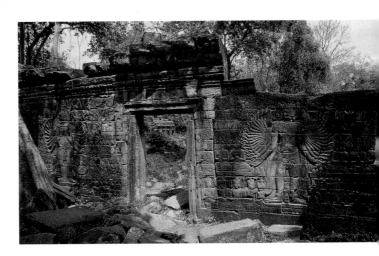

178 Spean Mei Mai, Siem Reap. The bridge is one of 12 remaining bridges from a total of 212 that once stretched along the Royal Way from Bayon to Phimai in northeastern Thailand.

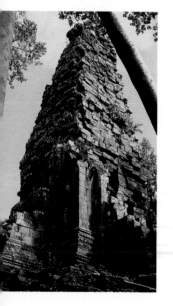

179 Preah Palilay, Siem Reap, sanctuary seen from the southwest.
This Buddhist sanctuary with its steep tower is flanked by steps and portals on all four sides. The fabrication of the tower is from previously used stones.

Jayavarman's attempts to establish temples at the boundaries of his empire and to maintain contact with these areas were supported by his erection of bridges and roads throughout the kingdom. There were more than two hundred between Angkor and Phimai alone, and although many have disappeared, some not only survive but are still in use [178]. Together with the myriad hospitals and associated chapels he built for pilgrims on the so-called Royal Way, the roads and bridges and hydraulic structures comprised a body of public works that no other Khmer monarch even attempted. Whether these enterprises signify megalomania or unprecedented royal dedication is a question that will probably be debated for ever.

The date of Jayavarman VII's death is not certain, but he must have been more than eighty years old. His posthumous name was Mahaparamasangatapada. There is scant information about the last years of his reign, and he was succeeded by his son, Indravarman II (1218–43). He seems to have continued the traditions of Buddhism but little is known about his life or reign, the only inscription concerning him being one mentioning the date of his death. It is possible that two later Angkorian creations could date from this period. One is the Buddhist shrine of Preah Palilay [179]. Its dramatically steep tower is unfinished, leading to the speculation that it might once have been covered with some materials, such as tiles, that have disappeared. Also of a late twelfth- or thirteenth-century date, or perhaps even later, is one of the more famous works in the National Museum, the statue of the so-called Leper King [180]. It has been speculated (on the basis of legend alone) that either Jayavarman VII or his son were victims of leprosy, perhaps miraculously cured. The image of the seated figure with one knee upraised, with long flowing locks and fang-like teeth, was found on the terrace in Angkor Thom that popularly bears his name, and offers a good illustration of the way popular legend can infuse the original purpose of an object or site with a new meaning. Current thinking identifies him as Yama, the god of death, which would reinforce the interpretation of that terrace as a cremation platform.

Jayavarman VII's reign is the last for which information from inscriptions and artifacts enables us to piece together a reasonable framework of chronology and style. Almost nothing is known about succeeding reigns, with the exception of the years just after the reign of Jayavarman VIII (1243–95), and this only through the fascinating account of his visit in 1296–97 by the Chinese emissary Zhou Daguan, at the beginning of the reign of Indravarman III

(1295–1307). The empire might have been in decline compared to its power under Jayavarman VII, but Zhou's description is of a kingdom showing every sign of pomp and circumstance. Whether the resources of the kingdom were so overtaxed by Jayavarman's manic building program, whether the empire had stretched too far for the centre to hold, whether the population increasingly resented the strain of carrying out such ambitious projects, or whether the increasing power and organization of the Thai civilization based at Ayudhya was simply superior in economic and military strength, we do not know, but by the fourteenth century the autonomy of the Khmer kingdom was severely depleted. It was probably a combination of these factors that led to the steady decline of power and influence culminating, after several decades of sporadic incursions and clashes, in the abandonment of Angkor in 1431 after a final triumphant Thai invasion.

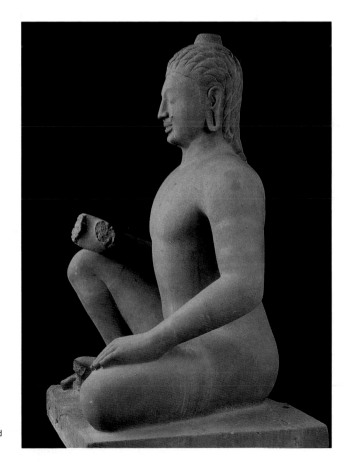

180 Leper King or Yama. Angkor Thom, Siem Reap, 12th century, inscription K295. Sandstone, 1.31 m (51½ in).
The lack of garments and other details makes it difficult to identity this statue. It has popularly been associated with the legend of a monarch of Angkor said to have constructed a temple in gratitude for being cured of leprosy, but there is no historical proof of this. It has also been suggested that the sculpture represents Yama, the god of death.

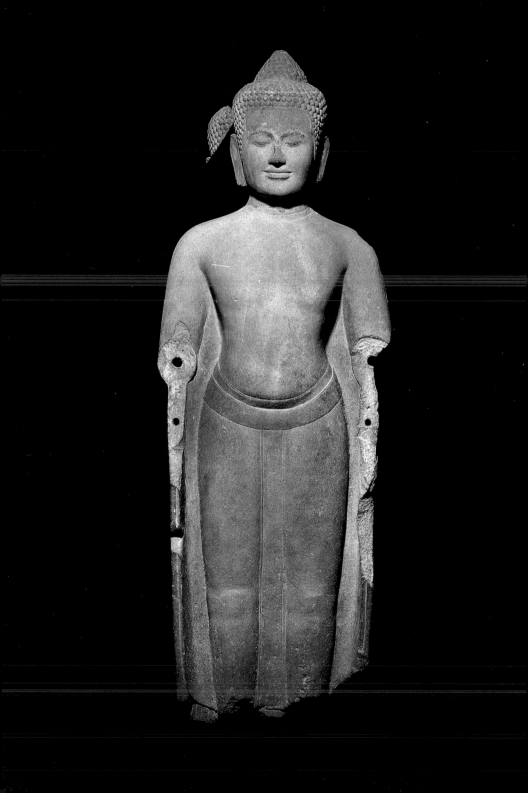

Chapter 8 After Angkor:
Political change and the continuity of culture, thirteenth century to the present

Angkor has so dominated perceptions of Cambodia that the events and creations falling outside the time and style it encompasses have tended to lack attention. While this has largely been adjusted for the magnificent culture of the pre-Angkorian centuries, the seven hundred years that have ensued are still little understood or appreciated.

As usual with historical and artistic transitions, there are few cæsuras to show where one era or style ends and another begins. While some of the temples in the Preah Pithu group and Preah Palilay were probably constructed in the thirteenth century, there were no more grandiose monuments in stone after the reign of Jayavarman VII except for Mangalartha, a large temple from late in Jayavarman VIII's reign (1243–95) where architectural skills show a marked decline. Sculpture, however, continued to express a grandness of vision that accorded well with the spirituality and humanism that had infused Bayon morphology. While the Buddhism of that time had been of the Mahayana school, Theravadin influences, apparent already in pre-Angkorian sculpture [14], had perhaps never totally disappeared. In the thirteenth century there is evidence that this Way of the Masters school of Buddhism was gaining more prominence, perhaps encouraged by increasing influences from Thailand, which followed that school. The type of the adorned Buddha in Angkor Wat style was superseded by the more ascetically garbed and somewhat reductive images (often referred to as the Commaille Buddhas, after the French curator of Angkor early in the twentieth century who warmly praised them) [181]. Though they are clad only in simple monastic robes and have eschewed the jewelled belts and crowns of earlier examples, they retain the benign and

181 Buddha. Preah Khan, north wing, gopura III east, second half 13th–14th cent. Sandstone, 1.78 m (70 in).
By the 13th century, under influences from Thailand, Theravada Buddhism was replacing both Brahmanism and Mahayana Buddhism as the principal religion of Cambodia. Serene images with pronounced humanistic traits replaced the more hieratic images of the Buddha seated on the naga that were typical of the previous century.

spiritual expression that reached its apogee in the Bayon period. They also embody the generous scale and naturalism of the huge Lokeshvara sculptures that proliferated during Jayavarman VII's reign, and with the swelling volumes of their abdomens and chests they emphasize the prana, or inner spiritual breath, that had been a marked feature of pre-Angkorian style.

The broken arms of the Buddha mentioned above reveal a new technique to deal with the vulnerability of projecting limbs (and perhaps to reduce the mass of the block of stone that had to be carved out to create the arms projecting a considerable distance in front of the torso). The clearly visible holes reveal the location of armatures that fixed in place limbs that had been carved separately and added later to the body of the statue. These may have been of stone (fragments have been found) but also perhaps of wood.

Skills in bronze casting continued, and several masterly examples from this period exist. The large standing Buddha from Kong Pisei [182], like the stone Buddha discussed above [181], is garbed in simple monastic robes that reveal the outline of the naturalistic torso and legs beneath. The expression, while tranquil and spiritual, is somewhat more iconic. The stylization of the curls in the coiffure perhaps indicates influences from the U Thong style of neighbouring Thailand, as does the flame that sprouts from the top of the slightly conical ushnisha, both stylistic elements stemming from the Theravadin style of Sri Lanka.

The account of the Khmer capital by Zhou Daguan (1296–97) is the last first-hand record of the Khmer kingdom until the reign of Ang Chan in the middle of the sixteenth century. Information about that period instead comes from Chinese records, much as it did in the earliest years of Funan. There were more than twelve missions from the Khmer court to China between 1371 and 1419, a higher number than for the entire Angkor period, as Chandler has pointed out. This might have been for trading purposes, as the Ming court instigated a greater outreach by China than previous dynasties had done, creating the first significant Chinese naval presence. The abandonment of Angkor after the most serious Thai raid of 1431 can be explained as much in the light of seeking a more favourable location for maritime connections as in the context of a flight from a marauding foe. It was perhaps a reversion to the patterns of Funan that had been abandoned by the rulers of Zhenla one millennium before. The region near Phnom Penh, which was the location of the court for much of the ensuing centuries, was at the junction of the Tonle Sap, outlet for

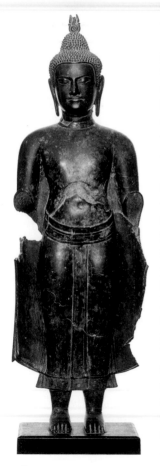

182 Buddha. Kong Pisei, Kompong Speu, 14th cent. Bronze, 0.85 m (33½ in). The post-Bayon image with its downcast eyes expresses the spirituality of the Theravada school. The flame-like extension of the ushnisha, or cranial protuberance, reveals the influence of Thai style.

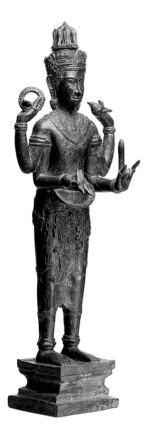

the agricultural and fishery bounty of the Great Lake, and the Mekong, major highway between the interior and the sea. As Chandler remarks, the Khmer army in fact managed to defeat the Thai in many battles after the crucial date of 1431, even as late as the seventeenth century, so the relocation might well have signalled not so much defeat as adaptation.

This interpretation helps to explain the apparent anomaly of continued production of high quality sculpture. A possibly sixteenth-century bronze of Vishnu-Vasudeva-Narayana [183] is of a size and facture that bespeaks skilled and sensitive artists. The highly elaborate sampot and jewels of this figure certainly show no decline from Angkorian sculptural standards. The image is interesting as an indication of the continuing presence of Brahmanism despite the pervasive Theravadin faith, a continuity that still exists to an extent in that Brahmans still guard sacred texts and oversee the rituals involved with rites of royal passage such as burial and consecration. A small sculpture, possibly of a slightly earlier date, shows a continued expressiveness and dynamism that had been seen in Angkorian bronzes [184]. The graceful figure wringing water from her hair represents Neang Preah Thorani, Khmer name for Dharani, the goddess of the earth, called upon to witness the resistance by the Buddha to the forces of Mara.

It is customary to interpret the disappearance of stone architecture as a sign of declining power and wealth in Cambodia.

183 Vishnu-Vasudeva-Narayana. North Khleang, 16th century (?). Bronze, 0.67 m (26⅜ in). The intricacy of this sculpture indicates that Khmer bronze casting skills were still strong in the post-Angkor period. Its subject, the supreme form of Vishnu, indicates that Brahmanism was still present in Cambodia despite the domination of Theravada Buddhism after the 14th century.

184 Neang Preah Thorani. Khum Prasat, Kong Pisei, Kompong Speu, c. 15th cent. The graceful female figure perhaps represents Preah Thorani, Khmer embodiment of the Earth goddess, who submerged demons attacking the Buddha with waves wrung from her hair.

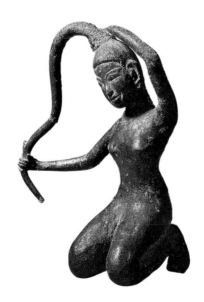

185 Standing Buddha. Angkor Wat, Siem Reap, 16th (?) cent. Wood, 2.45 m (96½ in).
This elegant adorned Buddha was found in Angkor Wat and is typical of the images created in wood when the monument was converted to Buddhist worship after the 15th century.

186 Kneeling worshipper. Angkor Wat, Siem Reap, 15th (?)–16th cent. Wood, 0.91 m (35⅞ in).
In the post-Angkor period wood was the usual medium for sculpture. The humility expressed in the seated pose of this praying figure is typical of the time. While the elaborate crown and jewelry reveal Thai influences, the spirituality and simplicity of the face are typically Khmer.

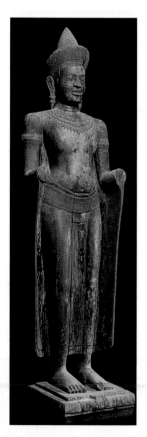

To some extent this was the case, but several factors should be kept in mind when explaining the change. First, the wood architecture that characterized the post-Angkor period was not an inferior new form resorted to as an alternative, for want of better. Even at the height of monumental construction during the Baphuon, Angkor Wat and Bayon era, timber was used for buildings to house the court, hardly lacking in prestige. Indeed, the summit sanctuaries of temples were made of wood in some cases. The glory of wooden architecture should not be dismissed when such examples as the temples of Japan are born in mind. Secondly, whereas the plateaux near Angkor were well endowed with sandstone, the land near today's Phnom Penh was part of the great plain of the Mekong and its tributaries, delta country poor in stone. Thirdly, the impermanent nature of constructions in wood accords well with the non-materialistic tenets of the Theravada faith.

These facts were also important in the evolution of sculpture in the post-Angkorian period. Bronze and stone production became rarer, though they still existed, and were replaced by a pervasive use of wood. The less intractable nature of this medium must certainly have helped in the creation of such compellingly spiritual and graceful images as the seated worshipper, or arhat, probably of the fifteenth or sixteenth century, with its intricately carved tiara and garment [186]. Its youthful face and slender body accord well with the image of an acolyte in humble supplication. Found in Angkor Wat, it was probably installed at the time of the brief restoration of Angkor as the capital under Ang Chan or his successor in the last quarter of the sixteenth century, a time when the conversion of Angkor Wat to Buddhistic worship was completed. That modification was probably also the stimulus for the carving of the towering wooden images of the standing Buddha that are found in that temple today. An example of the type [185], with its elaborate chest ornaments, ear pendants and crown, standing 2.5 metres (over 8 feet) tall, certainly does not lack monumentality. This majesty combines with a naturalistic treatment of torso, limbs and feet and a highly specific physiognomy that is unmistakably Khmer. The missing forearms demonstrate another example of elements that were added later. Preservation of these sculptures was doubtless aided by the technique of lacquering that was added as a finish after the completion of carving. A heavy layer of this dense substance was first added and dried, carved in turn, then coloured with a thin layer of red lacquer that was finally gilded.

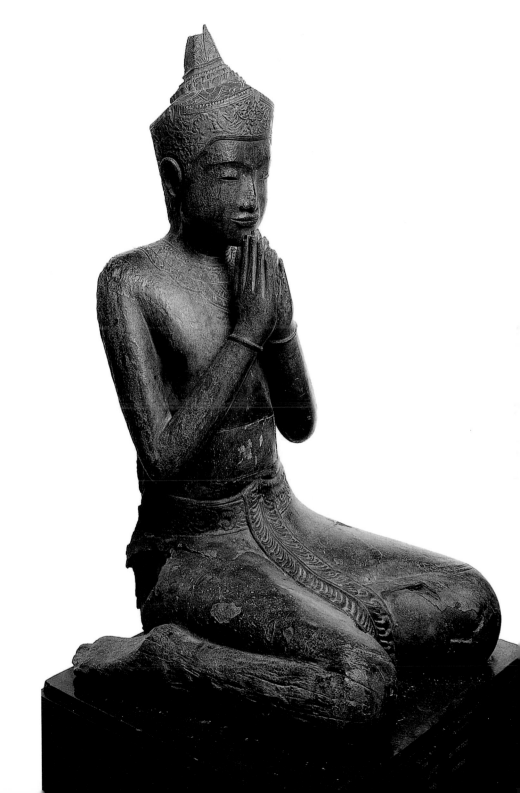

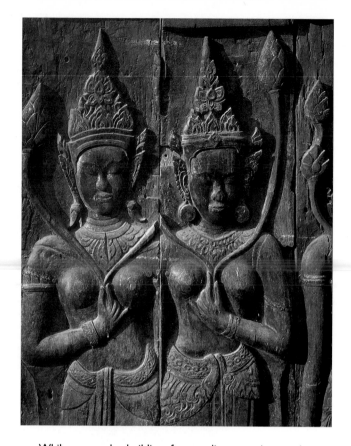

While no wooden buildings from earlier centuries remain,
the depredations of insects and the tropical climate constituting a
constant threat, some surviving elements from the seventeenth-
century monastery of Babor indicate the artistry that was applied
to architectural elements in post-Angkorian times [187]. There are
about twenty fragments from what seems to have been an inner
shrine of some kind. Their supple figures and lively depiction of
scenes of devotion and action offer a precious glimpse of the
continuity of the ancient Khmer carving talent, whose techniques
the Cambodians had adapted centuries before when they first
attempted the newer art of stone masonry. In a sense, the
renewed embrace of wood was simply a reversion to their roots.

Although no longer the capital, Angkor continued to be a
place of pilgrimage for several centuries. By the eighteenth
century most of the monuments, with the continued exception
of Angkor Wat, fell into disuse and were invaded by tropical
vegetation. European interest in the region was stimulated by the

accounts of the French naturalist Henri Mouhot of his travels between 1858 and 1861. An expedition organized in 1866 to 1868 by Doudart de Lagrée to explore the Mekong river included most notably Louis Delaporte, whose drawings and descriptions aroused tremendous interest. During the decades of French hegemony in Cambodia the monuments were gradually cleared, and with the foundation in 1898 of the Ecole française d'Extrême-Orient and the overthrow of Thai suzerainty over the northern part of Cambodia in 1907, systematic European scholarship developed.

One Khmer art that we know only from later centuries is that of literature. Stone inscriptions refer to poetry, so we know it was written, and indeed, in their Sanskrit form the inscriptions themselves were composed in verse, some of it of great beauty. The Khmer inscriptions, however, are often in prose of a rather factual nature . Literature would have been written on palm leaf manuscripts, as with other Indic cultures of the period. Palm leaf survives about a century, in good conditions. In contrast to the practice in Java and Bali, for example, where monks and priests spent a great deal of their time copying and recopying ancient texts, thus thwarting the inevitable decay by a process of constant renewal, the Khmer did not treat their texts in this way for reasons we do not know. Or, if they did, something happened to destroy their efforts. It may be that the change to Theravadin faith vitiated the value of older material, or that constant political upheavals destroyed the storage locations, but that is speculation. In the seventeenth century, however, the *Reamker* was created, the Cambodian version of the *Ramayana*. It remains a treasure of Khmer literature as well as a rich source of material for the performing arts, particularly shadow puppetry and dance.

Although the performing arts lie outside the framework of this book, poetry, textiles, music and dance have an integral relationship with the same religious rituals that were served by sculpture and ultimately by architecture. Considering the plastic arts without remembering the context of their role in a living society deprives them of an important layer of meaning. In the same category fall the extraordinarily elaborate jewelry items represented in sculpture. Inscriptions tell us that these were of gold, silver and precious gems. It is in the tragic and irredeemable nature of the greed of many collectors that not a single major example of ancient jewelry exists in Cambodia's National Museum.

Ceramic production in Cambodia began in prehistoric times. Pottery sherds dating from as early as the fifth millennium BCE are

188 Wasters from Thnal Mrec kiln site, Phnom Kulen, ?9th cent. The pale green glazes of the wares found at this 9th-century site indicate the influence of Chinese techniques, which accords with the local legends of the arrival of Chinese traders in a junk. Objects shown include glazed roof finials, tiles, bottles with narrow necks and covered globular boxes with lids decorated with fluted incisions and knobs in layered stupa-shaped form.

extensive in continuously occupied sites such as Mliu Prei, Samrong Sen and the Laang Spean cave. By the Neolithic period the unglazed earthenware is decorated with Dongsonian motifs like spirals and triangles, sometimes incised and sometimes in slip. Discernible links between these vessels – often bowls with pedestals and vases with flaring rims – and the ceramics of the historical period are yet to be established, though recent archaeological work at Angkor Borei by a team from the university of Hawaii indicates greater continuity of occupation and construction than had previously been supposed.

The precise dating of the wares is still open to question, but recent finds in the Angkor Borei area include decorated but unglazed earthenware from the third century BCE and continued production of bowls, jars and spouted vessels that resemble the seventh-century material found by B. P. Groslier at Sambor Prei Kuk. Systematic location and comparison of kilns requires further research. Recent Japanese excavations of multi-chambered kiln mounds at Tani in the Angkor region suggest that production there dates back at least to the tenth century. It is not impossible that production on the Kulen plateau, yielding architectural elements, might have begun around the time of the Angkorian temple construction of the ninth century.

Local legend on Phnom Kulen relates that the arrival of Chinese potters (see Chapter 3 for the tale of the shipwrecked junk) launched local ceramic production. Unlike earlier wares, the pots found here are glazed and were probably the earliest glazed wares made in Cambodia. Although no kilns have been excavated, abundant deposits of wasters indicate their former presence. The objects include architectural elements such as roofing tiles as well

as many examples of lidded boxes with refined moulded decorations on the lid [188]. These are mostly covered in a pale green, occasionally yellowish green glaze. The techniques of glazing were developed in China, lending credence to the theory that Chinese potters worked in the area. The forms, too, relate to the covered boxes of the Chinese tradition, and were possibly destined for use in temple ceremonies.

Excavations in the Royal Palace in Angkor Thom and in the dike of the Srah Srang baray yielded eleventh-century wares with brown glazes in varied forms, including lidded urns and bottles with wide mouths and carved decorations at the shoulder or rim [189]. In the Royal Palace the finds of Chinese vessels outnumbered Khmer pots, indicating the growing dominance of the Chinese in the ceramic trade of Southeast Asia and presaging the end of Khmer production of glazed wares by the fourteenth century.

A factor complicating the analysis of the ceramic traditions of Cambodia is the importance of the kilns and production of the Ban Kruat region of Northeast Thailand. Since this lay within the bounds of Cambodian hegemony during the evolution of Khmer pottery production, its wares should be considered integral with

189 Footed jar. Buriram province, Thailand, mid-11th–early 12th cent. Dark grey clay with blackish brown glaze, 0.355 m (14 in).
The rich black-brown glaze and the urn-like form of this baluster-shaped jar is typical of many Khmer wares made during the Baphuon period, when the province of Buriram was under Khmer hegemony and Khmer kilns were active between 1050 and 1125 CE. The form and glaze of this urn is virtually identical to ceramic production in Cambodia today. It has a pronounced flare at the overhanging lip, bands of incised and moulded geometric decorations at the base of the neck and shoulder and multiple carved rings encircling its narrow-waisted flat-bottomed foot.

the tradition. Its finds have been more thoroughly investigated and documented than the sites within present day political Cambodia, and reveal techniques and forms close enough to the Khmer examples to be considered as part of the same tradition. A characteristic form of the eleventh and twelfth centuries is the small pot, usually with lid, that might have been a container for lime or other ingredients associated with the preparations for the chewing of betel, a practice widespread in Southeast Asia. In many cases these have whimsical zoomorphic shapes, particularly of elephants [190].

A seventh-century Cambodian inscription in Sanskrit refers to a potter's wheel, so it can be inferred that the Khmers knew about the technique even though no ancient wheels have been found (presumably because they were made of perishable wood). The early wares are wheel-formed, with fabrication typically by coils attached to round base disks and then smoothed, either on a wheel or on a turning table of some kind; most vessels still have palpable ridges on the interior of the body. The clay, of a sandstone base with high iron content, was rather coarse and the wares are consequently rather heavy. An exception is the clay used in the southern areas, some of which yields refined buff- and orange-coloured wares.

190 Jar in elephant form. Grave site near Khao Din Tok, Tak province, Thailand, mid-11th (?) cent. Clay with green and brown glazes, 0.31 m (12¼ in). The lively and whimsical decoration of this jar is characteristic of Khmer wares produced in 11th- and 12th-century kilns in what is now northeastern Thailand. The moulded features of the elephant, its caparison, and its four legs forming the jar's base have a solid realism, while the human figures depicted on its sides (seven on the proper right, three on the left) present lively scenes. These include two figures drinking, three dancing, and three adopting martial stance, in addition to the mahout bestriding the elephant's head.

As the kilns so far examined were built from fired laterite blocks, they were not capable of inducing firing temperatures much higher than 1000 to 1100 degrees Celsius. Although the firing techniques did not produce glazes with the gloss and durability of Chinese production, the predominantly brown tones, sometimes dense and non-reflective in a chocolate richness, sometimes thin with a warm honey translucency, have a restrained beauty. The forms are classical, particularly the vases and urns, and the decorations sober, mostly comprising incisions of simple geometric shapes. Collections in the national museums are sparse and in need of conservation and documentation. Unfortunately the uncontrolled looting of the sites where pottery has been found has deprived the Khmer of an important element of their heritage and destroyed valuable historical evidence as well.

While ceramics, unless smashed by impatient excavation techniques or dropped, rank among the most enduring of materials, textiles fall at the other end of the survival scale and are perhaps the most vulnerable artifacts in cultural history. Western and Thai museum collections have a few specimens of nineteenth-century Khmer cloths, but the ravages of pests and the tropical climate have destroyed most of the woven heritage of Cambodia, and even mid-twentieth-century examples are rare and usually in bad condition.

It is not known when the Cambodian weaving traditions began. The earliest statuary depicts unpatterned skirt cloths with a pleated front panel and, by the tenth century, fine pleats overall. Evidence of brocaded or embroidered cloth comes from sculpture of the twelfth century, worn by apsaras figures in reliefs and by free-standing sculptures such as the kneeling figure of Tara [149], but whether the fabric was locally made or imported it is impossible to know. Zhou Daguan stated that only members of the royal family were permitted to wear clothing with overall patterning, and was dismissive of Khmer textile skills. It is conceivable that the panels in tile-like segments that are carved on the walls of temples from as early as the tenth century were intended to suggest brocaded hangings, but there too evidence of the source of the cloth, if it is cloth, is lacking.

Khmer textiles were highly regarded in the Thai court in the nineteenth century. The long cloths intended for the wrapped and draped sampot and for skirt cloths were woven of silk and patterned by motifs created by the warp ikat process, where threads of the warp are stretched on a frame and painstakingly tied in small groups to create a resist that is impervious to dye

baths. Where there are several colours, the process must be carried out in several stages. Most Khmer motifs are intricate and cover the whole ground with repeated patterns of geometric shapes like rhomboids and lozenges or of small triangles arranged in narrow bands [191]. They predominantly feature deep red, gold, green and almost black (possibly indigo) dyes, which in the nineteenth and early twentieth century were vegetal but today are chemical and less subtle. The borders sometimes have larger triangular forms that recall the tumpal motif of Indonesian textile borders. The only figurative elements in Khmer textiles are found on lively narrative weavings called pidan. Intended for processional cloths or temple hangings, they present Buddhist symbols and texts, temple roof structures, paired elephants and horses in three colourful horizontal rows.

There is also a tradition of brocaded weavings created by looms with multiple heddles to produce float weaves. These have been revived recently. Although production today is struggling to recover from the neglect of the Khmer Rouge period, Khmer textiles in the past were influential on neighbouring cultures. Cloth from northeast Thailand, the area that was under Khmer hegemony for many centuries and where the predominant language is still Khmer, is clearly influenced by Khmer techniques and motifs, as is some Lao production. Many of the mid-twentieth-century textiles come from Kompong Cham, which leads to the speculation that the Khmer motifs and techniques may be rooted in the Austronesian traditions that the Chams, and the related peoples of Kompong Cham, shared with the Indonesians, rather than in the Austroasiatic traditions that were the source of the Khmer language. Certainly the motifs of the silk lengths strongly resemble the silk sarongs and slendangs of Sumatra, and the pidan are reminiscent of the narrative temple hangings of Bali and the burial cloths of Sumba.

The tradition of wall painting is very strong in Thailand, and evidence exists to suggest that Khmer temples too were painted with narrative scenes. Recent restoration of the ninth-century temple of Preah Ko revealed residual wall painting high in the sanctuary tower. There are traces of depictions of the Dark Goddess on the eleventh-century temple of Prasat Khmau, and areas of residual paint on the interior walls of Preah Khan, so the mural painting of the Ramayana executed early in the twentieth century in the Royal Palace in Phnom Penh [193] springs from a long tradition, even if its predecessors are no longer legible. The brilliant paintings executed just a few years ago on the walls of the

191 Fragment of a silk skirt cloth, mid-20th cent.
The overall patterning of this textile comprises the rhomboid and triangular motifs that are frequently found in Khmer sarong and sampot lengths as well as weavings from neighbouring Laos, Thailand and Indonesia. The interlocking swastika forms may stem from Chinese influences, while the predominately deep red colour with elements of green and yellow is typical of the Khmer palate.

192 Painting, temple pavilion, Phnom Chisor, late 20th cent. The brilliant colours of this temple decoration, where contemporary Buddhist buildings are linked to the 11th-century Brahmanistic temple of Phnom Chisor in a practice that is pervasive in Cambodia today, may in fact reflect the original colourful condition of ancient temples.

193 Detail, mural of the Royal Palace, Phnom Penh, 20th cent. An entire courtyard gallery in the Royal Palace is lined with mural paintings of the Ramayana epic. This scene shows consultations between Rama and Hanuman in an elaborate pavilion in traditional Khmer architectural style with upswept naga eaves, finials and towering tiered stupa-form roof.

194 Royal palace, 20th cent., pagoda and stupa, Phnom Penh. The royal palace offers one of the best examples of Cambodian architectural style in the modern era.

monastery at Phnom Chisor [192] may strike the contemporary viewer as gaudy kitsch, but the question should be raised as to whether this is a more faithful fulfilment of the real tradition of decoration in sacred structures than the criteria of our more austere aesthetic, which is probably based on false premises created by the bleaching and stripping effects of time.

The other question to be asked is whether there is any other evidence of continuity in the creative genius of the Khmers. The colonial years overlaid cities and towns with an urban idiom that was climatically appropriate even if foreign, but this pleasant setting was swamped in the last part of the twentieth century by modern Western buildings offering nothing in climatic adaptation or cultural appropriateness. It is a pattern that is wearyingly familiar all over Southeast Asia. The simple but charming wood carving of rural village houses is gradually being usurped by concrete blocks, but a few examples still exist here and there of buildings to remind the Khmer of their carving heritage. The early twentieth-century Royal Palace in Phnom Penh [194] retains many of the old forms that we know to be indigenous from the echoes of the originals translated into stone on the gables of Banteay Srei

195 National Museum of Phnom Penh, 1917–20. The museum incorporates traditional Khmer roof style into a building stylistically appropriate for the repository of the national sculpture collection.

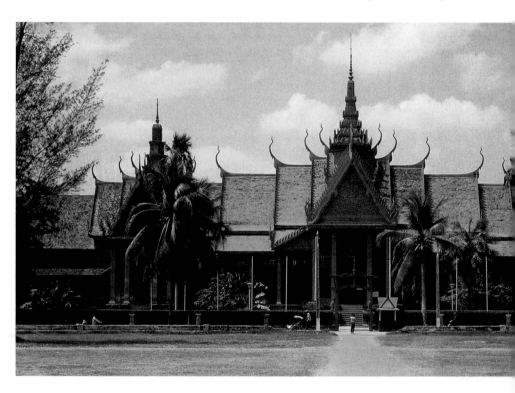

and Preah Vihear, among others. Ancient stone forms inspired the design of the Independence Monument by the architect Vann Molyvann, who combined a sophisticated knowledge of modern techniques with a profound understanding of national culture in an all too rare symbiosis. Appropriately, one of the finest examples of the adaptation of old Cambodian forms and motifs to modern use can be seen in the National Museum, whose magnificent roof with its upswept naga gables covers the glorious collection of sculpture that constitutes, along with sublime architecture, Cambodia's priceless cultural heritage [195].

Whether this treasured inheritance will survive the multiple threats that face it today is an important question. To the ravages of climate and the inherent engineering flaws that weaken the structures, and the vulnerability of sculpted reliefs in remote sites where Cambodia's precarious economic situation makes protection unfeasible, must now be added the insatiable thirst for exotic art evinced by collectors and slaked by looters. In addition, the exponential growth in the numbers of visitors fulfils the hopes that the tourist industry will bring economic prosperity but ignores the multiplication of the pounding feet of the enthusiastic but careless visitors who climb the monuments. The pilgrims who ascended the ancient steps for more than a millennium had reverence and bare feet. Failure to bridge the gap between these two attitudes will inevitably destroy one of the world's greatest art heritages.

Glossary of names
and Buddhist terms

abhayamudra gesture of the Buddha signalling absence of fear, right hand raised and palm facing out

abhisheka ritual of the consecration or anointing of a king

Airvata three-headed elephant, mount of Indra

Ak Yum the first temple mountain, 7th–8th cent., Siem Reap

akshamala rosary used in Buddhistic and Brahmanistic prayers

Amitabha one of the five Jina or supreme Buddhas of Mahayana Buddhism

amrita the nectar of immortality, churned from the Ocean of Milk by the devas and asuras

Ananta naga (serpent) without end (also called Shesha) on whose back Vishnu lies in Cosmic Sleep between cosmic cycles

Anavatapta mythological sacred lake in the Himalayan kingdom of the gods; its waters have healing powers; source of rivers watering the four cardinal points

Angkor Borei 'holy royal city', current name for putative site of capital of Funan

Angkor Thom 'great royal city', walled city built by Jayavarman VII, late 12th cent.

Angkor Wat 'city that is a temple', Vaishnavite temple, built by Suryavarman II first half 12th cent., later consecrated as a Buddhist temple

Angkor royal city or city state; name designating Khmer capital 802–1431

apsara celestial nymph born of the Churning of the Ocean of Milk

Ardhanarishvara androgynous form of Shiva comprising half male, half female

ashana aspects of the body in Indic iconography

Ashram Maha Rosei 'hermitage of the great ascetic', 7th-cent. temple, Ta Keo province

asura demon, or divine creature, foe of the gods

Avalokiteshvara 'lord who looks down from above', bodhisattva of compassion, also known as Lokeshvara, 'lord of the world'

avatar, avatara divine incarnation or manifestation

Bakheng temple mountain (c. 900) built on Mt Bakheng by Yashovarman I; dedicated to Shiva

Bakong temple mountain (881) built in Hariharalaya (now Roluos) by Indravarman I; dedicated to Shiva

Baksei Chamkrong small temple mountain (947) in Yashodharapura/Angkor, begun by Harshavarman I and completed by Yashovarman; dedicated to Shiva

Balarama avatar of Vishnu, brother of Krishna

Banteay Chmar 'citadel of cats'; 12th-cent. temple built in the west of Cambodia by Jayavarman VII and dedicated to Lokeshvara and to Jayavarman's son

Banteay Kdei 'citadel of cells', Buddhist temple, Angkor Thom, late 12th–early 13th cent.

Banteay Samre 'citadel of the Samre', first half 12th cent., built by Suryavarman II, Siem Reap; dedicated to Vishnu

Banteay Srei 'citadel of women', temple (967–68) north of Angkor by Yajñavaraha, influential guru to Jayavarman V; dedicated to Shiva

Baphuon temple mountain (c. 1060) built in Yashodharapura/Angkor by Udayadityavarman II; dedicated to Shiva

baray diked reservoir, sometimes perceived as symbolic of the cosmic ocean

Bayon Buddhist temple mountain, late 12th–early 13th cent., built in Angkor Thom by Jayavarman VII

Beng Mealea 'pond of garlands', first half 12th cent., enormous Brahmanistic temple complex northeast of Angkor by Suryavarman II

Bhaishajyaguru 'master of remedies'; the Buddha of medicine

bodhisattva being who has achieved enlightenment in Mahayana Buddhism, who postpones accession to nirvana to help others achieve the blessed state

Brahma god of creation; member of the trimurti; his four heads and four hands created the four *Veda*.

Brahmanism religion of India brought by the Aryans; its multiple deities are all aspects of the supreme deity. Also known as Hinduism

Buddhism philosophy founded in the 6th cent. BCE by Prince Gautama of the Shakyamuni clan, who renounced his royal status to seek enlightenment by meditation in order to achieve liberation from the endless cycle of existence

chaitya sanctuary, and monument symbolizing sanctuary in Buddhism and Brahmanism

chakra wheel or disk, symbol of the sun, attribute of Vishnu; symbol of Buddhist Wheel of the Law

chakravartin 'holder of the moving wheel', universal monarch

Champa land of the Chams in central Vietnam; one of the earliest Southeast Asian states

Chau Say Thevoda late 11th–early 12th cent. Brahmanistic temple in the Angkor Wat style

Churning of the Ocean of Milk legend in which devas and asuras, using Mt Mandara as a paddle and the naga Vasuki as rope, churned the Ocean of Milk to obtain amrita, the nectar of immortality

deva, devata deity (male, female respectively)

devaraja: 'god king'; central deity installed as guardian spirit of the kingdom, first initiated by Jayavarman II in 802; may have been symbolized by a linga

Devi literally goddess, but usually identified as spouse of Shiva

dharma cosmic law

dikpalaka guardian of one of the cardinal and sub-cardinal directions

Durga manifestation of Devi, shakti of Shiva, usually as Durgamahishasuramardini, slayer of the buffalo demon; also the sister of Vishnu, she is possessed of dual powers

dvarapala guardian of the gate

Dvaravati Buddhist kingdom of the Mons emerging in the 7th cent. in parts of present-day Myanmar and Thailand

East Mebon temple mountain (952) built by Rajendravarman, probably as an ancestor temple, Siem Reap; dedicated to Shiva

Funan Chinese designation for maritime kingdom 3rd–6th cent. with port at Oc Eo and capital at Angkor Borei

Ganesha elephant-headed god, master of categories and obstacles, son of Shiva and Parvati

Garuda mythological eagle-like bird, traditional enemy of the naga and the vahana (mount) of Vishnu

gopura gate or entrance pavilion to a temple or city, often a temple in its own right

Govardhana mountain in Hindu mythology

hamsa goose, mount of Brahma and Varuna

Harihara deity who is half Shiva (right) and half Vishnu (left)

Hariharalaya the capital of Khmer kings in the 9th cent. in present-day Roluos, south of Angkor

Hevajra chief deity in Tantric Buddhist pantheon, usually represented with eight heads and sixteen arms, dancing on the four Maras, or evils

Hinayana 'lesser vehicle', alternative name for Theravada Buddhism, the Way of the Masters

Indra king of the gods, lord of storms and guardian of the east

Indradevi second queen of Jayavarman II, sister of his first wife

Indratataka 9th-cent. baray of Indravarman at Hariharalaya

Ishanapura capital of Ishanavarman I, now called Sambor Prei Kuk

Ishvara one of the names of Shiva

jataka tales of the previous lives of the Shakyamuni Buddha

jatamukuta piled and plaited locks forming a crown, characteristic of Shaivite deities

Jayadevi 680/681–after 713, queen in eastern Cambodia

Jayarajadevi first queen of Jayavarman VII, sister of the king's second wife

Jina name for the Buddha and the five supreme Buddhas (Dhyani Buddhas) of the four cardinal points and the zenith

Kailasha mountain in the Himalayas, home of Shiva

Kaliya serpent who poisoned the River Yamuna, punished by Krishna

Kalkin horse avatar of Vishnu; avatar of the future who will bring about a new golden age

Kambujadesa land of the Kambus, or Cambodia

Kaundinya Brahman who founded the royal line in myths of origin of Funan

khleang 'emporium'; late 10th–early 11th-cent. buildings in Angkor Thom; style of the period

Koh Ker (Chok Gargyar) capital of Cambodia 928–44; called Lingapura in Sanskrit

Kratie site on the Mekong, source of several 7th-cent. female sculptures

Krishna 'dark'; youthful avatar of Vishnu

Krus Preah Aram Rong Chen 'sacred temple at the pleasant garden of the Chinese'; small temple mountain on Mt Kulen said to be the site of the installation of Jayavarman II as chakravartin in 802

Kubera god of treasures and guardian of the north

Kulen plateau northwest of Angkor, site of Jayavarman II's capital for several years of his reign; 9th-cent. name: Mahendraparvata; source of much of the sandstone used in the construction of the temples of Angkor

Kumara see Skanda

Kurma tortoise avatar of Vishnu, supported Mt Mandara during the Churning of the Ocean of Milk

lakshana distinguishing characteristics of the Buddha

Lakshmi shakti of Vishnu

Lakshmana brother of Rama in the *Ramayana*

Lanka home of Ravana (Sri Lanka), site of the battle of the *Ramayana*

linga non-manifest form of Shiva, symbol of the phallus representing the creative force of Shiva

Lokapala Buddhist guardian kings of the four cardinal directions

Lokeshvara alternative name for Avalokiteshvara

Lolei four-temple complex built in 893 by Yashovarman I in the Indratataka baray at Hariharalaya

Mahabharata Indian epic telling of the rivalry of the clans of the Pandava and the Kaurava

Mahayana school of Buddhism embracing multiple bodhisattvas

Maitreya the bodhisattva who will be the Buddha of the Future, to appear after the teachings of the historical Buddha, Shakyamuni, have been forgotten

makara mythological creature, part crocodile, part elephant, sometimes also with lion features

mandala diagram of the universe; can be two- or three-dimensional, as in a microcosmic temple mountain

mandapa hall, sometimes colonnaded, usually antechamber to main sanctuary

Mandara one of the sacred mountains of the gods, used as the paddle in the Churning of the Ocean of Milk

Mara demon of illusion; the four Maras: four evils

Meru cosmic mountain, home of the gods; the axis mundi

Muchilinda naga who came from his lake to raise the Buddha on his coils and protect his head with upraised hood during torrential rain falling during the Buddha's meditation

mudra gestures of the Buddha

mukhalinga linga with a face (mukha)

naga serpent, symbol of water and fertility, guardian of subterranean regions; enemy of the garuda; associated with Khmer myths of origin

Nagara Sanskrit for city, equivalent of 'Angkor' and 'Nokor'

Nandin divine bull, vehicle of Shiva

Narasimha lion avatar of Vishnu, adopted to kill the demon Hiranyakashipu

Neak Pean 'entwined nagas'; satellite temple of Preah Khan built late 12th cent.; dedicated to Lokeshvara

neak ta ancestor spirits

nirvana nothingness, extinction of the chain of existence

Oc Eo entrepot port of pre-Angkorian kingdom of Funan

Pali sacred language of Theravada Buddhism

Pandava the five sons of Pandu, heros of the *Mahabharata*

Parashurama avatar of Vishnu who carries an axe

Parvati 'daughter of the mountain'; shakti of Shiva

Phimai late 11th–early 12th-cent. temple in Thailand, precursor of Angkor Wat

Phimeanakas 11th-cent. temple mountain and royal chapel in the royal palace in Yashodharapura

Phnom Bok mountain near Angkor; 10th-cent. temple on Phnom Bok

Phnom Chisor 'mountain of the sun'; 11th-cent. temple built by Suryavarman I

Phnom Da hill near Angkor Borei, site of 7th-cent. temples of Funan

Phnom Krom hill at the edge of the Tonle Sap lake; 10th-cent. temple

Phnom Rung 12th-cent. temple in Buriram province in Thailand

pon Khmer title for leader or chieftain, in the Funan period

pradakshina clockwise circumambulation of a temple, keeping the temple on the right

Prajñaparamita perfection of wisdom, spiritual mother of the word and the Buddhas

Prakhon Chai site in Thailand where hoard of 8th-cent. bronzes was found

prana inner breath, control of life force and spiritual strength

Prasat Andet late 7th-cent. temple giving rise to the style of that period

Prasat Kraham enormous early 10th-cent. gopura temple at Koh Ker

Prasat Kravan five-towered red brick temple built in Angkor in 961 by Harshavarman I

Prasat Neang Khmau 'tower of the dark lady'; 11th-cent. temple south of Phnom Penh

Prasat Thom first quarter 10th cent.; temple mountain of Jayavarman IV in Koh Ker

prasat tower sanctuary

prasavya anti-clockwise circumambulation of a temple, keeping the temple on the left

Pre Rup temple mountain built in Yashodharapura in 961 by Rajendravarman

Preah Khan 'sacred sword'; temple built by Jayavarman VII in 1191 in honour of his father; dedicated to Lokeshvara

Preah Ko 'sacred bull'; six-sanctuary temple of 879 built in Hariharalaya by Indravarman I; dedicated to Shiva

Preah Palilay Buddhist shrine built in the 13th cent. at Angkor Thom

Preah Pithu group of five temples in Angkor Thom of the 12th and 13th cent. with both Buddhistic and Brahmanistic iconography

Preah Vihear 11th-cent. temple built in the Dangrek range area by Suryavarman I

Prei Kmeng temple near Angkor giving rise to the style of the second half of the 7th cent.

Rajendradevi alternative name for Indradevi, second queen of Jayavarman VII

Rama avatar of Vishnu; hero of the *Ramayana*.

Ramayana Indian epic dealing with the adventures of Rama, his wife Sita and his brother Lakshmana, and the battle of Lanka

rishi Shaivite ascetic, or sage

Roluos see Hariharalaya

shaka Indic chronology; calendar dates usually 78 years earlier than the Roman calendar

Sambor Prei Kuk 'hill in the forest of Sambor'; temple complex of the 7th cent. in eastern Cambodia, formerly Ishanapura

sampot traditional Khmer dress, cloth wound around the waist and drawn between the legs

Sdok Kak Thom temple in Prachinburi province of Thailand; inscription found there relates details of installation of Jayavarman II as chakravartin on Mt Kulen in 802

Shaivite pertaining to Shiva and his worship

shakti spouse, or female personification, of a Brahmanistic god

Shakyamuni 'sage of the Shakya'; the historical Buddha

Shiva one of the trimurti; both destroyer and creator, his linga is the symbol of fertility. Among his attributes are the trishula (trident) and the noose.

Shivakaivalya priest instructed by the Brahman Hiranyadama in the rites of the devaraja

Shri 'beauty'; consort of Vishnu; Lakshmi, who carries a lotus bud in each hand, born from the Churning of the Ocean of Milk

Sita wife of Rama

Skanda god of war, also known as Kartikkeya and Kumara, among others; his mount is the peacock.

stele inscribed tablet

Surya god of the sun

Ta Keo 'ancestor Keo' (or 'tower of crystal'); temple of late 10th–early 11th cent.

Ta Prohm 'the ancestor Brahma'; temple of 1186 built by Jayavarman VII in honour of his mother; dedicated to Prajñaparamita

Theravada 'the way of the Masters'; form of Buddhism that concentrates on the Buddha alone

Thommanon early 12th-cent. temple in Angkor, early example of Angkor Wat style

Tonle Sap river and lake in the Siem Reap area, rich source of water, fertile soil after annual flooding, and fish

tribhanga triple flexion, or S-shaped stance

tricira triple lock of hair, associated with Krishna and Skanda

trimurti the three gods of the Brahmanistic Trinity: Shiva, Vishnu and Brahma

tripitaka body of Buddhist texts

Trivikrama cosmic form of Vishnu, represented as taking three giant strides that conquer the triple world, incarnated in the dwarf avatar Vamana

Uma one of the shakti of Shiva

Umamaheshvara depiction of Shiva and Uma seated on Nandin; Uma is often shown sitting on Shiva's lap.

urna tuft of hair between the eyebrows, usually shown as a dot; one of the lakshana (signs of the Buddha)

ushnisha cranial protuberance; one of the lakshana (signs of the Buddha)

vahana vehicle or mount of a god

Vairochana the Jina of the zenith

vaijimukha horse-faced

Vaishnavite connected with Vishnu and the worship of Vishnu

vajra thunderbolt, diamond, lightning; symbol of Indra; also used in Tantric rites

Varuna guardian of the west and god of the waters; his vehicle is the hamsa, or goose.

vat alternative form of 'wat', temple

Veda set of ancient texts that embody the underlying principles of Brahmanism

Vishnu one of the trimurti; his vehicle is Garuda; carries conch, disk, mace and globe

vitarkamudra gesture of explanation: thumb and index finger of raised right hand form a circle.

wat temple

Wat Phu temple on Mt Lingaparvata, Laos

West Mebon 11th-cent. temple, Siem Reap

yaksha minor deities, protectors of property

Yama judge of the dead and guardian of the south

Yashodharapura Khmer capital from early 10th cent.

yogin devotee of ascetic meditation or yoga

Zhenla Chinese name for Khmer state that emerged after Funan, not known in Khmer epigraphy

Zhou Daguan Chinese emissary who visited Angkor in 1296–97; wrote an extensive account of the city and the court and customs of Cambodia

Select bibliography

Abbreviations
BEFEO: *Bulletin de l'Ecole française d'Extrême-Orient.*
EFEO: L'Ecole française d'Extrême-Orient.

Ang, Chouléan, 'Recherches récentes sur le culte des mégalithes et des grottes au Cambodge', Journal Asiatique 281/1–2, 1993, pp. 185–210

——, 'Le sol et l'ancêtre. L'amorphe et l'anthropomorphe', Journal Asiatique 283/1, 1995, pp. 213–38

——, E. Prenowitz and A. Thompson, *Angkor, Past, Present, and Future*, 1996

—— and Ashley Thompson (eds), *Udaya. Journal of Khmer Studies*, Phnom Penh, vol. 1 2000, vol. 2 2001, Vol. 3 2002

'L'Art de l'Asie du Sud-Est', *L'art et les Grandes Civilisations*, 24, Paris, 1994

Aymonier, Etienne, *Textes khmers*, Saigon, 1878

——, *Le Cambodge: I. Le Royaume actuel, II. Les Provinces siamoises, III. Le Groupe d'Angkor et l'histoire*, Paris, 1901–4

Banerjee, J. N., *The Development of Hindu Iconography*, Calcutta, 1956

Barth, A., *Oeuvres*, vol. 1, Paris 1914

—— and A. Bergaigne, *Inscriptions sanskrites de Campæ et du Cambodge*, Paris, 1885–93

Béguin, G., *L'Inde et le monde indianisé au Musée national des Arts asiatiques – Guimet*, Paris, 1992

Bellwood, P. S., 'Prehistory of Southeast Asia', *The Cambridge History of Southeast Asia*, 1, 1985

Bénisti, M., *Rapports entre le premier art khmer et l'art indien* (2 vols), *Mémoires archéologiques V*, EFEO, Paris, 1970

Bhattacharya, K., *Les Religions brahmaniques dans l'ancien Cambodge, d'après l'épigraphie et l'iconographie*, EFEO 49, Paris, 1961

——, *L'Ætman-Brahman dans le Bouddhisme ancien*, EFEO 90, Paris, 1973

——, *Recherches sur le vocabulaire des inscriptions sanskrites du Cambodge*, EFEO 167, Paris, 1991

——, *Religious Syncretism in Ancient Cambodia* (in preparation)

Biardeau, M., *L'Hindouisme. Anthropologie d'une civilisation*, Paris, 1981

Bizot, F., 'La consécration des statues et le culte des morts', *Recherches nouvelles sur le Cambodge*, pp. 101–39, Paris, 1994

Boisselier, J., *La Statuaire khmère et son évolution*, EFEO 37, Saigon, 1955

——, *Tendances de l'art khmer. Commentaires sur vingt-quatre chefs-d'œuvre du musée de Phnom-Penh*, Paris, 1956

——, *Manuel d'archéologie d'Extrême-Orient, Part I: Asie du Sud-Est. Vol I: Le Cambodge*, Paris, 1966

——, 'Notes sur l'art du bronze dans l'ancien Cambodge', *Artibus Asiae* 29/4, 1967–I, pp. 275–334

——, 'Pouvoir royal et symbolisme architectural: Neak Pean et son importance pour la royauté angkorienne', *Arts Asiatiques* 21, 1970, pp. 91–108

——, *La Sagesse du Bouddha*, Paris, 1993

Bosch, F. D. K., *The Golden Germ: An Introduction to Indian Symbolism*, The Hague, 1960

Boulbet, J., *Le Phnom Kulen et sa région*, EFEO Collection de textes et documents sur l'Indochine 12, Paris, 1979

——, and B. Dagens, 'Les sites archéologiques de la région du Bhnam Gulen (Phnom Kulen)', *Arts Asiatiques* 27, 1973

Briggs, Lawrence Palmer, *The Ancient Khmer Empire*, Philadelphia, 1951

Brown, R., *The Ceramics of South-East Asia. Their Dating and Identification*, Singapore and Oxford, 1988

Brown, R. L., *The Dvaravati Wheels of the Law and the Indianization of South East Asia*, Leiden, New York and Cologne, 1996

Bruguier, B., 'Le prasat Ak Yum', in F. Bizot (ed.), *Recherches nouvelles sur le Cambodge*, pp. 273–96, Paris, 1994

The Age of Angkor. Treasures from the National Museum of Cambodia (exh. cat.), Michael Brand and Chuch Poeurn, The Australian National Gallery, Canberra 1992

Cent objets disparus, International Council of Museums (ICOM–EFEO), Paris, 1993

Chandler, D. P., *A History of Cambodia*, Boulder, Colorado, 1983 and Sydney, 1992

——, and I. Mabbett, *The Khmers*, Oxford, 1995

Chihara, D., *Hindu Buddhist Architecture in Southeast Asia*, Leiden, New York and Cologne, 1996

Chutiwongs, N., *The iconography of Avalokitesvara in Mainland South East Asia*, dissertation for the Rijksuniversiteit, Leiden, 1984

Cœdès, G., 'Les bas-reliefs d'Angkor Vat', *Bulletin de la Commission archéologique de l'Indochine*, 1911

——, *Bronzes khmers. Ars Asiatica* 5, Paris and Brussels, 1923

——, *Inscriptions du Cambodge,* 8 vols, Hanoi, then Paris, 1937–66

——, 'La stèle du Preah Khan d'Angkor', *BEFEO* 41, 1942, pp. 255–301

——, *Pour mieux comprendre Angkor*, Paris, 1947

——, W. F. Vella (ed.), S. Cowing (trans.), *The Indianized States of Southeast Asia*, Hawaii, 1968

——, *Articles sur le pays khmer,* 1. Paris, 1989, 2. Paris, 1992

——, and L. Finot, 'Notes d'épigraphie', *BEFEO* 15, 1915 (whole issue)

——, and P. Dupont, 'Les stèles de Sdok Kak Thom, Phnom Sandak et Prah Vihar', *BEFEO* 43, 1943–46, pp. 57–134

Commaille, J. and G. Cœdès, *Le Bàyon d'Angkor Thom. Bas-reliefs publiés par les soins de la Commission archéologique de l'Indochine, d'après les documents recueillis par la mission Henri Dufour, avec la collaboration de Charles Carpeaux*, Paris, 1910, 1914

Coral-Rémusat, G. de, *L'Art khmer. Les grandes étapes de son évolution. Etudes d'art et d'ethnologie asiatiques* 1, Paris, 1951 (2nd edition)

Czuma, S., 'A Masterpiece of Early Cambodian Sculpture', *The Bulletin of the Cleveland Museum of Art* 41, April 1974, pp. 119–27

Dagens, B., *Angkor – Heart of an Asian Empire*, Thames & Hudson, London, 1989

Dalsheimer, Nadine, *Les Collections du musée national de Phnom Penh; L'art du Cambodge ancien*, Paris, 2001

Delaporte, L., *Voyage au Cambodge. L'architecture khmère*, Paris, 1880

Duflos, M. C., 'L'art préangkorien', *Angkor – L'Art khmer au Cambodge et en Thaïlande, Archeologia. Dossiers Histoire et Archéologie* 125, March 1988

Dumarçay, J., and B. Ph. Groslier, *Le Bàyon. Histoire architecturale du temple. Inscriptions du Bàyon*, EFEO, *Mémoires archéologiques* 3, 3/2, Paris, 1967 and 1973

——, *Ta Kev. Etude architecturale du temple*, EFEO *Mémoires archéologiques* 6, Paris, 1971

——, *Phnom Bakheng. Etude architecturale du temple*, EFEO *Mémoires archéologiques* 7, Paris, 1971

——, *Documents graphiques de la Conservation d'Angkor, 1963–73*, Paris, 1988

——, and B. Ph. Groslier, *Le Bayon. Histoire architecturale du temple*, EFEO *Mémoires archéologiques* 3/2, Paris, 1973

Dupont, P., 'Catalogue des collections indochinoises', *Bulletin de la Commission archéologique de l'Indochine, 1931–34*, Paris, 1934

——, 'Mission au Cambodge. Recherches archéologiques sur le Phnom Kulên 1, à Angkor et à Battamban', *BEFEO* 37, 1937

——, 'Les monuments de Phnom Kulên', *BEFEO* 38, 1938, pp. 199–208

——, 'Mission au Cambodge. Recherches archéologiques sur le Phnom Kulên 2', *BEFEO* 38/2, 1938, pp. 426–38

——, *La Statuaire préangkorienne*, Ascona, 1955

Ellul, J., 'Le mythe de Ganesa: le Ganesa cambodgien, un mythe d'origine de la magie', *Seksa khmer* 1/2, 1980, pp. 69–153

Filliozat, J., 'Le symbolisme du monument du Phnom Bakhen', *BEFEO* 44, 1947–50, pp. 527–54

Finot, L., 'Inscriptions d'Ankor', *BEFEO* 15, 1915, pp. 289–410

——, *Notes d'épigraphie indochinoise*, Paris, 1916

——, 'Arts et archéologies khmers 2', *BEFEO* 17, 1917, pp. 360–72

——, V. Goloubew and H. Parmentier, *Le Temple d'Isvarapura*, EFEO *Mémoires archéologique* 1, Paris, 1926

——, V. Goloubew, and G. Coedès, *Le Temple d'Angkor Vat*, EFEO *Mémoires archéologiques 2*, Paris, 1927–32

Freeman, M. and R. Warner, *Angkor: The Hidden Glories*, Boston, London, Melbourne, 1990

——, and C. Jacques, *Ancient Angkor*, Bangkok, 1999

Garnier, F., *Voyage d'exploration en Indochine effectué par une commission française présidée par le capitaine de frégate Doudart de Lagrée*, Paris, 1873

Giteau, M., *Guide du Musée national de Phnom-Penh I, Sculpture*, Phnom Penh, 1960

——, *Les Khmers. Sculptures khmères – Reflets de la civilisation d'Angkor*, Fribourg, 1965

——, *Guide du Musée national de Phnom-Penh II. Mobilier en pierre, éléments d'architecture, inscriptions*, Phnom-Penh, 1966 (1)

——, 'Iconographie du Cambodge postangkorien', *BEFEO* 100, Paris, 1975

——, D. Guéret and T. Renaut, *L'Art khmer, Reflet des civilisations d'Angkor*, Paris, 1997

Glaize, M., *Les monuments du groupe d'Angkor*, Saigon 1944, Paris 1963, reprinted 1994

Groslier, B. Ph., *Angkor. Hommes et pierres*, Paris, 1956

——, *Indochine carrefour des arts*, Paris, 1961

——, *Angkor. Hommes et pierres*, Paris, 1968

——, 'La cité hydraulique angkorienne: exploitation ou surexploitation du sol?' *BEFEO* 66, 1979

Groslier, G., *Arts et archéologie khmers I/3*, Paris, 1921–23

——, *Les Collections khmères du musée Albert-Sarraut à Phnom-Penh*, Coll. *Ars Asiatica* 16, Paris, 1931

Hall, K. R. and J. K. Whitmore (eds), *Explorations in Early South-East Asian History: the origins of South-East Asian Statecraft*, Ann Arbor, 1976

Higham, C., *The Archaeology of Mainland Southeast Asia: From 10,000 BC to the Fall of Angkor*, Cambridge, 1989

——, *The civilization of Angkor*, London, 2001

Jacques, C. 'Supplément au tome 8 des inscriptions du Cambodge', *BEFEO* 58, 1971

——, '"Funan", "Zhenla": The Reality Concealed by these Chinese views of Indo-china', in R. B. Smith and W. Watson (eds), *Early Southeast Asia*, Oxford, 1979, pp. 371–79

——, and R. Dumont, *Angkor*, Paris, 1990

——, and Michael Freeman, *Angkor: Cities and Temples*, Bangkok, 1997

Jessup, Helen Ibbitson, 'Spirit of Place; the Genius of the Khmers', *Kenro Izu. Light over Ancient Angkor*, New York, 1996, pp. 26–29

——, 'The Glory of Cambodian Art', *Minerva* 8/4, July–August 1997, pp. 31–38

——, 'The Khmer Aesthetic: a Chance for New Insights', *Orientations*, January, 1998

——, 'Ethics and Current Claims: Is there a fair solution?', *The Case for Cambodia: Cultural property and patrimony disputes in an age without borders*, New York, 2001

——, and Thierry Zéphir (eds), *Sculpture of Angkor and Ancient Cambodia: Millennium of Glory*, Thames & Hudson, London, 1997

Kern, Hendrik, 'Opschriften op oude bouwwerken in Kambodja', *Bijdragen tot de Tal-, Land- en Volkenkunde*, 1879, Leiden, pp. 268–72

Kulke, H., *The Devaraja Cult*, Data Paper 108, Southeast Asia Program, Cornell University, Ithaca, 1978

Lan Sunnary, 'Le Nandin de Tuol Kuhea (Duol Guha)', *Khméritude* 1, 1991, pp. 77–121

Le Bonheur, A. *Art khmer*, Paris, 1986 (2nd edition)

——, 'L'art postangkorien', *Angkor – L'Art khmer au Cambodge et en Thaïlande*, Archeologia. Dossiers Histoire et Archéologie 125, March 1988

——, *Cambodge. Angkor. Temples en péril*, Paris, 1989

——, and Jaroslav Ponçar, *Des Dieux, des Rois, des Hommes. Les bas-reliefs d'Angkor Vat et du Bayon*, Geneva, 1995

Lee, Sherman, *Ancient Cambodian Sculpture*, New York, 1969

Lewitz, S., 'Textes en khmer moyen. Inscriptions modernes d'Angkor 2, 3', *BEFEO* 57, 1970

Lobo, W., 'Reflections on the Tantric Buddhist

God Hevajra in Cambodia', *Southeast Asian Archeology 1994. Proceedings of the 5th International Conference of the European Association of Southeast Asian Archaeologists*, Hull, 1997

Lunet de Lajonquière, E., *Inventaire descriptif des Monuments du Cambodge*, 3 vols, EFEO 4, 8, 9, Paris, 1902–11

Mabbett, I. W., 'Devaraja', *Journal of Southeast Asian History* 10/2, September 1969, pp. 202–23

—— (ed.), *Patterns of Kingship and Authority in Traditional Asia*, London, Sydney, Dover, New Hampshire, 1985

——, 'Divine Kingship in Angkor', in Samaresh Bandyopadhyay (ed.), *Acarya-Vandana, D. R. Bhandarkar Birth Centenary Volume*, Calcutta, n.d., pp. 277–85

Mak, Phoeun, *Chronique royale du Cambodge (des origines légendaires jusqu'à Paramaræja Ier)*, EFEO *Textes et documents sur l'Indochine 13*, Paris, 1984

Malleret, L., *L'Archéologie du Delta du Mékong*, 4 vols, 1: *L'Exploration archéologique et les fouilles d'Oc-Eo*; 2: *La Civilisation matérielle d'Oc-Eo*; 3: *La Culture de Fou-nan*; 4: *Le Cisbassac*, EFEO 43, Paris, 1959–63

Mannikka, Eleanor, *Angkor Wat. Time, Space, and Kingship*, Hawaii, 1996

Mansuy, H., *Stations préhistoriques de Somrong Sen et de Longprao*, Hanoi, 1902

Marchal, H., *Le Décor et la Sculpture khmers*, Paris, 1951

——, *Les Temples d'Angkor*, Paris, 1955

Marr, D. G. and A. C. Milner (eds), *Southeast Asia in the 9th to 14th Centuries*, Singapore, 1986

Mauger, H., 'L'asram Maha Rosei', *BEFEO* 36, 1939, pp. 65–96

Michell, George, *The Hindu Temple: an Introduction to its Meaning and Form*, Chicago and London, 1988

Mouhot, H., *Voyage dans les royaumes de Siam, de Cambodge, de Laos et autres parties centrales de l'Indochine. Le Tour du Monde*, Paris, 1863

Mus, P., 'Le sourire d'Angkor. Art, foi et politique bouddhiques sous Jayavarman VII', *Artibus Asiae* 24, 1961, pp. 363–81

Nafilyan, G., *Angkor Vat. Description graphique du temple*, EFEO *Mémoires archéologiques* 4, Paris, 1969

O'Connor, Stanley, J. Jr, *Hindu Gods of Peninsular Siam*, Artibus Asiae Supplementum 28, Ascona, 1972

Parmentier, H., 'L'inventaire descriptif des monuments du Cambodge', *BEFEO* 11, 1911

——, 'Catalogue du Musée khmer de Phnom-Penh', *BEFEO* 12/3, 1912

——, 'Complément à l'Inventaire descriptif des monuments du Cambodge', *BEFEO* 13/1, 1913, pp. 1–61

——, 'L'art d'Indravarman', *BEFEO* 19/1, 1919, pp. 1–98

——, *L'Art khmer primitif*, 2 vols, EFEO 21 and 22, Paris, 1927

——, 'Complément à l'art khmer primitif', *BEFEO* 35, 1935

——, La construction dans l'architecture khmère classique', *BEFEO* 35, 1935, pp. 243–312

——, *L'Art khmer classique. Monuments du quadrant nord-est*, 2 vols, EFEO 29 b, Paris, 1939

——, *Angkor*, Saigon, 1950

The Path to Enlightenment. Masterpieces of Buddhist Sculpture from the National Museum of Asian Art/Musée Guimet, Paris (exh. cat.), Kimbell Art Museum, Fort Worth, 1996

Pelliot, P., *Mémoires sur les coutumes du Cambodge de Tcheou Ta-Kouan, version nouvelle suivie d'un commentaire inachevé*, Paris, 1951

Pichard, P., *Pimay. Etude architecturale du temple*, EFEO *Mémoires archéologiques 10*, Paris, 1976

Pou, Saveros, *Ræmakerti (xvie–xviie siècles)*, translation and commentary, Paris, 1977

——, *Nouvelles inscriptions du Cambodge 1*, Paris, 1989

——, *Dictionnaire vieux khmer–français–anglais: an Old Khmer–French–English Dictionary*, Paris, 1992

Rooney, D. F. *Khmer Ceramics*, Kuala Lumpur, 1984

——, *Angkor Observed. A Travel Anthology of 'Those There Before'*, Bangkok, 2001

Roveda, V., *Khmer Mythology*, Bangkok, 1997

——, *Preah Vihear*, Bangkok 2000

Sahai, S., *Les institutions politiques et l'organisation administrative du Cambodge ancien (vi*ᵉ*-xiii*ᵉ *siècle)*, EFEO 75, Paris, 1970

Seidenfaden, E., 'Complément à l'inventaire descriptif des monuments du Cambodge', *BEFEO* 22, 1922, pp. 55–99

Sircar, D. Ch., *Select Inscriptions bearing on Indian History and Civilization*, 1, University of Calcutta, 1965–83

Siribhadra, S., E. Moore and M. Freeman, *Palaces of the Gods. Khmer Art and Architecture in Thailand*, London, 1992

Smith, R. B., and W. Watson (eds), *Early South East Asia, essays in Archaeology, History, and Historical Geography*, New York, Kuala Lumpur, 1979

Snellgrove, D. L. (ed.), *The Image of the Buddha*, Paris, 1978

Stern, Ph., *Le Bàyon d'Angkor et l'évolution de l'art khmer (Annales du musée, Bibliothèque de vulgarisation, 47)*, Paris, 1927

——, 'Le temple-montagne khmer, le culte du *linga* et le *devaraja*', *BEFEO* 34, 1934, pp. 611–16

——, *Les Monuments khmers du style du Bàyon et Jayavarman VII*, vol. 9, Paris, 1965

Vickery, Michael, 'L'inscription K 1006 du Phnom Kulen', *BEFEO* 71, 1982, pp. 77–86

——, 'Some remarks on Early State Formation in Cambodia', in D. G. Marr and A. Milner (eds), *Southeast Asia in the 9th to 11th Centuries*, Singapore, 1986, pp. 95–115

——, 'What and where was Chenla?' *BEFEO* 80/2, 1993, pp. 197–212, Paris, 1994

——, *Society, Economics, and Politics in Pre-Angkor Cambodia. The 7th–8th Centuries*, Tokyo, 1998

Wang Gungwu, *The Nanhai Trade, a study of the early history of Chinese trade in the South China sea*, *Journal of the Malaysian Branch of the Royal Asiatic Society* 31/2, 1958 (whole issue)

Wolters, O. W., 'Khmer "Hinduism" in the Seventh Century', in R. B. Smith and W. Watson (eds), *Early South East Asia: Essays in Archaeology, History, and Historical Geography*, New York and Kuala Lumpur, 1979, pp. 427–42

Woodward, Hiram W., Jr, 'The Bayon-Period Buddha Image in the Kimbell Art Museum', *Archives of Asian Art* 32, 1979, pp. 72–83

——, 'Some Buddha Images and the Cultural Developments of the Late Angkorian Period', *Artibus Asiae* 42, 1980, pp. 155–74

——, 'Tantric Buddhism at Angkor Thom', *Ars Orientalis*, 12, 1981, pp. 57–67

——, 'Practice and Belief in Ancient Cambodia: Claude Jacques' *Angkor* and the *Devaraja* Question' (review of Claude Jacques and Michael Freeman, *Angkor: Cities and Temples*, see above), *Journal of Southeast Asian Studies*, 32 (2), June 2001, pp. 249–61

Zéphir, Thierry, 'L'Art Khmer' in *L'art de l'Asie du Sud-Est*, Paris 1994, pp. 151–249; trans. as *Art of Southeast Asia*, Paris, 1998

——, *L'Empire des Rois Khmers*, Paris 1997

Zhou Daguan, Michael Smithies (ed.), *The Customs of Cambodia*, Bangkok, 2001

Zimmer, H., *The Art of Indian Asia*, 2 vols, New York; 1st ed. 1955, 2nd ed. 1960

List of illustrations

153 Preah Khan. Siem Reap. Plan from Philippe Stern. *Les Monuments Khmers du Style du Bayon et Jayavarman VII*. Publications du Musée Guimet. Recherches et Documents d'art et d'archéologie, Tome IX. Paris, 1965.

154 Naga and deva, balustrade. Preah Khan, Siem Reap. © RMN Photo Thierry Olivier

155 Preah Khan, two-storeyed structure. Photo Helen Jessup

156 Preah Khan, Hall of Dancers. Photo Helen Jessup

157 Dvarapala. Preah Thkol, Preah Khan, Kompong Svay, Kompong Thom. Musée National des Arts Asiatiques – Guimet, MG 24614. Photo John Gollings

158 Neak Pean, Siem Reap. Photo Helen Jessup

159 Bayon, Angkor Thom, Siem Reap. Photo Helen Jessup

160 Bayon, tower. Photo Helen Jessup

161 Bayon, relief: general in procession. Photo Helen Jessup

162 Bayon, relief: woman in childbirth. Photo Helen Jessup

163 Buddhistic triad. Prei Monti, Roluos. NMPP, Ga 2424/5470. Photo John Gollings

164 Lokeshvara. North Khleang, Angkor Thom, Siem Reap. NMPP, Ga 5340. Photo John Gollings

165 Radiating Lokeshvara. Preah Thkol, Preah Khan, Kompong Svay, Kompong Thom. Musée National des Arts Asiatiques – Guimet, MG 18139. Photo John Gollings

166 Angkor Thom, Srah Srang. © Kenro Izu/Friends Without a Border

167 Angkor Thom, causeway and south gate. Photo Helen Jessup

168 Angkor Thom, west gate, north face. Photo Helen Jessup

169 Angkor Thom, elephant terrace. Photo Helen Jessup

170 Shrine with Hevajra. Unknown provenance. NMPP, Ga 2494. Photo John Gollings

171 Prajñaparamita. Unknown provenance. NMPP, Ga 5333. Photo John Gollings

172 Ardhanarishvara. Prasat Sra Nge, Roluos. NMPP, Ka 1847. Photo John Gollings

173 Ganesha. Unknown provenance. NMPP, Ga 2320. Photo John Gollings

174 Pediment. Preah Pithu, Siem Reap. Musée National des Arts Asiatiques – Guimet, MG 18912. Photo John Gollings

175 Standard in monkey form. Prasat Phnom Bayang, Ta Keo. NMPP, Ga 5472. Photo Helen Jessup

176 Bayon, relief showing standard with monkey. Photo Helen Jessup

177 Banteay Chmar, gopura, relief with Avalokiteshvara. Photo Helen Jessup

178 Spean Mei Mai, Siem Reap. Photo Helen Jessup

179 Preah Palilay, Siem Reap, sanctuary seen from the southwest. Photo Helen Jessup

180 Leper King or Yama. Angkor Thom, Siem Reap. NMPP, Ka 1860. Luca Tettoni Photography

181 Buddha. Preah Khan, north wing, gopura III east. Musée National des Arts Asiatiques – Guimet, MG 18048. Photo John Gollings

182 Buddha. Kong Pisei, Kompong Speu. Musée National des Arts Asiatiques – Guimet, Ga 2057. Photo John Gollings

183 Vishnu-Vasudeva-Narayana. North Khleang. Musée National des Arts Asiatiques – Guimet, Ga 5457. Photo John Gollings

184 Neang Preah Thorani. Khum Prasat, Kong Pisei, Kompong Speu. NMPP, Ga 5473. Photo Hans Hinz

185 Standing Buddha. Angkor Wat, Siem Reap. NMPP, Ko 311. Photo John Gollings

186 Kneeling worshipper. Angkor Wat, Siem Reap NMPP, Ko 315. Photo John Gollings

187 Panels with devata. Babor, Kompong Chnang. NMPP. Photo Hans Hinz

188 Kiln wasters from Thnal Mrec, Phnom Kulen. Held by the APSARA authority, Siem Reap. Photo Helen Jessup

189 Footed jar. Buriram province, Thailand. Bangkok University Museum

190 Jar in elephant form. Grave site near Khao Din Tok, Tak province, Thailand. Bangkok University Museum

191 Fragment of a silk skirt cloth. Handwoven silk with weft ikat, dyes (probably chemical). Private collection. Photo Helen Jessup

192 Painting, temple pavilion, Phnom Chisor. Photo Helen Jessup

193 Detail, mural of the Royal Palace, Phnom Penh. Museum of the Royal Palace of His Majesty King Norodom Sihanouk. Photo Helen Jessup

194 Royal palace. Photo Helen Jessup

195 NMPP. Photo Helen Jessup

Acknowledgments

Creating a cogent account of sixteen centuries of the art of Cambodia in the succinct requirements of this book was a formidable task. But the chance to reach readers lacking access to the mainly French basic material made the challenge worthwhile, even though the compact format precluded proper acknowledgment of the extraordinary efforts of scholars who have preceded me.

Since only archaeology and epigraphy can convert speculation and opinion into knowledge, the chief debt is to such towering figures as Cœdès, Barth, Bertaigne and Finot, later Sanskritists such as Bhattacharya and Jacques, and Pou and Vickery who have drawn attention to the importance of Khmer epigraphy. The researches of scholars including Parmentier, Glaize, Mus, Bizot, Boisselier, Giteau, Stern, de Coral-Rémusat, Bénisti, Le Bonheur and Mannikka, among others, also offer an extraordinary contribution.

My own research would not have been possible without generous help from many colleagues, in particular Ang Chouléan, Ashley Thompson and Thierry Zéphir, who have enlightened me on innumerable topics. The directors (both Pich Keo and Khun Samen) and staff of the National Museum have been generous in allowing access to sculptures and documents, and the Ministers and personnel of the Ministry of Culture have also been supportive. I am indebted to Nikos Stangos of Thames & Hudson for his patient support and understanding, and to his colleagues Philip Watson, my infallible editor, Wendy Gay who expertly orchestrated the illustrations, and John Morgan who created the sensitive design. I am especially grateful to my husband, Philip Jessup, whose moral support and tolerance of the absences of the researcher and the distractions of the writer was enriched by his skills as a critic. I thank them all. Their help has been incalculable, and the inspiration of the magnificent culture of Cambodia has been sustaining. The shortcomings of this book are entirely mine.

Index

Figures in *italic* refer to pages with illustrations.